CITADEL
CULTURE

CITADEL

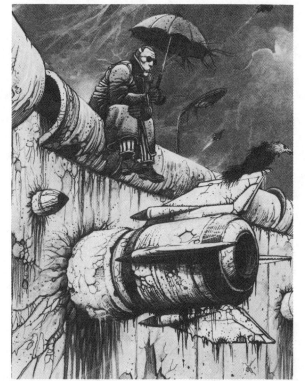

CULTURE

O. K. WERCKMEISTER

The University of Chicago Press / Chicago

O. K. Werckmeister is the Mary Jane Crowe Distinguished Professor in Art History at Northwestern University. He is the author of numerous articles, reviews, and books, including *The Making of Paul Klee's Career, 1914–1920*, also published by the University of Chicago Press.

Translated by the author from *Zitadellenkultur*, © 1989 Carl Hanser Verlag, Munich and Vienna, with editorial assistance of Diane Miliotes.

Illustration on the title page is from *Le Mur*, by Enki Bilal (1982), © Futuropolis/Bilal, Paris 1986. Used by permission.

The University of Chicago Press, Chicago 60637
The University of Chicago Press, Ltd., London
© 1991 by The University of Chicago
All rights reserved. Published 1991
Printed in the United States of America

00 99 98 97 96 95 94 93 92 91 5 4 3 2 1

Library of Congress Cataloging-in-Publication Data

Werckmeister, O. K. (Otto Karl), 1934–
 [Zitadellenkultur. English]
 Citadel culture / O. K. Werckmeister.
 p. cm.
 Translation of: Zitadellenkultur.
 ISBN 0-226-89361-8 (alk. paper)
 1. Arts, Modern—20th century. 2. Postmodernism. I. Title.
NX456.5.P66W4713 1991
700'.9'048—dc20 90-20529

CONTENTS

The past few days when I've been at the window upstairs, I've thought a bit of the shining "city upon a hill." The phrase comes from John Winthrop, who wrote it to describe the America he imagined. . . .

I've spoken of the shining city all my political life, but I don't know if I've ever quite communicated what I saw when I said it. But in my mind, it was a tall proud city built on rocks stronger than the oceans, wind swept, God blessed, and teeming with people of all kinds living in harmony and peace—a city with free ports that hummed with commerce and creativity, and if there had to be city walls, the walls had doors, and the doors were open to anyone with the will and the heart to get here.

That's how I saw it, and see it still.

And how stands the city on this winter night? More prosperous, more secure and happier than it was eight years ago.

<div style="text-align:right">

President Ronald Reagan
Farewell Address to the American People
12 January 1989

</div>

INTRODUCTION

Prometheus in the Citadel

At the end of September 1986, I arrived in West Berlin, and on my first evening out, I went to see the performance of a tragedy by Aeschylus in a new translation by Peter Handke, staged in one of the exhibition halls at the fairgrounds below the radio tower. The Austrian author had disregarded the customary German translation of the Greek tragedy's title, *The Shackled Prometheus* and had translated it, more literally, *Prometheus Shackled*, perhaps in order to underscore the intermediate stage in the mythical story that the title denotes. For in Aeschylus's complete trilogy, of which only this piece is extant, it was immediately followed by another, entitled *Prometheus Liberated*, which carries the story to a solution where the shackles are broken. Whereas the Athenian spectators of the fifth century B.C. had been able to follow and judge this sequence of events, the Berlin spectators of 1986 were not able to understand *Prometheus Shackled* as a transitory phase which can only be comprehended once the end has been reached. The piece broke off with the hero in a state of indeterminate punishment:

> You see me. You see how I
> Am suffering injustice.

These were the last words spoken in the play.

The producers of the performance in Berlin must have been aware that the dynamic tragedy was here transformed into an epic recital of suffering without conclusion, since they had reprinted on the posters and program leaflets Franz Kafka's short story *Prometheus*. Kafka relates four uncertain variants of the myth, all ending with Prometheus remaining forever shackled to the rock, and concludes:

> What remains is the inexplicable chain of rocks. —The tale attempts to explain the unexplainable. Since it originates from the grounds of truth, it must again end in the unexplainable.

In this unpublished, private text of 17 January 1918, Kafka devised hypothetical "tales" about Prometheus's endless imprisonment which leave the myth itself in the darkness of forgotten traditions. Aeschylus's tragedy, however, had been an attempt to clarify uncertain mythical traditions through the medium of discursive political theater addressed to the ruling social elite of a democracy which would subject the religious ethos of the myth to a public discussion. In 1986, Handke, invoking Kafka, transformed the tragedy into a tale that ends on a lament without solution.

In the ancient Greek semicircular theater, the open platform of the stage and the ascending stalls for the spectators were concentrically arranged, but in the rectangular exhibition hall of the Berlin fairgrounds these two spaces were located opposite one another. The Greek stage front, with the central gate out of which actors would step onto the *orchestra*, was facing the stalls. In Berlin, on the contrary, the ascending stalls doubled as an invisible stage front, so that the actors were emerging from under the spectators, facing in the same direction, and were beginning to speak while they were still moving below the stalls. Thus the confrontational distance of the Greek theater

space, where actors would put their arguments forth to the audience, was cancelled. In the center of the rectangular stage platform there stood the giant rock mentioned at the end of Kafka's text:

> What remains is the inexplicable mountain chain of rocks.

Figures and fragments of antediluvian animals were scattered around it. Amidst the ear-shattering din of a sledgehammer blasting from the sound system, the actor Bruno Ganz was riveted to the rock as if nailed to a cross. Then, standing upright in chains throughout the show, he began to harangue the other personages, the choir, and the public, with a dogged, melodramatic exposition of his plight, a sequence of blasphemous accusations, implacable reckonings, exasperated pieces of advice, and defiant predictions of vindication:

> It pains me to speak about it.
> But silence, too, means pain. Disgrace all around!

These verses, which were printed in the program leaflet next to Kafka's parable, circumscribe the grousing, inconclusive display of suffering into which Aeschylus's tragedy fragment was turned in this performance.

The Greek tragedy's pondering of destiny, the "inexplicable," mythical lament, as a spectacle on the industrial fairgrounds of West Berlin, was staged at the foot of an architectural complex with a high-tech shape and metallic silver surfaces, built at a cost of a billion marks at the traffic junction where the highways from the Federal Republic discharge into the subsidized, isolated city of business and culture. This architectural configuration evokes the Dionysus theater at the foot of the Acropolis at Athens, where Aeschylus's complete tragedy was originally performed. It was a spectacle of citadel culture. This

is the metaphor I use here to characterize the dominant artistic and intellectual culture of the democratic industrial societies during the years 1980–87, the time of their greatest economic success, a culture contrived to exhibit the conflicts of those societies in a form that keeps any judgment in abeyance.

Citadels were fortresses from which ancient cities, centers of commerce, culture, and power, were to be defended against attacks from outside enemies and against rebellions of their own inhabitants. As long as they were suited for warfare, until the nineteenth century, "Acropolis," the word for the castle of Athens, was rendered as "citadel" in literate English. In 1986, I read in a dictionary of current German usage that the word *Zitadelle* was becoming obsolete, just at a time when the American phrase "Strategic Defense Initiative" was being introduced into colloquial German. Indeed, the artfully designed and constructed fortresses on the highest points within big cities, or at their outskirts overlooking their approaches, may now be obsolete, useless for defense against bombings from the stratosphere and unnecessary for the control of restless populations now provided by riot police helicopters. But the new American term denotes the same idea. The projected electronic dome to be extended over North America, the center of the Atlantic conglomerate of democratic industrial states, designed by the sharpest thinkers of science and strategy and to be produced and maintained with the most advanced technology, is in fact an all-encompassing citadel, with a strategic designation where defense and attack have become inseparable. Whatever the dictionaries might say about the current status of the German language, I use the word citadel as a metaphor for the artistic and intellectual success culture of the eighties, which dealt with nothing but crises in the midst of affluence.

Citadel Society

In 1986 it was taken for granted that we had been living, and would continue to live, in a citadel of coexistence, secured through a system of electronically interconnected, graduated armaments extending all the way from the underground batteries of intercontinental missiles in Wyoming to the submachine gun slung over the shoulder of the border police at the Helmstedt checkpoint. Today, in August 1990, this global military network is still fully in place, just less aggressively staged. It extends beyond the borders where our armies stop, into the electronic surveillance systems orbiting in outer space over enemy territory, and feeds back into the computer-stored target maps for first and second strikes in our military command centers. It is only thanks to this militarization, we are told, that war between the two blocks has never broken out. We are compulsively conscious of the all-pervasive military conditions of our existence, but we cannot gauge how they function technically and how they are guided politically. The democratic institutions that allow us to empower, change, and control our governments have made sure that this entire operational system of weaponry is withdrawn from our political initiatives. A boundless public sphere of perpetual but fragmentary manifestations and debates makes up for the lost political self-determination of democracy about the conditions of its security.

Between 1980 and 1988, open wars were being waged at the outskirts of the enduring political confrontation between the two peacefully coexisting power blocks headed by the United States and the Soviet Union. In Nicaragua, Angola, and Afghanistan, they were conducting regional wars by proxy, and the border war between Iran and Iraq, which until 1986 had been a regional conflict in which the

capitalist industrial states were supplying both sides, put the oil supplies of these states in jeopardy and had to be concluded. In 1988, when I finished the German version of this book, the proxy wars between the United States and the Soviet Union were about to be settled in the course of a revived coexistence policy tied to urgent reductions in military expenditure. The capitalist industrial states, just like the socialist ones, had participated in the proxy wars through flexible involvements ranging from economic embargoes or political pressure all the way to financial aid, arms shipments, military assistance, and outright intervention. When those wars were at their high point, between 1982 and 1986, they were technically and economically sustained through the calculated overproduction of an arms industry whose investments into increasingly costly, complex weapons systems could not be recovered from the defense budgets of their own countries. The regional wars had become constant figures in the instant electronic balance sheets of international finance systems, vital percentages of gross national products, government budgets, and labor markets, critical test data for technological research, in short, worldwide economic determinants of our lives. Hence in the fall of 1986, when I began to write, in the industrial democracies war and peace production still appeared to be compatible and were being publicly represented as mutually beneficial. Just one year later the credit base for the financing of this kind of productivity began to prove untenable. Today, in 1990, as the whole process is being subjected to political rationalization in an effort to restore the balance between war and peace production on the basis of diminishing growth rates of overall productivity, the same principle of militarization remains in force.

The high point of productivity attained by directing the capitalist economy toward rearmament, and the attendant

rise in living standards for substantial segments of the working population, have furnished this economic policy of the democratic industrial states with the political legit- imacy claimed by their governments. Thus democracy has come to be the political order of a society armed to the teeth. In the subordinate supply and market regions of the Third World, where the capitalist economy does not serve the interests of majorities, democracy was lacking. Here, until about 1986, political power was sustained by grad- uated forms of force, through military dictatorships, ple- biscitarian one-party states, or unaccountable presidential regimes. Here mass demonstrations alternated with elec- toral reforms, coups d'état with emergency decrees, police terror with revolutionary violence, and civil wars with truce conferences. They turned out to be politically unsuccess- ful efforts to stabilize the fitting of these states into the global cash economy, while banks and stock exchanges, finance ministries and budget committees were attempting to adjust their national economies to the unpredictable vacillations of the attendant exchange system. The gradual political democratization of Third World countries under way since 1986 has remained precarious as long as the social disparity generated by the economic system stays in place.

To their own populations, the industrial states them- selves guarantee law and order, affluence and security, freedom of opinion and uncensored culture. Still, even here, growing minorities remain excluded from prevalent living standards, underpaid, unemployed, pauperized, socially degraded, politically discounted, still too few in number to make a difference in electoral power calcula- tions, hence without participation in the democratic pro- cess, too disillusioned even to vote. These minorities are being pacified with social programs constantly in danger of

being cut according to the economic logic of state budgets, but kept in place according to the political logic of internal security. If they become politically active outside democratic institutions, they turn into target groups of emergency planning, with its political police bureaus, control bureaucracies, computerized surveillance programs, legally graduated operating regulations, riot police details, prison vans, water cannon, tear gas grenades, visor helmets, high-impact plastic shields, batons, rubber bullets, and live ammunition. Constitutional lawyers and politicians are bent on defining the distinctions between emergency and legitimacy within this dense net of democracy's self-policing.

Accordingly the officeholders of democracy are being protected by elaborate security apparatuses as soon as they venture out into the public sphere. Special police in military gear secure the topography of the fairs, operas, and boulevards where they make their appearances. Armed plainsclothes officers, wired to their command centers through button earphones, surround them, staring from behind their dark sunglasses into all directions of the public assemblies. Sharpshooters are posted on the rooftops of the high-rise buildings in the vicinity. And yet no political direction can be ascertained from which the terrorist threats might come. This kind of political stagecraft is called by the same word as the constant military alert, the word "security," citadel society's key term.

All of this is common knowledge in the public sphere, with its constitutionally guaranteed, potentially boundless freedom of media and opinion. It is abundantly documented in television programs, films, photographs, books, journals, statistics, maps, and graphs and is perpetually updated through instant reportage and commentary. The resulting permanent crisis-consciousness is being ex-

pressed by an accompanying artistic and intellectual success culture which, rather than helping to clarify it, merely registers its shocks and worries, but does not expose its historical conditions.

Argumentative Culture

In the 1970s there was, by contrast, an argumentative, critical culture that explicitly referred to contemporary history. The references were unmistakable because they were advanced in openly political terms. This culture differed from that of the eighties not because of its contemporary historical themes, but because of its artistic form, which was both dramatic and subject to rational assessments, assent, or opposition. Implicitly or explicitly, it unfolded along the traditional political spectrum from left to right. Toward the end of the decade, it lost its force of conviction in the public sphere, not because it had misjudged the situation, but because its political predictions and ideals remained unfulfilled. The artists and intellectuals who produced this culture did not wish to settle for diagnoses, but advanced unredeemable, utopian alternatives, and hence eventually became disconcerted about the accuracy of their thinking. Just like their predecessors in the thirties, these liberal or radical minds had to live down the powerlessness of critical culture in the face of conservative politics with democratic majority support. Yet, unlike their predecessors, they had little to suffer. The economic expansion of the early seventies enabled them to pursue their work more ambitiously than before and even install themselves institutionally. Only social reality remained beyond the reach of their calls for change. Despite the semblance of a steadily growing public impact of culture, they were most often arguing with no one but themselves,

in growing numbers, to be sure, but still confined to a sphere of their own. The dynamics of the global economic cycles left them behind. When the economic crisis of the late seventies prompted the democratic governments of the industrial states to adopt conservative policies of social disparity and aggressive rearmament, this culture of political emancipation did not have to be suppressed. Its lack of political credibility allowed it to be continued, although its social dysfunctionality became more and more apparent.

In the realm of art, Peter Weiss's three-volume novel *The Aesthetics of Resistance* (1975, 1978, 1981) and Francis Ford Coppola's film *Apocalypse Now* (1979) mark the high points and end points of argumentative culture. The German writer and the American filmmaker had both developed their programmatically ambitious works by bringing traditional literary and visual forms to bear on the experience of the American defeat in Vietnam. Under the pressure of this decisive political issue of their time, they drew on the typologies of the *Bildungsroman*, the theoretical treatise on culture, and the war reportage to devise the existential biography of a traditional protagonist whose compulsory self-examination in times of historic emergency leads him to the point of utterly negative reflections. The subjective outrage of an individual about the brutality of a history in which he himself participates animates an artistic exposure that is the more relentless the more futile any resistance proves to be. *The Aesthetics of Resistance* is a progressive self-refutation of the program suggested by that title under National Socialist oppression and Stalinist duplicity, ending in the historical catastrophe of the Second World War. Between 1937 and 1944, a handful of German workers and intellectuals vainly attempt to confront Hitler's dictatorship in the name of a revolutionary tradition to be recovered from attentive studies of European culture.

However, their struggles invariably end in flight or death, and even Germany's defeat leaves their hope for liberation and reconciliation unfulfilled. *Apocalypse Now* shows how the barbaric technical perfectionism of the American war effort in Vietnam regresses into the exotic, mythical behavior of a commander who establishes his own theocracy in the Cambodian jungle and how the officer sent out on a mission to remove him takes his place in his own mythical rite of sacrifice.

Both the novel and the film take the form of a progressive reflection driven and sharpened by disillusioned observation. Graphic descriptions of historical experience are fused with an uncompromising critique, serious or satirical, of the traditional artistic idea of emancipatory self-awareness, which is the premise of their literary form. The mythical scenes of an endless return to barbarism at the end of both works are antithetical conclusions drawn from this critical reflection, not alternative escapades. Weiss evokes the unresolved history of the struggles of the oppressed as an imaginary multifigure relief on the Pergamon Altar, whose Hellenistic frieze depicting the defeat of the giants at the hands of the Olympian gods has served as the guiding image of oppressed rebellion throughout his book. In this imaginary relief, the broken-off figure of Hercules the liberator is still missing. (In the Berlin production of *Prometheus Shackled* nothing suggested that in that mythical story Hercules would also eventually appear as a liberator.) Coppola stages on the terraced architecture of a Khmer temple precinct the perversion of the apocalyptic city of heaven into a barbaric execution site and bloody sacrificial area for rituals of the rule of evil. Both these endings follow a traditional scheme of recapitulation, where the end of a work of art relates to its beginning; but they don't project any ideas of transhistorical renewal, only an

ultimate hesitation as to whether history will really termi-
nate in a catastrophe. The alternative between the cyclical
concept of mythical return and the targeted concept of
apocalyptic finality remains in suspense. Thus *The Aes-
thetics of Resistance* and *Apocalypse Now* mark the point in
time where the radical historical reflection of argumen-
tative culture was forced to turn back on itself.

The unequivocal suggestiveness of their historical sub-
ject matter and the clear chronological progression of their
narrative gave the book and the film their argumentative
form. Thus both works were compatible with verbal and
conceptual forms of experience and reflection outside their
particular artistic medium. This is why they prompted
widespread political discussions far beyond artistic culture
about the pessimistic conclusions their authors had drawn
from the most recent disappointments of the worldwide
protest movements against the American war of interven-
tion in Vietnam, faced as it was, at the end of the seven-
ties, with the mass flights of the boat people from Vietnam
and the massacres in Cambodia. Long controversies en-
sued about the political self-delusions of the Left in the in-
dustrial democracies and about the moral justification of
their partisanship for the communist insurgents in the Viet-
nam War. These controversies were not merely prompted by
the realistic contents of the book and the film, but shaped by
the propositional quality of their artistic form. This is what I
call argumentative culture.

Citadel Culture

Since the end of the seventies a new artistic and intellec-
tual culture with official support and with public success
has emerged which I call citadel culture. This culture has
freed itself from any direct political reference to the present

times with all the more self-assurance the more threatening contemporary history appears. However, it offers no positive social fictions, no otherworldly aesthetic illusions. On the contrary, its displays of wars and catastrophes, of crisis and alienation, of violence and suffering may well exceed those of argumentative culture. Citadel culture is deployed without limitations, expresses itself without inhibitions, is capriciously designed and grandiosely staged. Its profuse associations with the brutality of contemporary experiences, which make it appear aesthetically compelling and thematically topical, are shattered into large and small fragments and reassembled into arbitrary configurations, quickly changing as in a kaleidoscope. Historic and fictitious at once, this culture does not soften reality but aestheticizes its painful experience. Its enhanced sensual forms of expression are often carried to the point of claiming the immediacy of sensual experience. This is its most fundamental illusion, for no aesthetic experience can break the border between art and reality, no matter how far that border has been pushed back by the technical advances of the media, the breakdown of aesthetic convention, and the radicalization of free expression. Contemporary art does not become any more realistic in the process. The more fragments of reality it incorporates, the more willful its aesthetic posture.

Citadel culture correlates aesthetic and historical experience without reciprocal clarifications about art or reality. It is addressed to a public that cannot at any time forget the danger zones beyond and within citadel society. The news reports and the photo reportage, the dossiers of the investigative committees, and the statistics of the aid organizations transmit continuous documentation of the unjust sufferings there, of which the members of citadel society are spared any sensual, that is, real experience. Now

citadel culture transposes anecdotes, memories, and asso-
ciations of those sufferings into crass aesthetic displays,
tragic collages that maintain a dim awareness of how they
contradict our well-being. Exempting bad news from ra-
tional clarification, and shirking the call for change, citadel
culture neutralizes political consciousness, illuminating in-
stead the complete but decisionless freedom of information
and opinion secured in the democratic industrial states.

Like the culture of capitalist democracy, its political
self-representation jars against the worldwide information
about contemporary history, since it tends to focus on the
internal functions of national economies and state admin-
istrations. In spite of their multinational entwinement,
capitalist interest policies are being projected into nation-
alist ideologies, because their global reach can no longer
be justified. All through the eighties, U.S. governments
with huge electoral mandates were able to conceal their
worldwide policies of hegemony behind domestic ideals of
democracy, which in the country itself are only being im-
plemented by a minority of voters and which they did not
actively support in their interest spheres abroad. Since
1982, West German governments, emerging as the most
faithful executors of U.S. interest politics in Western Eu-
rope, have propagated revalidations of twentieth-century
German national history all the more stridently the less
they were able to stand for any independent national pol-
icy. Such political introversions of interest, such collective
egocentrisms of industrial democracy have supported cita-
del culture. The educational level and the intelligence of
its numerous technical, social, and political elites are
too highly developed to find their self-understanding in
straightforward assertions of the values by which they live.
These elites demand a culture which appears to do justice
to the contemporary historical situation, or which even

represents it as problematical as it is, but without making a problem of what its permanent crises have to do with their privileged conditions of existence. The aesthetic projections of a general consciousness of tragic conflict which this culture provides contribute to the relief from political responsibility for the predicament of the disprivileged social segments within citadel society and the dependent populations outside.

Grandiose Performances

The steady growth of citadel culture in scope and funding seems to have kept pace with the rebound of the capitalist economy after the crisis of 1980–81, in correspondence with the general shift of priorities from political programs of social services to market-oriented investments. While state expenditures for educational programs are shrinking, while budgets and payrolls for adult education and libraries, for research institutions and universities are being cut, a spectacular culture is being funded generously by variable combinations of state subsidies, corporate investments, advertising accounts, and returns from large audiences. Government agencies and grant offices, capital-shielding foundations, publicity departments of industrial corporations and banks, tourist programs and academic representation funds are offering this culture to an educated mass public with growing purchasing power. They continually enlarge this public by blurring the distinctions between elite and popular culture. Hence the continuous growth of the partly state-owned, partly private capital investment in the culture industry, with its new theaters and museums, international blockbuster shows and orchestra tours, television productions, auctions and congresses, festivals and prizes, art tourism, stereo and video sets for

electronic reproduction of music and film, computerized color screening and typesetting, and high speed printing presses. The spectacular successes of this industry, the number of visitors to art exhibits, the running time and gross intake of films, the editions of books, the auction prices of famous paintings are continually being superseded as a matter of principle.

In this expanding culture, creative individuals excel with grandiose projects, with voluminous works in ever faster succession. Their productivity knows no technical or financial limits, since nearly always a paying public stands waiting, and if not, the sponsorship programs of ministries, airlines or computer companies step in. Culture-producing artists or intellectuals no longer question but transfigure the successful individual, the fundamental ideological figure of capitalism's competitive society. There was a time when dissident modern artists and intellectuals embodied social nonconformity, when their introversion radicalized itself into subversion, when their disobedience activated itself into protest. The democratic culture after the Second World War encouraged this dissident posture because it could be stylized into the ideal of everybody's freedom of opinion. Today, artistic and intellectual nonconformists have become leadership personalities of culture, officially entrusted with the self-representation of their idiosyncrasy. The public behavior they can afford, the shrill political critique they can advance, are not impediments but preconditions for this leadership role. But now their success does not merely confirm the freedom of opinion in political democracy, it has come to advertise the endemic misgivings of the affluent society as a whole against the preconditions of its well-being. This society has come to insist on being questioned by a general social critique. It requires a cathartic culture which incessantly proclaims that growth of production entails the danger

of war, the destruction of the environment, the impoverishment of other countries, and the alienation of the individual.

Now at last free artists and intellectuals, who had already neither been subject to directives nor compelled to resistance, have a market for their opposition. They can turn it into the great achievements which citadel culture endows and circulates. Their readiness to speak for society at large relieves them of any responsibility toward determinate social segments whose interests they might advocate against the prevailing social order. They have come to be the protagonists of the classless, generalized public of capitalist democracy, which stages the permanent but inconclusive spectacle of its self-critique. Here they are not obliged to take issue nor show solidarity with one another. Their presentations are often pooled in television talk shows, conferences, or academic lecture series, collective publications or exhibitions because their pluralistic acceptance makes any debate superfluous as to which kind of art or literature might suit the situation and which might not. The time has passed when modern art was the arena of exasperated ideological struggles ranging from fascism to the popular front. Citadel culture has no fronts, only competing propositions. Its protagonists coexist in an unrestricted dynamics of self-realization, absolute and relative at once. The colorful variety of their achievements can juxtapose contradictory phenomena without missing anything, producing shock effects in passing, neutralizing one another in an endless sequence.

Aesthetic Transfiguration

However, the more grandiosely citadel culture can be staged, the more ominously does it present itself. The self-assurance of its secure financing, bold planning, and so-

cial mass success does not prevent it from offering painful spectacles about the hopelessness of life under the pressure of social conditions and the constraints of political authority. A tragic ambivalence of suffering under favorable conditions is the aesthetic form whereby it illuminates political irresolution. In the course of the last decade, the license of representation in all media has been achieved as a deceptive image of the democratic right to free opinion. For the first time in the history of public culture, the principle of obscenity has been all but abolished. This verbal and visual emancipation of citadel culture facilitates unbridled representations of sexuality and death. But the more glaringly the psycho-physical appearance of human nature is illuminated, the more obscure the historical actuality of human life remains. The bloodier the wounds look, the more invisible the weapons that have caused them. Raw spectacles of sexuality and death are anecdotally isolated in past or present stories, in an arbitrary selection of interesting individuals, and are fitted into colorful fantasies. Only their transposition into patterns of mythical eternity, from popular folklore to esoteric tragedy, reestablishes a general understanding, that of fiction.

Grandiose representations of painful self-indulgence, such as that of Prometheus in West Berlin, forever chained to his rock, preoccupy a public consciousness attracted to catastrophes but oblivious to history. Aesthetic lament and political apathy feed upon one another. Stoic introversion of suffering is being extroverted as a cultural mass sensation. Citadel culture incessantly repeats the message that problems cannot be solved but must be voiced, debated, and sustained. Its radiant pessimism makes the steady announcements in public politics about imminent or necessary change sound less credible and hence more bearable. This sentiment is citadel society's internalized, aestheti-

cally sublimated reaction to the conflicts it maintains at its
margins and beyond its frontiers in order to sustain itself.

Deconstruction of Thinking

Parallel to the collage realism of aesthetic experience, a
philosophical literature has become prominent during the
eighties which narrows thought down to a self-reflection of
its language structure. The apparent failure of thinking to
experience and master reality redirects theory toward its
own verbal expression as its primary object. Now that re-
flection has turned away from the relationship between ex-
perience and consciousness, it can once again proceed
with verbal self-assurance. This kind of thinking by way of
texts and discourse, which exposes texts and discourses
for what they are, regenerates and multiplies itself in a
bloated academic literature of books and journals, in an
uninterrupted sequence of methodological mass seminars
and international conferences. By blurring the distinctions
between word and object, cause and effect, sensation and
concept, deconstructive thinking constitutes itself as a
self-contained explication of philosophy. It is inconclusive
and all-encompassing, abstract and existential all at once.
As a rhetorical critique of culture, it has first infiltrated
and then largely replaced the political critique of culture
from the left.

Chronologically, the ascendancy of deconstructive
thinking coincides with that of sensual effects in visual cul-
ture. Deconstructive discourses, unerringly aimed at insol-
uble questions, are warnings not to draw any conclusions
from the dramatic exposures of raw reality. The more haunt-
ing the images of mayhem and death in movie theaters and
on television, the cruder the random objects propped up as
artworks in museum shows and galleries look, the more

abstract the learned disquisitions sound about reality as a text or a sign system, about statements as statements on themselves, about books that speak to books, about critique as its own subject matter. The analytical language which poses as a medium of emancipation from the validity claims of traditional thinking codifies itself with a vengeance in a vocabulary of its own, which is derived from the authorities of deconstruction like scholasticism from the Church Fathers. The contention that no statement can have objective validity is not advanced as an admonition to resign oneself, but as the promise of the intellect's liberation from unfounded constraints. And yet the constraint returns in the formulaic schematism of the deconstructive language. Here it can be more easily sustained than in reality. If its radical critique of language is aimed at the torrent of political assurances issued by democratic governments, parties, and interest groups and multiplied in the loquacity of the public sphere, it instills pride in empty subversion. Deconstructive thinking thereby takes the place of ideology critique, the philosophical form of reflection germane to argumentative culture, which was focussed on the political determination of language. In so far as deconstruction has shed both the foundational obligations of the political theory of society and the commitment to political practice, it has an easy time surpassing ideology critique in radicalism. After all, no more is at stake than the fundamental inadequacy of terminologies to reality. Since its proponents do not feel bound to proceed from critique to propositions which would have to withstand critique, texts and images remain their preferred subject matter. Thus deconstructive thinking has reached an autonomy which reinforces the self-assurance of its liberating role. It has become the philosophical mode of reflection for the permanent self-doubt of citadel culture.

Politics without Decision

In the diffuse crisis consciousness of citadel society, it is always uncertain whether a state of crisis is acute at any given point in time. Like the monthly tabulations of the multibillion dollar debts of the dependent countries which the international finance agencies and banks carry over at regular intervals, past and current messages of doom are flashing back and forth from day to day in the fragmented, forgetful consciousness of actuality. Even the stock market crash of 19 October 1987 was an event whose bearing on the economic process has remained an open question, perhaps a symptom, perhaps a warning, perhaps merely a malfunction in the electronic acceleration of bidding. The inconclusive motions of citadel culture, its indefinite consciousness of time, which may be suspended at any moment, confirm this economic process. Its fundamental preconditions of progress and growth appear in jeopardy one day and on the recovery the next, overshadowed by continuing worries about the end of the business cycle. But when the business cycle does not end, long-term confidence is never restored. The expectation that the multifarious reform programs constantly being projected—disarmament and debt restructuring, famine relief and drug interdiction, job creation and structural change—will not prevail against the dominating interests is already presupposed in the process of their public discussion.

Citadel consciousness is bound to remain inconclusive because the emergencies which it denounces are to be charged to just those economic and social conditions whose democratic political system grants the freedom of their critique. It allows for a critique in the awareness that none of those emergencies will be redressed, a self-delusion which pertains to the internal privileges of citadel society, de-

pendent as it is on its continuation without change. Mass movements that challenge the institutionalized decisions of democracy, such as the demonstrations against the installation of American medium-range missiles in West Germany, have foundered in their confrontation with the constitutional state as soon as they transgressed the borderline of a mere expression of opinion. Revolutionary violence, isolated to the extreme, has atrophied into terrorism, and thereby discredited even the most minute acts of resistance against the legality of democracy, which is in turn being defined with subtlety to accommodate oppression. And no political alternative to democracy can be conceived.

Thus, critique becomes abstract and anarchistic, myopic or without perspective, tied to passing moments or repetitiously reactive, naïve or cynical. The unavoidable schematism of its aggressive remonstrations falls short of the pluralistically weighted subtlety of citadel culture, which offers its top performances within the constitutional legality of free opinion. This culture will be caught neither in applause for nor in protest against the situation. Its intellectual and artistic forms of expression simulate vacillations between extremes beyond judgment. It is the culture of a society dependent on the decisionless perpetuation of its crises.

ECO

The Art of Silos

I have studied medieval art history and have taught it as an academic subject for many years. It was in 1952 that I first held in my hands, in the Department of Manuscripts of the British Museum, the illuminated copy of Beatus's Apocalypse Commentary, completed in 1109 at the Abbey of Santo Domingo de Silos. This lavish manuscript contains over a hundred miniatures, all sharply delineated and painted in brilliant colors, many of them filling the whole parchment page. The Apocalypse illustrations depict the bewildering visions, cataclysmic panoramas, and triumphant tableaus of the Book of Revelations in flat, pigeon-holed compositions, designed to clarify the text. They are the standardized end results of a pictorial tradition several centuries old, already devised at the end of the eighth century, when Beatus wrote his lengthy commentary, for the purpose of aiding the monks in their formalized reading practice, intent on understanding the Apocalypse and its spiritual sense.

Since 1952 I have visited the abbey of Silos several times in order to study both the early medieval manuscripts of the abbey library and the Romanesque cloister, which was built at about the same time the Beatus manuscript was written and illuminated. This cloister contains a series of six large-scale stone reliefs depicting a liturgical

selection of scenes from the New Testament which range from Resurrection to Pentecost. They visualize the physical presence of the dead and resurrected Christ with as much suggestive realism as could be mustered by an artist of the early twelfth century. One of them in particular, which shows the doubting Thomas as he places his finger in Christ's wound, amounts to a programmatic visual statement about the empirical experience of the doctrine of resurrection.

In my bibliographical studies I soon found out that the most important work of scholarship about the art of Silos had been written by Meyer Schapiro, one of the outstanding art historians of the United States, and one of the few pioneers of Marxist art history in capitalist countries before the Second World War. During the 1930s he had belonged to the circle of Marxist intellectuals in New York who wrote for the journal *Partisan Review*, attempting to combine their political activism with the promotion of modern art. Between 1936 and 1939 these intellectuals had to take issue with the cynical tergiversations of the Communist International in the Spanish Civil War, the three Moscow show trials, and finally the Hitler-Stalin Pact. As a result, along with others, Schapiro broke with the Soviet Union but upheld his Marxist convictions. He sided with Leon Trotsky in his unconditional insistence on artistic freedom.

In 1939, at the high point of these dramatic events in the Marxist intellectual culture of New York, Schapiro's sixty-two-page article about the art of the abbey of Silos appeared in the official scholarly journal of the College Art Association, the *Art Bulletin*. A learned treatise with more than two hundred footnotes and an abundance of bibliographical references, it was intended as a paradigm of Marxist art history, without touching upon the contemporary historical situation with as much as a word. With a

scholarly accuracy far surpassing the literature before him, Schapiro interpreted the transition from the predominantly abstract, "Mozarabic" paintings of the Beatus Commentary to the relatively realistic, "Romanesque" stone sculpture of the cloister as expressive of a historic progression from an authority-bound imagination of doctrine to a rational observation of visual reality according to Christian faith. Behind the artistic shift from abstraction to realism, he believed he could discern a dynamic social process compelling the medieval church to address the worldly mentality of burghers in the newly developing cities. The resulting readjustment of public religious art from doctrinal symbolism to realistic visualization, corresponded, in Schapiro's view, to the transition from dogmatic assertions to rational expositions of Christian doctrine, from authoritative exegesis to philosophical inquiry, culminating in early scholastic theology.

For this historic interpretation of the interrelated changes in visual experience and pictorial representation, Schapiro took his cue from the notes and excerpts on the subject of aesthetics which the young Marx compiled in 1842–43 for his lost article "On Religious Art," which in 1938 had become available in the English translation of Mikhail Lifshits's book on Marx's philosophy of art. Marx had derived from his study of Hegel the thesis that art in the service of religion becomes alienated from its ideal quality, human realism. Controlled by a caste of priests, art becomes the repressive instrument for enforcing blind faith in dogmas and fear of gods. The Beatus Commentary of Silos, with its apocalyptic picture story of Christ's inexorable victory through an eschatological trajectory of catastrophic destructions, painted by a monk in a predominantly abstract style, corresponded to Schapiro's Marxist notion of religious art. The reliefs of the cloister, on the other hand, large-scale representations of intimate physical encounters

between Christ and his disciples, sculpted by lay artists, corresponded to the complementary notion of an art that does justice to human experience. Such an assertion of artistic rationality and freedom was in line with Schapiro's Trotskyist opposition against the Stalinist dogmatization of Marxist art theory pronounced by the Communist party. Trotsky himself had proclaimed the revolutionary mission of free artists in the struggle against both Fascism and Stalinism after his encounter with André Breton and Diego Rivera at Coyoacán, Mexico, in February 1938, in their common manifesto "Towards a Free Revolutionary Art," which *Partisan Review* published later in the year.

From Schapiro to Eco

After what I had thus learned about the relationship between scholarship and ideology critique in the course of my work as a medievalist, I read Umberto Eco's novel *The Name of the Rose*, which appeared in 1980, with a professional academic interest. Its story is set in the Romanesque buildings of an unnamed Benedictine abbey, and the "Mozarabic" Apocalypse Commentary of Silos with its illustrations figures prominently in it. Eco offers here a historically accurate, though fictitious reconstruction of medieval culture as the scenario of a modern drama, in which the abbey of Silos with its illuminated manuscripts is the starting point for a historical dynamics of mutual clarification between dogma and rationality that recalls Schapiro's art-historical treatise. Actually the Beatus Commentary described in the novel is not that of Silos, but another manuscript of the same text which was produced in 1047 for the collegiate church of San Isidoro in León and is today preserved in the National Library in Madrid. In 1973 Eco published a lavish artbook with many color plates about this latter manuscript, where he dealt with medieval

apocalyptic culture. In the film *The Name of the Rose* it appears open for view in the abbey library, and William of Baskerville recognizes it as "the version annotated by Humbertus of Bologna."

In his novel Eco has dramatized medieval culture by making its dynamic social principles, religious authority and critical rationality, clash in an unsolvable conflict rather than have them historically follow one another, as most standard cultural histories would have it. Eco does not speak of any progress from authority to reason. The two principles are personified and balanced in Jorge of Burgos, the guardian of tradition turned criminal, and William of Baskerville, the rationalist scholar turned detective. In the altercation between these two monks the principles refute one another, and the Romanesque abbey with its cultural treasures goes up in flames. It is from the abbey of Silos that Jorge of Burgos brought to his Italian abbey the lost manuscript of the second book of Aristotle's *Poetics*, which develops the notion of critical reason through an analysis of laughter, along with a whole collection of Beatus Commentaries. In these two texts, the two principles are codified.

Eco's novel of 1980 reenacts the dialectical scheme of history which Schapiro, the famous Marxist art historian, had discerned in the art of the abbey of Silos at the time of the Hitler-Stalin Pact. Although Eco does not list Schapiro's name among the random bibliographical references given in his *Postscript to the Name of the Rose*, he must have read Schapiro's writings about Romanesque art, including the article on Silos, which were republished in 1977 in a book of collected essays. Here the historical models of nearly all important Romanesque artworks that figure in Eco's imaginary abbey are discussed. In the novel, Schapiro's Marxist historical dialectics of authority and reason recurs, dramatized into the suspenseful action of a crime novel and a uni-

versal history. Eco has replaced the American Trotskyist's conflict-ridden but progress-oriented panorama of class struggle with a melancholic hindsight on the unsolvable contradictions of culture. However, in making medieval cultural history relevant to contemporary culture, he has been more successful. For while Schapiro's art-historical treatise of 1939 remained hidden away in a scholarly journal, Eco's historical novel, with millions of copies printed in many languages, an almost instant trail of commentary literature, and, finally, an adaptation into a film, surpasses its model in public impact as only culture itself can surpass cultural theory.

Text Culture

In the introduction to *The Name of the Rose* the fictitious author presents his text as a paraphrase of a medieval chronicle and dates his work to the time between 16 August 1968 and 5 January 1980. During these twelve years, the well-known historic changes in the industrial societies took place which led to the conservative political turn of the early eighties. After a phase of political contestation— the student rebellion in Paris, the suppressed political reforms in Czechoslovakia, the worldwide, ultimately successful protests against the American war in Vietnam— there followed a phase of political stagnation and then, reaction—the oil crisis, terrorism in Western Europe, the Soviet occupation of Afghanistan, nuclear rearmament by both superpowers. During this time span, Left-wing intellectuals who had ascended to influence in the academic institutions and the public culture of those industrial states revised the aims of their work. They retracted their unfulfilled claims to political practice, be it through radical democratic reforms or through a cultural revolution, and began to justify their resigned accommodation to existing

political conditions as a refinement of thought, particularly
since they were at liberty to pursue their thought as long as
they stuck to their academic enclaves. Now they developed

their increasingly abstract, global theories, neo-Marxisms,
semiotics, and structuralisms, culminating in the system-
atic deconstruction of thinking. Their new penchant for
conceiving thought no longer as a response to experience,
but as a self-deployment of literature, resulted in an her-
metic, overcomplicated language, where all intellectual
activity was defined as a self-feeding process of reading
and writing, printing and reviewing, commentary and cri-
tique. The "text" became the surrogate of reality.

Looking back on those years, the fictitious author of *The
Name of the Rose* historically positions himself with mock
self-complacency:

> I transcribe my text with no concern for timeliness. In
> the years when I discovered the Abbé Vallet volume,
> there was a widespread conviction that one should write
> only out of a commitment to the present, in order to
> change the world. Now, after ten years or more, the man
> of letters (restored to his loftiest dignity) can happily
> write out of pure love of writing. And so I now feel free
> to tell, for sheer narrative pleasure, the story of Adso of
> Melk, and I am comforted and consoled in finding it
> immeasurably remote in time (now that the waking of
> reason has dispelled all the monsters that its sleep had
> generated), gloriously lacking in any relevance for our
> day, atemporally alien to our hopes and our certainties.

Hence the literary fiction of a historical chronicle has texts
and books for its subject. But the sarcasm professed in the
introduction already betrays the author's judgment of text
culture, which is more critical than he lets on. The book
around which the narrative turns is being stolen and hid-
den, poisoned and swallowed. Eventually all books go

up in flames along with their library. Years later, the chronicler returns in order to pick through the charred parchment scraps at the ruined site. And like the ostensible self-sufficiency of books, the claimed contemporary-historical irrelevancy of storytelling is being refuted by the obvious topical significance of the events so vividly narrated. Only this significance can explain why the book of an academic intellectual, which deals with academic pursuits, has found such an extraordinary public response as a work of contemporary literature.

Citadel Library

Between 1932 and 1939, Meyer Schapiro had published a number of large art-historical articles about Romanesque sculpture and painting, whose conclusions he summed up in his article of 1950, "On the Aesthetic Attitude in Romanesque Art." In all of these writings he had interpreted features of representational realism, of asymmetrical composition, and of decorative independence in Romanesque art as the expression of a social dynamics of medieval culture pushing against the boundaries of order. In Eco's unnamed abbey, the unequivocal symmetry of Romanesque art acts repressively on, and eventually succumbs to, an unruly social dynamics. Eco describes the building complex according to the precedent of famous twelfth-century monasteries. The plan of the abbey, which is printed on the endpapers of the book, resembles the well-known plans of Cluny or Canterbury in its modular regularity. The fundamentally rectangular stereometrical structure of this Romanesque architecture, with the regular numerical proportions of its columns, bays, and vaults, encases the liturgical regularity of monastic life, which unfolds like a three-dimensional chess game according to the measured time divisions of the Benedictine Rule. Eco has broken

this liturgically ordered continuum of time and space by assigning the seven days of the week in which the story unfolds to the seven apocalyptic trumpets, thereby transposing monastic life from the cyclical repetition of the church year to the irrevocable progress toward the end of time. Accordingly, the harmonious regularity and liturgical stereotypy of monastic architecture is being confounded by the surreptitious moves of the blind monk Jorge as he pursues his murderous plans, and by the equally surreptitious hunt of the detective-friar William of Baskerville, bent on uncovering Jorge's scheme. Monks appear as suddenly as they vanish, gather at the discovery of the corpses in hysterical crowds, hide from and spy on one another from behind pillars and corners. At the climax of the story, a thick fog has settled over the abbey so that no one can find his way.

Towering over the compound of Romanesque monastic architecture is a centralized building from earlier times, which is not identified by function but simply called "the building" (*aedificium*).

> This was an octagonal construction that from a distance
> seemed a tetragon (a perfect form, which expresses the
> sturdiness and impregnability of the City of God) . . . I
> did not possess the experience of a master builder, but I
> immediately realized that it was much older than the
> buildings surrounding it. Perhaps it had originated for
> some other purposes, and the abbey's compound had
> been laid out around it at a later time, but in such a way
> that the orientation of the huge building should conform
> with that of the church, and the church's with its.

This is the library where the book treasures of Christianity are kept under lock and key. Because of its Early Christian date and form it can be viewed as the architectural equivalent of the written authority codified in those books. Just as

Benedictine observance follows the doctrine of the early Christian Fathers, the Romanesque plan of the abbey compound is fitted around the octagon of the *aedificium*. It also resembles the royal fortress buildings of the High Middle Ages:

> In its bulk and its form, the aedificium resembled Castel Ursino or Castel del Monte . . . , but its inaccessible position made it more awesome than those, and capable of inspiring fear in the traveller who approached it gradually.

The library building's association with military architecture erected by kings and feudal lords as a monumental representation of their dominion over the surrounding territory is to suggest the unfathomable repression of thought into which spiritual authority has been turned in this abbey, which one of the monks compares with "a citadel erected to defend the library."

The explosive events originating in this building follow from the contradiction between its outer appearance and its inner structure. Whereas the polygonal ground plans of medieval centralized buildings open the inner space up to all sides, the *aedificium* encloses a three-dimensional labyrinth. From the outside it appears symmetrical and harmonious, but inside it appears confusing and is filled with traps. However, by contrast to the Library of Babylon in Jorge Luis Borges's story of 1941, whose infinitesimal honeycomb design poses mind-boggling geometrical riddles without solution, the *aedificium*'s labyrinthine structure reveals its clue without great difficulty to the criminalist, patristically schooled acumen of William of Baskerville, who recognizes it as the distortion of a simple scheme of early Christian world maps. Unlike Borges's intellectual agonies, Eco's bibliographic detective story confronts reason with no intellectual, but rather with moral problems. It

is these which cannot be solved under the historical conditions of the intellectual's existence.

Illuminated Manuscripts

In his lost essay about Christian art of 1842, the young Marx had confidently envisaged a historic transition from the crude, abstract character of the "idols of ancient peoples," an art which is tied to the physical object. In the act of viewing them, "fear contracts the soul." Marx had assumed that the "inborn imitative capacity and the resulting artistic disposition" of human beings cannot, in the long run, be suppressed by idols. Almost a hundred years later, Meyer Schapiro, in his comparative analysis of the art of Silos, had embraced this progressive perspective of Marxist art theory, which is derived from Hegel, but he was no longer able to see it redeemed by a transition to socialist realism in his own time. Thus, after the Second World War, he fell back on acclamations for abstract art as an expression of democratic freedom.

Eco in turn, taking up Schapiro's thought, has stripped it of any progressive perspective. In his protagonist, Jorge of Burgos, Marx's "rule of priests" turns criminal. Jorge's treasure trove of illustrated Beatus commentaries at the abbey of Silos earned him his appointment as librarian of his own abbey, which would have been the stepping-stone to the highest office, that of abbot. However, Jorge turned blind and had to be replaced as librarian, thus foreclosing his eventual ascent to absolute authority. He then attempted to control the abbey by making his successor run the library according to his wishes and by becoming the confessor of the abbot and most of the monks. Beatus's Apocalypse Commentary, with its unquestioning expositions of the mysterious text as a moral and spiritual allegory and with its steadfast defence of Christological dogma

against any heretical deviation, embodies more than any other manuscript the unflinching authority Jorge is resolved to uphold in the face of changing times. The other text he had brought from Silos, "perhaps the only copy" of the "second book of the *Poetics* of Aristotle, the book everyone has believed lost or never written," he hides in the *aedificium,* so that no reader will be tempted to subject the authority of tradition to its questioning mentality. When it is discovered nonetheless, he poisons its sticky paper pages so that anyone leafing through them with wetted fingers is killed while reading on. From then on the octagonal library building becomes the center of Jorge of Burgos's intrigues, where he moves like a spider in the center of its web.

In the course of his story, Eco transforms one of the colorful Beatus illuminations, which were originally designed and copied as pictographic clarifications of the obscure text, into an uncanny medium of enchantment:

> On the table beside a thurible, a brightly colored book was lying open. I approached and saw four strips of different colors on the page: yellow, cinnabar, turquoise, and burnt sienna. A beast was set there, horrible to see, a great dragon with ten heads, dragging after him the stars of the sky and with his tail making them fall to earth. And suddenly I saw the dragon multiply, and the scales of his hide become a kind of forest of glittering shards that came off the page and took to circling around my head. I flung my head back and I saw the ceiling of the room bend and press down toward me . . .

Jorge had laid out the opened Beatus Commentary as a trap beside a censer giving off poisonous fumes so as to frighten William and Adson, the importunate visitors, off the library. The burning incense perverts Adson's perception of

the two-page miniature into an illicit sexual fantasy. The archaic abstract image with its glowing colors casts a spell on the beholder. The early medieval picture composition, originally a didactic visualization of unquestioned faith in Sacred Scripture, now magically clouds his consciousness.

The earliest works of this kind of abstract, sharply delineated and colorful book painting, the Irish and Northumbrian manuscripts of the seventh and eighth centuries, are stored in the *aedificium* right next to those from Spain. Their miniatures are masterpieces of geometrical subdivisions and ornamental entanglements. In Eco's narrative, William and Adson, on their secret visit to the library, behold such a manuscript, the Echternach Gospels, now in the Bibliothèque Nationale in Paris, in an even more ambivalent, uncanny fashion than they did the Beatus Commentary. One of its two miniatures described at length shows the abstract figure of a monk holding in his hands the opened gospel book, in the center of a cross-shaped frame filled with an interlace pattern clearly structured by alternating color fields. The figure is labeled *imago hominis* by an inscription. It is the symbol of the evangelist Matthew, that is, of Christ's incarnation, suggesting that the spiritual perfection to be attained by the monastic way of life culminates in the monk's Christlikeness. The theological straightforwardness and visual clarity of this picture leaves nothing to be desired, but Adson is experiencing it differently:

> I opened a richly illuminated volume that, by its style, seemed to me to come from the monasteries of Ultima Thule. . . . my eye fell, at the opening of the Gospel of Matthew, on the image of a man. I do not know why, but it frightened me . . . : the face was a man's, but this man was sheathed in a kind of stiff chasuble that covered him

to his feet, and this chasuble, or cuirass, was encrusted
with red and yellow semiprecious stones. The head,
which emerged enigmatically from a castle of rubies and
topazes, seemed (how blasphemous terror made me!) that
of the mysterious murderer whose impalpable trails we
were following.

The investigator searching the *aedificium* no longer cap-
tures the doctrinal significance of the miniature. Instead,
he perceives its abstract forms as realistic depictions of
metal and jewels, and the figure as armored, unassailable,
or threatening. Finally, he associates the figure with the
murderer, still unknown, who defends authority as codified
in symbols against rational experience. Thus, in his eyes,
the symbol of salvation turns into its opposite.

In the decisive scene of confrontation between the two
antagonists at the end of the novel, Jorge of Burgos in fact
assumes the posture of the *imago hominis* in the Echter-
nach Gospels. He extends to William of Baskerville, who
has finally tracked him down, the longed-for Aristotle
manuscript:

Jorge reached out his shaking hands and drew the book
to him. He held it open but turned it around, so that
William could still see it in the right position.

Now the suspicion Adson harbored when he viewed the
Irish miniature in the library is borne out. The reversal of
its meanings is complete. Jorge is holding the opened Ar-
istotle manuscript in the position of the Gospels, but not in
order to let the reader share in its contents, but in order to
withhold it from him to the last. In the next instant, he be-
gins to swallow the poisoned manuscript, just as the Old
Testament prophet Ezekiel swallowed the book in which
God's commands were transmitted to him. Through this
last reversal of progressive mirror confrontations, the blind

monk finally acknowledges the divine authority of the Aristotle manuscript.

Sculpted Portals

In his art-historical publications of the thirties, Meyer Schapiro had interpreted the sculpture of Romanesque portals, pillars, and capitals as a calculated attempt on the part of the medieval Church to proclaim its principles of belief and morality in the new public sphere of cities and pilgrimage roads by means of a suggestive realistic imagery. The sculpted representations of redemption and doom were argumentative statements, conceptualized into pointed visual antitheses, like the *Sic et Non* of early scholastic dialectics. By contrast, Eco in his novel exposes dialectical reasoning for its lack of results. William of Baskerville is always cutting short his disputations with Jorge of Burgos under the pretext of humility. Similarly, Eco has adjusted the argumentative polarity of Romanesque sculpture to a dialectics thrown back upon its negations, merely commenting on processes of destruction.

In the imaginary Romanesque abbey there are two sculpted portals, whose descriptions are based on the portals of the abbey churches of Moissac and Vézelay from the first half of the twelfth century. Shortly after his arrival, Adson contemplates the portal of the abbey church, which is modelled on Moissac. Following the incorrect interpretation of the portal of Moissac prevailing in the art-historical literature, Eco describes the apocalyptic vision of the One on the Throne surrounded by the twenty-four Elders as a Last Judgment. However, he suppresses the opposition between good and evil, salvation and punishment, which is in fact depicted in the jamb reliefs of the porch of Moissac, on either side of the doorway. He only describes the reliefs on the left jamb, representing the punishment of the rich

man and of the personifications of avarice and luxury, but omits those on the right jamb, with the scenes of the Annunciation, the Visitation, and the Birth of Christ, which carry the countermessage of salvation. For these, Eco substitutes yet another, invented image of the torments of hell, multiplying those on the left:

> . . . other creatures . . . , all prisoners in a forest of
> flames whose searing breath I could almost feel. . . .
> The whole population of the nether world seemed to have
> gathered to act as a vestibule, dark forest, desperate
> wasteland of exclusion, at the apparition of the Seated
> One in the tympanum, at his face promising and threat-
> ening, they, the defeated of Armageddon . . .

Thus in the portal of Eco's abbey church, a universal, triumphant degradation of the damned replaces the clear alternative of the history of salvation projected in the portal of Moissac. The uniformly negative sculpted imagery announces to the viewer the inexorable apocalyptic course of events which he will experience in the coming seven days.

> And I knew we had made our way up there in order to
> witness a great and celestial massacre.

Eco has transformed the Romanesque pictorial sculpture from a moral appeal into a fatalistic prophecy of doom. The harmoniously proportioned buildings of the Romanesque abbey with their solid masonry contain the images of its imminent peril. What the public sculpture on the abbey churches of the twelfth century threatened to the unruly lay society in order to hold them to spiritual discipline, is now turned inwards, against the abbey, the fountainhead of discipline itself.

Consistent with this negative projection, the Romanesque abbey becomes the scene for a self-refutation of political reason founded on religion, where privileged intel-

lectuals witness the failure of their claims to moral leader-
ship. Here repentant, heretical terrorists have taken refuge,
and delegations of the pope, the emperor, and the mendi-
cant orders meet to resolve their differences; but all these
efforts at social peace run into conflict with one another.
Eco's description of another Romanesque portal, that of the
abbey church of Vézelay, illustrates this compulsive dis-
cord. It appears at the entrance to the chapter house,
where the delegations are gathering for their decisive
debate. The sculpted tympanum of Vézelay shows the res-
urrected Christ, enthroned in the midst of the twelve apos-
tles, as he sends them on their worldwide mission, and at
the same time anticipates the mission's fulfillment in far-
away exotic regions with strange populations. Eco follows
this scheme, but his enumeration of the fantastically de-
formed creatures inhabiting "the unknown worlds," as they
are listed in medieval geography and natural history, far
exceeds the imagery which the sculptor of Vézelay was
able to accommodate in the space of his composition.
These additional creatures correspond to the suppressed
and tormented victims of doom Eco had invented for the
sculptures on the right jamb of the porch of his abbey
church:

> But none of them caused uneasiness because they did
> not signify the evils of this earth or the torments of hell
> but, rather, bore witness that the Word had reached all
> the known world and was extending to the unknown; thus
> the doorway was a joyous promise of concord, of unity
> achieved in the world of Christ . . . A good augury, I
> said to myself, for the meeting to take place beyond this
> threshold . . .

However, the following hysterical dispute of the two par-
ties who have met to discuss the issue of Christ's poverty
abruptly disproves "the great promise of peace and se-

renity confirmed in the stone of the tympanum." They take their seats "in a hemicycle, the two sides separated by a table where the abbot and Cardinal Bertrand were sitting," thus mirroring the symmetrical grouping of the apostles to the sides of Christ. But this liturgical reenactment of the apostolic seating arrangement depicted in the tympanum induces no concord. The two parties hurl increasingly grotesque, self-serving arguments at one another and finally turn violent. Armed security guards have to break up the assembly.

In Eco's adaptation of the two Romanesque portals, the events of the narrative confirm the negative image of Moissac and refute the positive one of Vézelay. This suspension of the medieval polarity of salvation and damnation comes to a head in the confrontation between William of Baskerville, who thinks with reason but without reflection, and Jorge of Burgos, who insists upon authority but dispenses with morality. William bypasses portals, sneaking through secret doors and subterranean corridors into the *aedificium*, to find the Aristotle manuscript and to clear up the murders committed in order to prevent its discovery. He can expose but not prevent the murders, he can find the manuscript but cannot read it before it burns. While authority turns into blind menace, enlightenment comes too late.

From Cultural Critique to Culture

By contrast to Meyer Schapiro's article of 1939, Eco's novel implies that culture cannot be renewed in order to be adapted to the historical changes of social and political reality and still do justice to them. It becomes either dogmatic to the point of repression or critical to the point of self-destruction. In the process, the critique of culture loses any social function. The two protagonists of the novel, William of Baskerville and Jorge of Burgos, jointly ani-

mate this process through their conflict. During their last, decisive encounter in the labyrinth of the *aedificium*, the pursuer and the victim, the discoverer and the seducer, attract one another with a potentially erotic obsession. In one last reversal, they mirror one another. Jorge, who has condemned laughter, is laughing, William, who has defended jokes as a means of knowledge, is crying, both with the same despair. Since the contradictions cannot be solved in historical reality, their conceptual or emotional clarification has become meaningless. "Jorge has won, but you have defeated Jorge because you exposed his plot," Adson helplessly attempts to console William in the end. History leaves them both behind. Jorge burns together with his library; William makes off, soon to fall victim to the black death. The moral refutation and the physical destruction of past traditions foreclose on any perspective on the future. Such short circuits between a discontinuous past and a future without history prevail in citadel culture. Already the late works of argumentative culture of which I wrote in the introduction have such endings. In *The Aesthetics of Resistance* and in *Apocalypse Now*, an individual's path of reflection leads to negative conclusions in the face of the perpetual visions of horror on the reliefs of the Pergamon Altar in Berlin and in the rituals of the temple precinct in the Cambodian jungle. In the *Name of the Rose*, the path of reflection leads astray, in spite of the citadel's ruin.

Schapiro wrote his treatise about the art of the abbey of Silos both as a Marxist critic of culture and as an advocate of modern art. He was all the more resolved to maintain the perspective of art on progress and freedom, since the policies of the Soviet Union at the time appeared to invalidate any such prospects for Marxist theory. Already then, an intellectual's faith in modern art could compensate for his resignation in the face of political reality. In the ensuing years, the culture of democratic industrial societies

has made this perspective its own. Therefore modern art becomes subject to the same critique as the society which now sustains it, foreclosing any political antagonism between the two. Thus, forty years after Schapiro, Eco has radicalized the contradictions between dogma and reason in Romanesque art beyond any dialectics of conflict. Deprived of a political antithesis, his immanent critique of culture evokes a vicious circle of self-perpetuation and self-refutation.

In *The Name of the Rose* Eco, a leading representative of the science of semiotics, which during the seventies had been promoted as a promising method of interdisciplinary research, discredits any autonomous theory of the intellect. Here the science of signs serves for little more than tracking down an escaped horse from a combination of broken twigs and Latin schoolbook learning. If it is applied to the task of solving crimes, it only causes more crimes to happen. In the end, William of Baskerville, the champion of investigative reason, must recognize that the signs he was ostensibly deciphering in reality, were actually false trails his adversary had laid to make reality look different from what it was. The investigation turns into a medieval precedent for the deconstruction of thinking.

In his *Postscript to the Name of the Rose*, Eco has written:

> But the moment comes when the avant-garde (the modern) can go no further, because it has produced a metalanguage that speaks of its impossible texts (conceptual art). The postmodern reply to the modern consists of recognizing that the past, since it cannot really be destroyed, because its destruction leads to silence, must be revisited: but with irony, not innocently.

Such *salto mortales* of discarding and preserving what is devalued cannot make up for the lost historical perspective into past or future. Did Eco, with his story of a medieval

abbey's destruction, wish to suggest that the destruction of the culture of the past, in the absence of anything new to say, might or should lead to silence, all the while convinced that past culture cannot be destroyed, and hence reassuring himself of continuous talk? In view of the threatened destruction of all culture, and of all life, in the war society of the nuclear citadel, this was hardly what he meant. Thus, his postulate leads to the conclusion that in citadel culture the alternative between destruction and preservation can no longer be decided either way. Meanwhile, the author's ironic perspective enables him to imagine the hypothetical destruction of past culture all the more radically the more opulently and entertainingly he reconstructs it as a cultural legacy.

From the Novel to the Film

Even more than the novel and its mass circulation, it is the film made of the novel which shows how much success cultural critique can have today if it is reprocessed as culture. Now Eco, the medievalist, the theorist of scholarship, and the philosopher of the day, has crossed the media frontier. In his essays of twenty years ago, he had still advocated a correlation of mass culture with political mass democracy as a way to overcome the political disappointments of the left-wing intellectuals in the 1930s. Now he has himself become a master of popular culture, of the new convergence of media and of education levels. Long ago he wrote treatises about Sean Connery; now Sean Connery is cast as the protagonist of his story. Jean-Jacques Annaud, the independent director, and Bernd Eichinger, the most successful West German producer, collaborate on his colorful drama of cultural critique. It allows the former to pursue his personal realistic movie-making style with no interference on the author's part, and it requires the latter to

juggle the set between the abbey of Eberbach, a classified historical monument, and the advanced stage technology of the Cinecittà.

Eco and Annaud have publicly stated that they did not aim for a faithful film version of the novel, which they could hardly have produced, given the intellectual simplification entailed by the media transfer. It is hard to gauge the artistic, technical, and commercial motivations for the changes made to the story of the novel in the course of its screen adaptation. In any event, the film does not dramatize the novel's systematic, mutual pitting of dogma against reason. It does, however, picture the theological alternative of seriousness and laughter, the issue of William of Baskerville's and Jorge of Burgos's learned disputations in the novel. From the moment William and Adson catch sight of the faces of the first monks emerging from behind the opened entrance door, all of the abbey's life is stylized as a grotesque. Monks and clerics are caricatures, their physiognomies molded by plastic additions to their noses, jaws, and ears, making them appear both comical and ghastly in everything they do. The chronicler seems to perceive the events in just the form of ridicule which his mentor promotes as an emancipatory agent of reason, and which belies the spiritual and cultural seriousness of whatever is transacted in the abbey. Yet the ridicule is only apparent to the viewer of the film. Within the film, Adson usually only laughs about what his teacher points out to him, while most other things he sees fill him with fear and horror. Hence the grotesque collapse of monastic life does not entail the liberation which the rationalist might have hoped for. Schapiro, in his article about the art of the abbey of Silos, had already interpreted the grotesque as a liberating contestation of theological order and had made it part of his interpretation of Romanesque art as a medium of social emancipation. He saw the *drôleries* of

initials and capitals, or the depictions of musicians and jugglers, as projections of claims to artistic freedom pre-figuring those of modern art. In the film *The Name of the Rose*, such initials of an illuminated manuscript appear in close-up view under William of Baskerville's magnifying glasses. They reveal political caricatures: the pope as a fox, the abbot as a monkey. Accordingly, in the action of the film itself, Benedictines, Franciscans, and papal en-voys appear as if drawn by Daumier.

However, the film is not just funnier than the novel, it also seems to open some new if weak revolutionary pros-pects. According to the credits, the second protagonist, besides William of Baskerville, is not Jorge of Burgos, but Bernard Gui, the Dominican inquisitor. And the film does not just end with the self-dissolution of the scholastic unity of faith and reason, but also with a confrontation between reason and power which draws the latter into the total ca-tastrophe, whereas in the novel power triumphs over faith and reason alike. The inquisitor, instead of leading his prisoners away to burn at the stake, is forced to flee. Peas-ants topple his carriage, and he crashes down the abbey hill to his death, impaled on the spikes of his own torture machine. Thus the film grants Eco's hopeless self-criticism of culture and reason the anarchistic consolation that op-pression too will be drawn into the general peril.

In the novel, long debates of moral theology and poli-tics are waged about the unalterable oppression of the simple folk, and hence the simple folk don't intervene in the action. The film, on the other hand, ends with the dumb rebellion of the speechless as the political counter-image to the failure of loquacious culture. When ragged throngs of peasants are milling forward against the stakes, stones in hand, making armored soldiers grumblingly back off, a dark sense of protest mitigates the balanced hope-lessness of the book. And here the nameless "girl," to

which the title *The Name of the Rose* alludes, gets away. Unlike the two convicted heretics, she does not burn at the stake, but is set free by the peasants of her village at the last moment. And yet, the rescue of the beautiful young woman, who must prostitute herself for subsistence, who is dragged in chains to her interrogation, who never says a word, restores her to no more than bare survival. She stays behind by the wayside as her lover rides away, speechless like an animal, just as women were classified in medieval moral theology. The worse her humiliation, the more enticing her sexuality. Her wild sexual assault on the novice, her magic copulation with the black cat, blend voyeurism with social critique. Her beautiful face, her beautiful nude body emerging from under rags and dirt, turn the perception of injustice into an aesthetic experience. As she disappears into the darkness of nocturnal villages and fields, the conflagration of the library illuminates the catastrophe of culture as citadel culture's fireworks.

BILAL

Serious Comics

For several years I have been subscribing to the colorful
comic magazine *Heavy Metal* because I find in it an in-
creasing number of realistic images about contemporary
history. Previously I had never been interested in the
strenuous academic interpretations of the old comic strips
with their condescending revalidations of popular culture,
their scholarly transfigurations of Mickey Mouse and Pop-
eye, Superman or Charlie Brown into mythical figures, their
analyses of scene sequences and talk bubbles in the aes-
thetic terms of communications theory. But now I observe
how the scenery of the comics has become increasingly spe-
cific and their themes increasingly contemporary-historical.
In 1984, *Heavy Metal* published Enki Bilal's *Hunting
Party*, a picture novel about the politics of the Soviet
Union and the Communist parties of Eastern Europe from
the Second World War to the Poland crisis. The issue of
August 1986 contained his most recent work, *The Woman
Trap*, which deals with the street battles of immigrants
from the Third World in the European metropolises of the
future. In Bilal's exactly drawn, colorful street prospects of
London and Berlin, Pakistanis and Ghanaians, Muslims
and Maronite Christians battle one another with machine
guns and bombs. The illustrated newspaper reports from
the civil war in Beirut, the race riots in London, the vio-

lence against foreign immigrants in West German cities came to mind.

It has become an article of faith that contemporary art offered to the public in galleries and museums, in spite of all its aesthetic self-sufficiency and self-reflection, is expressive of the historical present. One of the main arguments to that effect has long been that the straightforward depiction of social realities has become the task of photography. Today it is no longer necessary to draw on the radical objections which left-wing artists and writers such as George Grosz and John Heartfield, Georg Lukács and Bertolt Brecht had raised against these assertions since the end of the First World War. At a point in time when the picturing of visual reality by means of television cameras and video recorders has been technically and aesthetically intensified beyond all bounds, and when effortless photography with electronically automated focus and exposure has simplified everyone's private production of pictures to an instant reflex of the hand to the gaze, the comics show historical realism regaining pictorial relevancy on the level of popular art. This art form is not financially secured in cultural institutions, but forced to prove its visual suggestiveness on the free market, to a mass public whose visual habits are conditioned by photography and film.

Since the 1970s, the comics have offered a pictorial literature of drawings and paintings with claims to artistic status and, at the same time, with an appeal to familiar realms of life experience in the contemporary world. They have left the sphere of jokes and caricatures, the stereotypical schemes of the short-term installment comic strips in daily newspapers and pulp weeklies. Their leading artists draw on the dynamic pictorial forms of films and television just as directly as on literary text forms ranging from novels to radio messages. Since their subject matter is not tied to the conventional probabilities of space and time,

they are free to deal with any theme. This integrated art of total experience issues weekly from the newsstands and bookshops a torrent of contemporary-historical imagery into the hands of the mass public. It has become the basis of an art form whose claims to seriousness are steadily being raised by publishing houses, journals, critics, university professors, and by the artists themselves. The French state academy of the *bande dessinée* at Angoulême organizes annual festivals and awards. On these occasions publishers and magazine editors meet to devise marketing strategies that will keep investments in the newest technologies of color reproduction and offset printing profitable. The dynamics of this market expansion require that the *bande dessinée* be set apart from the funnies in the daily press and from the trivial literature for children, and that it be moved closer to the visual and experiential standards of an educated adult public.

This cultural revalidation of the comic strip is furthered by the general tendency of citadel culture to eliminate in the course of its market expansion some of the cultural borderlines established by the social divisions of education. Just as elite culture aspires to, and achieves mass popularity, so the media and art forms of popular culture are being intellectually upgraded and emotionally enriched. The pluralist society of culture presents a classless appearance. And just as in all realms of visual entertainment culture, the comics' market expansion is fostered by the unbridled representation of sexuality and violence. However, their newly acquired seriousness also includes the historical topicality of their subject matter.

In 1987, Enki Bilal won the grand prize given by the comic academy at Angoulême. For over fifteen years professional critics have been watching and commenting upon the development of his growing oeuvre, which specialized bookstores regularly keep in stock through new editions

and reprints. Bilal's artistic messages about contemporary history are not masked behind trivial stories, as with past comic artists such as Caniff, Capp, and Schulz. Rather, he adapts the visual conventions of socialist realism and surrealism, he quotes Baudelaire's texts and Eisenstein's shots. Between 1979 and 1986, he has dealt with contemporary history in four picture books.

Together with his text writer Pierre Christin, Bilal created two historical reckonings with the politics of the Left. In 1979, he published *The Phalanges of the Black Order* (issued in the United States under the misleading title *The Ranks of the Black Order*), a story about the reciprocal terroristic struggle between two groups of veterans from both camps of the Spanish Civil War. In 1983, there followed *The Hunting Party*, a story about the assassination of a young, hard-line member of the Soviet politburo at the hands of a conspiratorial group of old, disenchanted party functionaries from Poland, Bulgaria, Hungary, Rumania, Czechoslovakia, and the Soviet Union itself. Both these stories are dressed up as picture reportages and bear an obvious relation to contemporary-historical political problems: in 1977, terrorism in Western Europe, in 1981, the Poland crisis. (The two-year time delay in the publication dates of both these books recall the belated appearance of the one I am writing here.) In both, the action is historically specified through exact chronological flashbacks from the life stories of the individual characters. On the endpapers, fictitious documentary photographs or dated résumés identify all protagonists. These comics about contemporary history do justice to their series title: Legends of Today.

On his own, without his text writer, Bilal created two interconnected, mythic fantasies about future capitalist world history involving the participation of Egyptian gods.

The Immortals' Business, which appeared in 1980 (it was recently released in the United States under the misleading title *Gods in Chaos*), is set in the year 2023 and recounts the overthrow of a fascist dictatorship in Paris by a revolutionary collective. *The Woman Trap*, which appeared in 1986, is set in the year 2025 and tells of the rescue of a woman news reporter from London and West Berlin, after both these metropolises have declined into terrorized environments, battles zones for rivalling drug syndicates. These two picture books were published in another series, called Fantastic Histories, but their contemporary topicality is more striking than that of the historically realistic but politically diffuse Legends of Today about the Spanish Civil War and the decline of the Cominform.

The Immortals' Business

Paris – beginning of March, 2023 – On the eve of yet another meaningless sham election – Nothing seems about to change in the immense urban agglomeration of Paris, politically autonomous and turned fascist beyond recovery – The city's division into two districts, unequal from every point of view, appears less reversible than ever . . . – The first district, which forms the center, houses a privileged society, an imposing regular army and the ruling class – The second, which surrounds the first and which extends beyond sight, has become . . . the hub of adventurers and extraterrestrial beings of all kinds. Government militia provides the control and, in addition, the security of this universe of degeneracy, misery, and filth.

This is the setting of the picture book *The Immortals' Business*. It presents the city of Paris as a citadel, its original

early medieval layout, when the Frankish kings fortified the island of today's Cité into an unassailable realm for their castle and cathedral, now adapted for a projection of global class rule as it seemed to be imminent in the industrial societies of 1981. "After two nuclear wars," the introduction goes on to say, the rulers of Paris have fortified the city center against the surrounding residential areas of the oppressed. Behind the Renaissance architecture of the Louvre and the Elysée, the concrete bunkers of the new Cité are towering up, bristling with roadblocks, control posts, and guns. Here rules the dictator in uniform over a conformist elite society, all dressed in black, faces made up in patterns of black, white, and red, rushing along the straight boulevards in grim silence. By contrast, in the outskirts, buildings crumble and people waste away, a colorful mass of ragged, leprous, dwarfed figures of misery kept in submission by heavily armed military police.

Bilal, the cultivated comic artist, has resumed a fantasy of the future that has haunted writers and artists of Paris ever since Baron Haussmann's urban reconstructions, that of the city's eventual ruin. He has connected this traditional vision with a comic-book convention of picture stories which has appeared more and more frequently in recent years. These stories deal with futuristic metropolises crumbling into ruins, their supertechnology unable to save them from falling into barbaric chaos, their scattered inhabitants, survivors of catastrophic wars, engaged in primitive subsistence struggles. Here the conditions of the megacities in the so-called developing countries, the endless slums of Bombay, Lagos, or Mexico City, are transferred into the industrial states themselves. Their administrations assume the utopian oppressive forms of Orwell's *1984*.

In *The Immortals' Business*, the future dictatorship of Paris is confronted with the mythical world dominion of the Egyptian gods, who are cruising in a rocket-propelled

pyramid through outer space. At the start of the picture story, they are hovering over Paris in order to negotiate with the dictator about his immortality in exchange for fuel. At the same time, two outsiders are returning to earth from outer space: the falcon-headed god Horus, who has quit the council of the gods, and the astronaut Nikopol, a deserter from the French army. They engineer a coup-d'état, which brings the dictator down and a popular council government to power. This symmetry between mythical and human figures determines the unfolding of the picture story. Horus challenges the jackal-headed Anubis, the god of the dead, who has usurped the rule over the council of gods, in mythical correspondence to the fascist dictator's rule over Paris. According to Egyptian mythology, however, Horus himself is the god ruling the heavens and the universe and appears incarnate in the king on earth. After each defeat at the hands of his brother Seth, he resurrects to reassume his rule. Bilal's picture story, however, does not present Seth as Horus's antagonist, but Anubis, who in the Egyptian pantheon merely rules over the dead and protects the cemeteries. The flying pyramid, where Bilal depicts Anubis presiding over the council of the gods, is the ruler's funeral monument converted into a celestial body and propelled by rocket engines like a spaceship. The world rule Anubis exercises from here, which in 2023 qualifies him as the divine protector of dictatorship on earth, is the rule of death. Thus Horus, the legitimate world ruler, confronts him as a murderous rebel leader.

The city's liberation, however, entails the liberators' penance. Horus, the god, encased in the stone of the flying pyramid, is carried away into outer space. His human partner, Nikopol, the lonely astronaut, is committed to an insane asylum, where he meets the toppled dictator as his fellow patient. The figure of the subversive liberator assumes the tragic, sacrificial posture of the modern artist.

In Christ-like fashion, Nikopol points to his mortal chest wound, which he has survived thanks to the intervention of the gods, while reciting verses from Baudelaire's *Flowers of Evil:*

> At times it seems to me that my blood is flowing forth,
> Just as a fountain does with rhythmic spurts.
> I hear it well, as it flows with a long murmur,
> But I vainly palpate myself to find the wound.

These verses, taken out of context, read like a motto for the plaintiveness of citadel culture, a plaintiveness uncertain of its causes. Baudelaire's complete poem celebrates a desperately self-conscious, hypothetical artistic revolt, evoking an imaginary sacrifice of the asocial artist, who spills his blood in the streets in order to quench the thirst of all creation. The comic-strip painter of 1980 has turned this romantic fantasy into an image of suffering under impenetrable mythic struggles governing the history of the future.

Bilal has given to his figure of Nikopol the features of his friend, the actor Bruno Ganz, who in September 1986 played the lamenting Prometheus in Berlin. Here he appears laid back, hesitant, reticent, much like his performance in early films directed by Wim Wenders, as he showers Horus with sneering insults and sarcastic objections. Six years later, in the Greek tragedy of 1986, Ganz appeared once again as the disobedient challenger of a mythic god, but now deadly serious.

The Woman Trap

Six years after *The Immortals' Business*, Bilal continued the picture story in *The Woman Trap*. Now he abandoned the fantastic liberation prospect of his earlier book.

> The city's political situation is without interest and to-
> day's date is the 22d of February, 2025 . . .

The efforts of the popular collective leadership of Paris
seem to have had no lasting results. Nikopol, psychically
ruined, still survives in a shabby bedroom of the "psychi-
atric center Saint-Sauveur." Meanwhile, astronauts in outer
space are blasting Horus, his divine antagonist, out of the
stone blocks of the flying pyramid. He kills them on the
spot and takes their spaceship in order to return to earth.
Nikopol, sensing his return, leaves the asylum in order to
intercept the god in his murderous rampage. He admon-
ishes him:

> It's very simple, we're both on our way to becoming drop-
> outs—each one in his own world. You, in a world of gods
> which I don't understand and which you hate, and I, on
> my part, in this human society which you despise and I
> feel alienated from.

They no longer intend to interfere in the political course of
events, but merely to rescue a beautiful young woman and
fly with her to the sunny South. The story of the woman is
the main theme of the new picture book.

Here Bilal fully exploits the unlimited license of the
comic strips to manipulate technology, space, and time, in
order to depict contemporary history as a report from the
future to the past. In the year 2025 the beautiful young re-
porter Jill Bioskop ("film" in Serbo-Croatian, Bilal's native
language) reports from the racially polarized battle zones
of drug syndicates and religious sects in London and Ber-
lin. By means of the "scriptwalker," a small telex device,
she dispatches her reports back into the year 1993 for pub-
lication in the daily *La Libération*. Jill's past is our, the
readers', future, seven years from the date of Bilal's pic-
ture book. The book contains as a loose-leaf insert a mock

issue of the newspaper from 1993, where we can read the original text of Jill's reports. The pictures of 1986 reveal the reality of 2025, of which the printed dispatches of 1993 are merely fragmentary, subjective testimonies. Moreover, they reveal how in 2025 the enterprise of reporting contemporary history has actually failed. The hypothetical editors and readers in 1993 cannot know that the dispatches are just testimonies of a personal crisis in which the reporter is caught. Only the pictures from the year 2025 in the book of 1986 lay all these difficulties bare.

From the hotel Mauer Palace, which is protected by steel-helmeted, uniformed security guards brandishing submachine guns, Jill Bioskop ventures on her dangerous explorations through the dark, dull city of Berlin, between Mabuse Square and the Catacomb cabaret. Already from within the hotel, through the wall-sized window of the swimming pool with its wet bar, street fights can be observed as if in a film.

> It normally starts very early in the morning, with the
> sound track. Shots of mortars, of rockets, heavy machine
> guns, and even, sometimes, of bomb explosions . . .
> Through the bullet-proof glass of the Mauer Palace, you
> get the image if you want to. Guaranteed first-class box
> seats.

However, the young woman is unable to assert herself as a witness to history, but becomes its sexual victim. Her friend and fellow-reporter is blown up in a red London telephone cabin, right in the middle of busy street traffic. Strong, determined men come to her aid during the day but at night break into her hotel room to rape her. Jill starts up from her sleep in panic and stabs them with the antenna of her little telex machine, their blood splashing all over her nude white body.

The young woman cannot bear such shocks of contem-

porary history and sexual aggression except by taking memory-clouding drugs, which however thwart her mission as a chronicler. Still, she writes for her readers of 1993 even about that, half in a drug daze, half in bewildered detachment. Whatever she eventually remembers gets jumbled, even the names of the men she has killed. Fainting spells and delusions of consciousness frustrate her work. Slurring word fragments to herself, she finally abandons her writing.

Just at this moment Nikopol enters the hotel room of the Mauer Palace, coming to Jill's rescue. Horus, in his little airplane, flies them both to the sunny land of Egypt. Here the failed reportage from the centers of European civilization proves to be a nightmare from which the young woman can awaken. At the foot of the pyramids, under Horus's protection, Jill and Nikopol find one another.

> I am starting a journal, because I feel the need to write,
> even more than before. . . . I've just re-read the things I
> wrote on the scriptwalker and I feel very detached from
> all that. . . . That same day, the 6th of March 2025, I
> burn the testimony of that sad and brutal nightmare . . .

The move from the historical reportage which can no longer be written except at the risk of one's life to the diary record of subjective feelings marks a recurrent critical transition in citadel culture. Contemporary history is by no means forgotten, but as one reads about it, one remains conscious of one's private retreats. For Jill, Nikopol, and Horus, too, the respite in the sun is just a passing moment. At the end of the book, they have to take off once more in their little airplane, since the flying pyramid of the Egyptian gods in their unerring pursuit is already appearing in the sky. In 1980, Bilal's story still moved forward from oppression to political "revolution," only tempered by a sarcastic edge of melancholy. In 1986, it is starkly polarized between his-

torical terror and mythical happiness, with an uneasy transition from one to the other.

The Newspaper of the Future

The news dispatches Jill Bioskop decides to burn in 2025 had been printed long before in the mock issue of *La Libération* from the year 1993, inserted in the picture book of 1986. The paper provides the historical background information for the events which remain obscure for the readers of the picture sequence. On 2 October 1993, in a corner of the editorial archives of *La Libération*, an old telex machine, long placed out of service, has suddenly spat out these texts. Since their doubtful authenticity cannot be verified according to the professional standards of journalistic source-checking, a team of staff writers subjects them to extensive scrutiny and comment, concluding that from the vantage point of 1993, Jill Bioskop's account of the future seems quite probable.

According to the staff writers' in-depth historical analysis, the metropolises of the capitalist industrial states will be the combat zones where the most fundamental social problems, immigration and drug trade, will exacerbate one another. Immigrants from the Third World will be followed by those from outer space, with an ensuing power struggle between both groups. The writer of the historical commentary in *La Libération* surveys from the vantage point of 1993 the situation which transpires from Jill's dispatches:

> The year 2023 appears as the conclusion of our present logic of the division of economic powers . . . This was to be expected. It suffices to read the balance sheet of today's monopolies.

Sooner or later the drug trade will attain the command positions and key functions in the capitalist economy, rul-

ing society by crime. Monopolies will have taken power from the state.

> Dark portents for the alliance between Labor and Communists which this year has won parliamentary elections in Great Britain. The defeat of the ultra-liberals of the ageing Margaret Thatcher will only be temporary. In the year 2025, if you believe the *"special correspondence"* from Jill Bioskop, one lives in the era of hyper-liberalism.

The most sophisticated analysis to which Jill's dispatches are subjected in *La Libération* is a philosophical and literary commentary which vies with any treatise of comparative literature scholars in 1986. "This text will make history," asserts the headline, with due deconstructive ambivalence.

> One knows languages, dead and buried, which have returned from nothingness in order to deliver a message that sometimes rests indecipherable for a long time, until archaeology renders us its truth. Does one have to assume, over and above all skepticism, that languages can exist, more vivid than the one we presently speak, whose subject matter is already the future? By definition, the future is not yet structured in the way of a language. Whence, then, the fragments of a history that will sleep in a state of weightlessness for a whole eternity?

Friedrich Schlegel's or Walter Benjamin's categorical pronouncements about the introverted relationship of history, prophecy, and imagination, those literary devices that shield today's academic theories of culture and literature from any confrontation with historical reality, are succinctly verified in the daily press of 1993. And yet only the picture story which depicts the failure of the reportage, rather than this kind of mock semantic analysis, could really explain the text. In *The Immortals' Business* Bilal

had still inserted press clippings with information and commentaries into the picture story itself as a way of confirming its documentary authenticity. In *The Woman Trap* he no longer follows this convention of the comic-strip medium. Here the contradictory interplay of text and picture mocks the self-doubt of citadel culture.

On the feuilleton page of *La Libération* yet another writer levels an unremitting critique against the banal eroticism of Jill's dispatches, heaping special ridicule on what he calls "this manner to exalt her lover to a paragon of the sado-masochistic bondage scene." He concludes: "If Jill is a man, she should say so right away." Although the feuilleton of 1993 anticipates the objection against the sexual introversion of contemporary history, to the viewer of the comic book the large-figured, colorful pictures of 2025 prove that the story has indeed happened just this way. Thus, while in the politics and business sections of *La Libération* the reports from the future are analyzed as serious history, in the feuilleton they are reduced to conventions of present culture. How this contradiction between politics and culture can be resolved is left to the reader.

Rockets in Decay

Bilal's meticulously drawn views of Paris in *The Immortals' Business* depict colossal fortress buildings made from concrete inserted into familiar city sights. Vaulted bunkers, shaped like those of the German Atlantic Wall of the Second World War, tower over the Elysée Palace and Notre Dame Cathedral. Helicopters and space capsules provide the connection to outer space, recalling the projection of global electronic strategy into outer space attained already today. And yet, Bilal's buildings and machines are both deformed as if they were petrified and shot through with cracks as if they were crumbling. Outside this fragile for-

tification zone of absolute power, buildings, people, and the environment decay altogether. Contemporary comics dwell on such partitions of the cityscape into fortresses and ruins. Bilal has merely specified the historical topography of these visions.

Six years later, in *The Woman Trap*, the familiar city sights of London and Berlin are barely altered, only pictured as decaying. Their precisely visualized street perspectives no longer include any buildings of power. In addition, not only decay but terror and fear have penetrated the city centers. As police glide in crimson armored Hovercraft through London's night alleys, the canalization tubes, leaking clouds of vapor, break forth from under the asphalt pavements. In Berlin, the black flag of anarchy and the red flag of revolution are hanging across one another from the window of a house adjacent to the wall. Everything is cast in a greenish-gray dusk laced with patches of smoke or fog. Huge missile duds are sticking from Kensington's white limestone façades, or have half pierced the concrete slabs of the Berlin Wall.

With the interpenetration of walls and rockets, Bilal has created a visual metaphor for the suspended consciousness of conflict and war in citadel society. Are those duds in Kensington remains from the street wars of a city civilization turned criminal, waged with the weapons systems of modern armies? No, they are

> fake bombs of painted plaster (stirring hyper-realism)
> which Freddy Bombex and his French sculptors have
> implanted on numerous walls of London, for obscure ar-
> tistic reasons.

So Jill Bioskop reports in the fictitious issue of *La Libéra-tion* of 1993. Yet it is just these sculptures, her report goes on to say, which serve London's street fighters as particularly insidious hiding-places for explosive charges, since

no one would suspect them there. Thus bloody reality authenticates environmental art.

In Bilal's pictures, rockets and castles look the same. One of the illustrations for a science fiction novel shows a spaceship bristling with missiles, from whose cracked surface brushwood is growing in flight direction, as if from the walls of an ancient building, with the bundled rocket engines doubling as staggered towers. This fusion of horizontal and vertical, dynamic and static imagery visualizes the idea of the spaceship as a citadel, familiar from American films such as *Star Wars* and *Battle Star Galactica*. The irregular, defective surfaces of Bilal's spacecraft look as if they were made from stone, cracking up, crumbling at the edges. Herein they differ from the neatly assembled plastic architecture of the spaceship models in science fiction films, just as they differ from the metal construction of spaceships and capsules in reality, whose computer-measured riveting must be of infinitesimal precision in order to withstand the extreme pressure and the whizzing acceleration of flight. By comparison, Bilal's flying fortresses already appear as high-tech ruins of the future, with somber-faced, defiant astronauts at the controls.

The Berlin Wall

In his portfolio *The Berlin Wall*, which was published in 1982 as a luxury edition with a preface by actor Bruno Ganz, Bilal has made the ambivalence of militant fortress architecture, oscillating between aggression, containment, and decay, the subject of a series of full-page color plates about the wall between East and West Berlin. He took his cues from the anarchist, radicalized popular culture flourishing in the city districts along the west side of the wall, the subculture of punks and "autonomous" youth gangs with their faces painted white and half-shaved hairdos,

with their exhibitionist eroticism and provocative brutality. A soldier of the National People's Army in field-gray uniform, wearing black goggles under his steel helmet, and a half-naked punk with black eye makeup, posing as a Samurai, are guarding the aging city wall from both sides. White snow, gray fog, reddish brown rust and scarlet-colored blood cover this fortified zone of decay. Giant, leechlike blood-filled tumescences overgrow the tube of concrete atop the wall's edge and the scarred face of the border guard.

Here Bilal has extrapolated images of fantastic breakthroughs from the graffiti which in the course of many years have come to cover the western side of the wall, and which aestheticize, comment upon, and ironically challenge the unchanging status of the fortification. They dwell upon the fantasy of a door painted on the wall which can be opened for passage. People pierce the concrete only to get stuck, bleed, and grow stiff. They include nude lovers, embracing one another from both sides, and an officer of the National People's Army yelling at two photographers, or maybe just screaming in a failed escape of his own. A heavy truck breaks through, recalling the spectacular escapes of trucks ramming through the frontier barriers which are sometimes reported in the press; but it is only one of the armored water cannon trucks which the riot police in West Berlin habitually use on their own street demonstrations.

Bilal's portfolio of 1982 depicts West Berlin as the citadel city from which, four years later, the reporter Jill Bioskop will escape the chaos of history toward the south. Here the artist found the comic-book fantasy of an internal fortification of modern metropolises existing in reality. Two years earlier he had polarized the imaginary fortifications of the Cité of Paris into an unequivocal topography of oppression and rebellion. In the German citadel city, however, he was unable to distinguish a center of power from a periphery of protest, or to ascertain a political dynamics

between both sides of the fortification. The Berlin Wall crumbles and still remains secure, it is pierced throughout and yet can never be crossed. The final picture of the portfolio, reproduced on the dust jacket of this book, shows the tail engine of a giant rocket stuck in the wall. The tip of another, smaller one emerges from the opposite side. Streaks of rust flow down the concrete surface from the edges of the metal. A man wearing pyjamas and a raincoat sits on the rounded crest of the wall, gazing through black sunglasses in the direction from where the rocket has come. He has opened his umbrella, but it isn't raining. Only two jet fighters soar through the black sky.

Man, Woman, God

From 1980 to 1986, Bilal's continuing picture story about Horus and Nikopol has become somber and pessimistic. Paris as the scene of the showdown between power and misery is followed by London and Berlin as the scenes of random violence, where neither is power visible nor liberation envisaged. In *The Immortals' Business*, Nikopol, the man, acts as a mythical incarnation of an Egyptian god, to the point of a psychic self-sacrifice for the sake of political liberation. The verses by Baudelaire which he recites transfigure him into a Christ-like redeemer figure. In *The Woman Trap*, Jill Bioskop, the woman, suffers, just trying to record her observations. She escapes into Baudelaire's "artificial paradises," first of drug intoxication, then of the palm-treed landscape at the foot of the pyramids. Still, both are exposed to the severest psychic strains. Nikopol's painful god-possessedness ends in a delirium which brings him to the psychiatric asylum; Jill Bioskop's drug-induced spells of distorted consciousness make her fall into the hands of prowling men whom she can only ward off by means of murder. While Nikopol's recitals of Baudelaire's

measured sonnets evoke a modern artistic tradition of sub-
versive self-awareness, Jill Bioskop's incoherent stammer
sinks below the level of literature or any verbal commu-
nication. In both his protagonists, the comic-strip artist
shows how a fantastically intensified experience of con-
temporary history drives the individual to psychic ruin.
His readers need not face such situations, assured of their
aesthetic distance by the gruesome comic-book grotesque.

Bilal has not been slow in giving to his readers an ac-
count of his choice of a woman as the protagonist for the
resigned continuation of his earlier picture story. He has
thus provided the public self-reflection which is obligatory
in citadel culture. In an interview during the marketing
campaign for his new picture book, he has justified the
sexual difference.

> In 1980, at the moment of *The Immortals' Business*, I was
> still having illusions. I was impassioned by the great
> political events, it seemed important to me to address
> them, even in an indirect way. I have changed. I have
> told myself that the important thing is to be close to
> people.

The tuning into the subjective introversion of citadel cul-
ture leads from political disillusionment to a sensibilization
of personal relations. This is why Bilal wished finally to
create a story with a female hero.

> Up to now I have drawn few women, but I have always
> tried to give them a class aspect, be that in *Phalanges*,
> be that in *The Hunting Party*. I wanted to create a female
> personage of my own, this became the driving idea of the
> picture book. It [shows] part of the life of a girl of which
> one does not know much.

In Bilal's political "legends" from the Spanish Civil War
and from the early history of the Soviet Union women ap-

peared as acting individuals, albeit in the minority. Now, in his "fantastic history" from the year 2025, a woman is given first billing, but as a victim. In the process, the artist's interest has shifted from the "class aspect" to a kind of life "of which one does not know much." The fierce-looking women who, at the conclusion of *The Immortals' Business*, take the collective leadership of Paris into their hands, have dyed their hair red and are made up in green, just like the men with whom they rule in equal numbers. Jill Bioskop, on the other hand, with her chalk-white skin and her blue hair, lips, nipples, and tears, stands out from all other people.

> I find Jill Bioskop strange, desirable, realistic, but not too much, so as not to deprive her of her representative character, her force of conviction.

Her passivity is sexually determined, of course. She appears in many postures of helplessness and horror— throwing herself headlong into an armchair, sobbing incoherently; fumbling her pillbox in confusion as she stands before the bathroom mirror in her black underwear; nude, unconscious, dangling in the arms of a man who tries to revive her under a cold shower; starting up from her bed, nude again; stabbing the man who assaults her; staggering out of the shower, nude, blood-spattered ("I am sure I fell in love with you at that very moment," writes Nikopol); later languishing in her bikini at the edge of the swimming pool, clutching her long drink with the split lemon on the rim; and finally relaxing in the arms of the man who is carrying her away in Horus's airplane, lost in thought. "Kiss me . . ." are her last words.

Here Bilal has heeded the marketing strategists' demands to extend the readership of the *bande dessinée* to young adults by dwelling on erotic subject matter. The rueful mocking of this subject matter in the fictitious issue

of *La Libération* as a sadomasochistic men's fantasy is included in the offering. The open contradiction between this judgment and the interview with the artist himself pertains to the self-critical ambivalence of citadel culture, which protects the plausibility of its exaggerations by bouncing them back and forth between critique and self-critique. Nonetheless, it is clear what Bilal's female protagonist embodies historically. In the mythic future of 2025, old images of murderous women, ideological negatives of women's oppression, still return. In those images, instinctive sexual inferiority and instinctive brutality of defense belong together. Jill Bioskop's resolve to kill yields her no self-consciousness and at the end of the picture story turns out to have been a delusion. Brutality makes up for the inability to withstand the experience of contemporary history. The female reporter uses her writing instrument as a blood-stained weapon. She is not allowed to shed her own blood for the cause of freedom, as is the Christ-like man.

Bilal's Egyptian pantheon duplicates the shift toward the brutality of weakness. Horus, the sun god, who in 1980 rebels against the rule of the god of the dead, topples a dictatorship on earth, and has to do penance for this act, has in 1986 turned into a desperate dropout and senselessly murderous terrorist. Instead of redeeming the crime-ridden world, he is becoming part of it. Also in 1986, Bilal designed a hypothetical Horus statuette which embodies this ambivalence. The half-figure of the god as a street fighter in uniform, carrying a giant missile on his shoulder as if it were a bazooka or an antitank grenade launcher, appears to be striding forward, but below the waistline he is immersed in a massive square pedestal which brakes his advance. At the bottom of the pedestal, a second, tiny Horus figure, with a complete nude human body, hands lowered, faces a flight of steps leading up to the pedestal

which he might ascend, or which he has perhaps ascended in order to turn into his giant double, armed and armored, but immobilized. The discrepancy in scale makes the "statuette" into an imaginary colossus. This double image of the god fuses the vacillations of the personage between overwhelming strength and weakness, between terror and comtemplation, into the mythical cycle of reincarnation.

However, it is the beautiful young woman, tossed back and forth between sex and murder, who embodies the cycle of ambivalence at its most seductive. *La femme piège* means literally "The woman who was a trap," or *Woman Trap*, for short. In *Heavy Metal*, the title was mistranslated as *The Trapped Woman* (in the later book release, it was corrected to read *The Woman Trap*). In the advertisements for the picture book in the daily newspaper *La Libération* (the real one of 1986, not the fictitious one of 1993), the headline read: "Jill Bioskop est la femme piège. – Piègé?" So the ambivalence of the ungrammatical collage of words was intended from the start. Is the woman the trap, or is she caught in the trap? This is how the unsolvable questions of citadel culture are phrased.

Bilal's Self-Reflection

In his interview on the occasion of the publication of *The Woman Trap*, Bilal has expounded on his change of style. No longer did he feel bound by the conceptual conventions of the comic strip, which ensure the readability of the picture stories by means of pedantic, small-scale subdivisions of phases and extensive lettering.

> I don't feel any more like doing stories with little checker squares. For this story, the classical *bande dessinée* appeared insufficient to me . . . the narrow cutting with dialogues, with onomatopoetics, appeared inappropriate.

> *The Woman Trap* follows a cinematographic design: more
> horizontal images, as in cinemascope films. With an
> average of four frames per page we are far removed from
> the classical [comic-strip] cut of twelve frames.

While the pictorial form of earlier comic strips emulated
the medium of film by its sequences of long shots, medium
close-ups, and close-ups, a fundamentally abstract format,
Bilal's new form aims for the panoramalike conviction of
documentary photography. However, the stark pictures of
contemporary history he can produce in this way turn
opaque once more under the complicated literary reserva-
tions of an experience assumed to be both prophetic and
retrospective. The picture story is congealed and simplified
into tableaus which no longer explain themselves, as the
comics were meant to do. This self-refutation is appropriate
for the story of a helpless writer of contemporary history
abandoning her enterprise and burning her own texts,
which readers can nonetheless review in the newspaper in-
sert of the picture book. Hyperrealism and phantasmagoria
feed upon one another in a perfect ambivalence, the wordy
commentary on which is part of the effect. Between 1980
and 1986 Bilal's comics have indeed become more realis-
tic. From a mythical overthrow of future fascism they have
been dimmed to a projected intrusion of the Third into the
First World. The individuals exposed to that hyperrealistic
experience fall back from rebellion to reportage, from re-
portage to suffering, from suffering to oblivion, and from
oblivion to introversion, to relaxation on the run.

STIRLING
BACON

Bacon Retrospective

It was by chance that I saw the great retrospective exhibition of the British painter Francis Bacon in December 1985 in the New State Gallery at Stuttgart, rather than in London, where it was shown before, or Berlin, where it was shown afterwards. James Stirling's museum building, the most extravagant showpiece of postmodern architecture, had just been completed the year before. Thus, for me, the castlelike agglomeration of walls, ramps, square blocks, arches, stairs, gates, courtyards and rotundas at Stuttgart came to enclose the long series of large, gold-framed panels in which a painter's life's work unfolded over a period of forty years, an intermittent sequence of cramped, bloody nude bodies and contorted, blurred faces. The triumphal aesthetic environment for the raw representations of violence and suffering may have been a coincidence, but it also happened to be a spectacle of citadel culture.

Sixty-four million marks had been the cost of the new building, commissioned from one of the most celebrated international architects of the time. It was to be a centerpiece in the cultural program of a West German state whose economy has been flourishing thanks to its government support for new, marketable high technologies, and it was designed to function as a hub in the far-reaching urban planning concept of the state capital, which was already

being affected by the ups and downs of the business cycle. Two million marks, I was told, would be the price of one of the paintings on exhibit—inexpensive for a painting by a leading contemporary master today, in 1990, but a record price in 1985—if one were still available. However, even the paintings just finished were already set aside, only to be looked at as showpieces in the marketing strategy of the British Marlborough Gallery, which keeps Bacon, one of the most celebrated painters of the time, under exclusive contract. Thus, both the building and the pictures are part of a culture financed from the new record sums of capital returns, tax revenues, and subsidies. High officials, wealthy patrons and consulting intellectuals decide upon the programs of that culture and offer it to the public with the implication that it is financially and politically out of reach. To make up for this distance, visitors are allowed to check, in the official handbook about the building, a table with a detailed breakdown of its costs; to view, at the video monitors in the auditorium, the painter himself as he explains his work; to carry home, in the large catalog, color reproductions of the pictures on exhibit; to enjoy, in short, the democratic illusion of an art for the people.

Stirling's Postmodern Career

James Stirling was once a modern architect who considered the social and aesthetic consequences of the modern tradition of functional form with particular consistency, and realized them in his housing projects and university buildings of the 1950s and 1960s with particular intransigence. With his "brutalist" visualizations of the practical use of space, his demonstratively technical treatment of materials, and his didactic color distinctions, he had exposed himself to vehement debates among architectural critics. His engineering school at the University of Leices-

ter, built in 1963, had become famous as a triumph of the aesthetics of functional, economical building. Here a cluster of lecture halls, laboratories, workshops, and offices sprawls in all directions, but it nonetheless coheres below a giant hydraulic water tank, an irregular stereometric block of red bricks and open spaces under glass. At an undetermined point in time, either for lack of commissions or for considerations of his own, Stirling abandoned such projects with progressive social functions and began to design large building complexes for centers of industry, power, and culture. Thus he withdrew from the realms of public architecture which, in the course of the economic crisis of the late seventies, were funded insufficiently and turned to those realms which, in the conservative politics of the eighties, were being supported generously.

During long years of international competitions, Stirling and his collaborators have staged this transition of sponsorship as the breakthrough of a new artistic originality. In England they no longer submitted large projects. They sent their planning kits, styled as art works in their own right—complete with exact landscaping studies, expansive urban calculations, variable ground plans and elevations, transparent isometric projections, color studies of detail, and lavish models—to Cologne, Doha, Florence, Nairobi, Rotterdam, Teheran, New York, and Düsseldorf. Although most of these projects were never built, international architecture critics documented, analyzed, celebrated, and disputed them at length. By way of lectures, discussion panels, picture books, and architectural journals, Stirling rose to be a world-famous architect, an honorary member of professional associations, a recipient of honorary doctorates, teacher at academies and universities, without winning a single big commission. Finally, at Stuttgart, he won his first top-rank competition. The selection committee justified the

award with a citation to the effect that Stirling had given new impulses to international architecture after twenty years of stagnation. Thus the public prestige of divergence from the norms of modern building, which Stirling had attained during those years, had become the winning hallmark of his work. His prize-winning project immediately became the object of discussions about the very principles of contemporary architecture. With the New State Gallery still under construction, Stirling received in 1980 the gold medal of the Royal Academy in his own country, where he had built nothing of importance for quite some time; and in 1981, he received the Pritzker Prize, the "Nobel prize of architecture," in the United States. The New State Gallery was acclaimed as a world-class building long before completion. After its opening on 9 March 1984, it duly became an instant public success.

The process of Stirling's career is characteristic for the change of modern architecture's social function from the aesthetic articulation of work and life to the cultural monumentalization of governments and corporate administrations. Whether or not his projects are called "postmodern," they have moved into programmatic distance from the technical and social function of modern architecture as a principle of its artistic form. Modern architecture had been justified by a total social utopia of a more human, and hence more beautiful, environment of life and work, whose aesthetics were meant to be confirmed by buildings of culture. These aesthetics lost their credibility when large collective housing projects declined into social problem zones, strongholds of family dissolution, drug trade, and crime, because the underprivileged segments of society tended to concentrate there. In his film *Koyaanisquatsi*, produced by Francis Ford Coppola in 1983, Godfrey Reggio dramatized this decline of modern high-rise housing.

First the cameraman, from an airplane flying at the lowest possible altitude, surveys the panorama of empty tenements with shattered windows and littered streets, then he soars high to take a bird's-eye view of the building blocks, row after row collapsing under the explosions of demolition charges. Now architects and architectural critics charge modern architecture with the vital problems of mass society, in a reversal of their predecessors' claims that architecture could solve them. However, the postmodern critique of the social reform programs which Le Corbusier once summed up in his slogan "Architecture or Revolution" foregoes any political alternative. The new architectural forms it propagates are no longer sustained by the ethos of housing, but by the aesthetics of the built public sphere. At a time when comic-strip artists are picturing fantastic, futuristic metropolises, devoid of decoration, as future sites of oppression and decline, postmodern architects are offering a richly decorated scene, not for work or living, but for the enjoyment of culture.

This is the change manifest in Stirling's career. Now he designs huge, symmetrical complexes where the buildings are composed around towering units. In 1976, he submitted to the sheik of Qatar at Doha his plans for a straight main boulevard originating from the ruler's palace, along which ten ministries of different volumes line up, each one arranged around a square courtyard of equal size behind look-alike rectangular, two-tower façades. In 1978, for the research center of the Bayer Corporation at Monheim, Federal Republic, he grouped four different-sized laboratory complexes in a pattern of radial symmetry around a semioval terrain of grass and trees, with the similarly semioval main administration building towering over them from a distant point on the middle axis. Why such unequivocal architectural complexes of uncompromising subordination

were ultimately not built remains unknown. Perhaps the
West German corporation found a research center, styled
as a power center on the model of a castle park, inappro-
priate for its self-representation in a democratic state.

Historicism and Originality

Between 1975 and 1977, Stirling participated in three
competitions for museum buildings in the centers of West
German cities: in Düsseldorf, Cologne, and Stuttgart. In
each case, he fitted his pictorial, symmetrical building
types into the historical urban context of the individual site.
His projects not only offer comprehensive rearrangements
of the traffic patterns and connections with the extant sur-
rounding buildings, but they also take those buildings'
forms into account, acknowledging them as testimonies of
historical epochs of style. They were meant to recall his-
torical traditions visually, all the while maintaining their
distinctive contemporary form. In Cologne, an uncovered,
imaginary crypt was to repeat the ground plan of the ca-
thedral nearby, leading as a subterranean entrance hall
through a portal in the apex of the apse into the museum.
In Düsseldorf, a square entrance pavilion was to stand on a
plain forecourt at an oblique angle to the street line, visu-
ally announcing to the viewer from afar the basic shape of
the recessed museum, which itself was to be squeezed into
invisibility between the surrounding buildings. In both
cases, the architect seemed to resolve contradictions of ar-
chitectural design which would have been deemed unre-
solvable in the modern tradition. On the one hand, his
plans looked preservation-minded and historicizing, while
on the other, they looked willful and playful. To have an
international firm from England historicize architecture in
the Federal Republic would have cleared the restorative

trends in West German culture of any suspicions of conservatism and nationalism. For the prime minister of Baden-Württemberg, just as the sheikh of Qatar, Stirling acted as the distanced, understanding international observer of local building history.

Stirling's three West German museum projects follow the same formula of demonstrative, deliberate contradictions. After being fitted into their local setting with care for local cultural history, they are given even more provocative shapes. Postmodern architects have taken offense at the aesthetic confrontations modern architecture imposes on its historical environment; such contrasting effects are now confined to the details and the surface of the building, but raised to a searing pitch. Since Stirling no longer cares to respect the self-limitations of modern functional design but claims the status of the sovereign artist, he freely operates with forms and colors, motifs and ideas. The curvilinear building blocks of the New State Gallery at Stuttgart are garnished with pediments and encased portals, freestanding columns supporting nothing, erratically applied steel sculptures covered with glaring paint. Architecture has once again become a representational art, expanding the visitor's visual experience over and beyond the building's functional designation. The museum is conceived like the installations and environments of conceptual art, which in turn are only here assigned their artistic identity. The building itself becomes an installation, a museum piece of architecture, the first work of art on exhibit.

The architect himself becomes a contemporary figurehead of the creative artistic individual who combines absolute originality with respect for historical tradition and who is able to develop fully and freely under prevailing conditions. In his precise studies of functional requirements and building codes, traffic patterns and budgets, in his coopera-

tion with local building firms, and in his concern for the wishes of patrons and juries, Stirling was presumably no less flexible than his competitors. He separated himself from them only in the demonstrative artistic arbitrariness of both the basic forms in the first sketch and the surface shapes and colors of the finished building. As the historically most conscientious, and at the same time aesthetically most original architect of his time, he became the showcase figure of postmodern license toward history. Weighty picture books reproduce his unbuilt models and plans with equal abundance as his completed works, documenting his career as the success of free invention. However, in contrast to the picture books by Bruno Taut and Antonio Sant'Elia from the early days of modern architecture, those of Stirling are no utopian projections, but real investments in fantasy. They offer to the official and corporate patrons of the eighties the artistic profile of an architect able to stage the selective overfinancing of representation culture in citadel society as the sovereign play of creative freedom.

Breakthrough

The sprawling but compact building of the New State Gallery at Stuttgart, centered on a rotunda and encased by ashlar walls, is visible from far away, unfolding up the slope of a hill. Stirling has complied with the stipulations of the competition to integrate the building into a traffic rearrangement of the entire city center in such a way that the building facilitates but does not depend on the integration. Since the traffic rerouting has not been accomplished to this day, the building has the effect of a walled-in monument which people must enter in order to move freely. From behind the massive balustrades of the stone platforms and walkways, safe and relaxed in the citadel of culture, they look down

onto the noisy, smoky auto traffic on the expressway rushing past the portal below.

Stirling has taken recourse to the millenarian tradition of massive colossal building, Schinkel's classicism, the utopian architects from the time of the French Revolution, Rafael, the Villa Hadriana, the Roman Pantheon. When in 1977 the jury chose his project over those of the functionalist competitors, an ideological debate about architecture broke out in the West German press in which the project was denounced as fortress architecture and attacked as undemocratic, totalitarian, or even fascist. However, Stirling's adversaries, in comparing him with Albert Speer, overlooked the fundamental changes in design he had undertaken in the course of his move from an architecture of power to an architecture of culture. By contrast to the hierarchically centered, visually detached building groups for the sheik of Qatar and the Bayer Corporation, here he had designed a partly symmetrical, partly asymmetrical architecture of passages. His theme was not the potentially authoritarian coordination of administration and research, but the aesthetic accessibility of great achievements in the public culture of industrial society. The daring ambivalence of pure technology and inventive form, of collage and quotation, whereby Stirling both asserts and mocks traditional monumentality, is not oppressive, only stunning. In the official handbook about the New State Gallery, the word "ambivalence" is used to characterize artistic subjectivity, even artistic freedom. It is an apt word to denote the aesthetic double meanings of citadel culture, strung out as it is between intransigence and compromise, between power and play.

In Stirling's first plan for the gallery, the solid wall which seals off the museum complex from the street line was still high and steep. The museum's building administrators

prevailed upon the architect to open the wall onto the street in order "not to make the building appear too forceful," as the official handbook notes. Now the gentle inclines of the walkways lead up into the open rotunda of the inner courtyard, which visitors can traverse as they exit the building to the back street at the upper level of the hill. This architecture, simultaneously imposing and dispersed, invites the visitor to penetrate its mass, to reach its inner core. Large, rectangular window openings are cut into the heavy ashlar walls of the rotunda so that the visitor can view the surroundings. This is no center of power, thought, or art, just an empty courtyard with some bleached classicist statues lined up along the inner wall, a place where visitors can sit in the sun on garden chairs. It is a citadel at once unyielding and accessible. With this self-effacement of fortress monumentality, Stirling has forestalled the critics who labelled his building autocratic. It is in fact a monument of today's democratic public sphere.

During construction, it is reported, workers were encouraged to set the multishaded plaques of travertine wall sheathing in random sequences as a way to avoid a regulated, rhythmical look. "Each plaque possesses an individual appearance of its own," the official handbook asserts. These plaques represent a spontaneous, corporate harmonization of patron, artist, and waged workers, which is perpetuated in the visitors' spontaneous aesthetic response. In such aesthetic dissimulations of conformity, transfigurations of a democratic consensus with power, the architect went even further. At a random spot on the long, narrow sidewalk at the main street line, a large hole seems to have been broken through the wall of the basement parking garage. The missing square blocks are scattered on the lawn in front of it as if they had been punched out from the inside. Thus the ventilation of the subterranean

parking lot has been shaped into an image of political aesthetics. A wall breaking open in an unexpected place, looking either still unfinished or already dilapidated, does not seem impenetrable and may even forestall the provocation to blast it from the outside. Stirling even wished to preserve some protest graffiti sprayed on the wall, such as "Viva la Revolución," as historic documents about the construction, but the building administration did not let him. Why not? A call for revolution on a shattered museum wall, displayed with magnanimity, would have been an appropriately self-assured expression of citadel culture.

Bacon's Autobiographical Art

In his address at the opening of the Francis Bacon retrospective in the New State Gallery, in December 1985, the government official of the state of Baden-Württemberg was already able to register the public success of Stirling's novel architecture:

> State Secretary Schneider . . . pointed out that the New
> State Gallery with 1.5 million visitors in the first year
> after its opening had moved to the top of public favor.

How did the state secretary envisage a corresponding public success of the Bacon exhibit?

> [He] paid tribute . . . on behalf of the state government,
> to the rich variety of the artist's work, which most profoundly corresponds to the anxieties and menaces of the present time and emphatically brings home to the beholder the rootlessness of the individual.

Thus the government official was taking for granted that the public's art appreciation was informed by negative existential sentiments. He seemed to say that "anxieties and menaces of the present time" and "rootlessness of the indi-

vidual" are part of general experience in the public sphere and can therefore count on general understanding. What those two empty formulas of crisis, the general one about the "time" and the specific one about the "individual," might denote in reality, he left open. He merely voiced the success principle of citadel culture, according to which "rootlessness of the individual" is in "public favor."

In front of Bacon's paintings, such claims to aesthetic and existential generalization of individual anxiety would have had to be carried to a critical extreme had they been taken seriously. The state secretary would have had to admit that the autobiographical self-representation of a homosexual artist represents the self-understanding of the public at large. Indeed, the social and cultural emancipation of homosexuality which has been under way during the last fifteen to twenty years, touching upon the lives of millions of the general population, would have permitted the organizers of the show to acknowledge the autobiographical contents of the life's work of an artist whose homosexuality had never been denied, but also never discussed as an artistic issue. In 1985, such an outstanding artist would have been a representative figure, requiring the public to test the new sexual permissiveness of behavior and self-display reached in society in general with a kind of sexuality which had until recently either been rejected as abnormal or passed over in silence.

The retrospective of the life's work of a seventy-six-year-old homosexual artist would, however, have required a critical review of the public career of such artists in the times before the emancipation of homosexuality. In his ascent as one of the leading modern artists after the Second World War, Bacon has adapted himself to the interplay between concealed biography and existential abstraction required in such a career. Whoever reads David Sylvester's published interviews with the artist of 1980 can find, scat-

tered among technical and art-critical disquisitions, intimations of an autobiographical art project according to modern tradition.

> Sylvester: You didn't start painting full-time till quite late.
> Bacon: I couldn't. When I was young, I didn't, in a sense, have a subject. It's through my life and knowing other people that a subject has really grown.

Bacon has eluded any questioning about this "subject" all the more tenaciously the more firmly he clung to the privilege of modern artists to be not just tolerated but acclaimed in the unbridled expression of their sexual marginality. Society has granted them this dubious privilege under the condition that the self-expression lends itself to being aesthetically formalized and existentially generalized by the viewers. As long as Bacon transposed his configurations of homosexual agony or fulfillment into formal variations of Edweard Muybridge's sequential photographs of nude wrestlers and labelled them "Studies of Figures on Beds," he was still working according to the game rules of the half-concealed, half-confessional homosexual culture in which the supposedly unencumbered artistic freedom of the modern tradition has found its limits. This boundary was drawn by the legal suppression of and social discrimination against homosexuality during most of Bacon's lifetime and has been once again enforced in Britain by the Prohibition of the Promotion of Homosexuality by Local Administrations, passed by the House of Commons on 15 December 1985. The visual blurring the painter used to take the edge off his realism, those cleavages and mirrorings of spaces, breaks and shadows of objects, dislocations and distortions of faces, are expressions of those game rules. The sharply focussed photographs in black and white with seemingly innocuous themes from which Bacon professes to draw,

lead astray any viewers intent on ascertaining the contents of his pictures. Bacon's incessant assertions that pure painting is his sole concern conveniently assuage this contradiction between the proclaimed pedigree of his pictures and their uncomfortable visual appeal.

And yet the spectacles of physical degradation, torture, and manslaughter, whose voyeurs share the picture space with the protagonists, are visually irrefutable in their manifest contents. Here Bacon fulfills the modern artist's traditional task of representing the asocial or even criminal behavior of outsiders within the legal bounds of culture. In the process, established culture habitually denies the literal significance of the themes' visual brutality, proclaiming all the more emphatically their supposedly epochal truth. On the middle panel of a triptych from 1974 a naked man rises from the toilet, turning around to wipe himself clean. On the lateral wing a cameraman steps in, ready to film the event. Such a scene would surely have had a provocative effect not long ago. Today the exhibitionism modern art once used to present itself as a form of social subversion no longer meets the resistance which then gave it its shock value. The dynamics of severe censorship and shrill slave language are becoming increasingly dysfunctional. Now the sexual theme of Bacon's work could have been exhibited without dissimulation, looking back upon and taking leave from the cultural alienation which constrained its representation in the past. This would have been a retrospective in both the historical and the biographical sense of the term.

If one looks back on the time of suppressed homosexuality, a time now passing but by no means past, the sexual forthrightness of Bacon's paintings finds no match.

I've always hoped to put over things as directly and rawly as I possibly can, and perhaps, if a thing comes across

directly, people feel that is horrific. Because, if you say something very directly to somebody, they're sometimes offended although it is a fact.

Until about 1975, Bacon's pictures of homosexual themes show physical entanglements of violence and tenderness, grief and fulfillment, hurt and memory, whose associations with established art-historical conceits reach all the way to slaughtered animals and crucifixions. In an interview with Fritz J. Raddatz of autumn 1985, Bacon has for once explained his notion of homosexual love:

> . . . may be this situation of a struggle is a homosexual experience—relationships between men are more implacable; one [of the two] is always the stronger; and there is never a compromise—not because of money, not because of a compulsory bourgeois lifestyle, not because of children. This kind of love has something uncompromising, jangling, and pitiless about it.

But even here the artist still thought it prudent to withdraw again behind the façade of pure art:

> What I have said earlier about the sexual struggle sounds somewhat grandiloquent. First and foremost it is a problem of form for me. Already early on I was influenced by the motion photographs of Edweard Muybridge, whose wrestlers, as you know, also look like men in copulation . . .

And so Bacon, when talking to his commentators, has nearly always patiently disclaimed depicting anything that might happen in reality. Most of those commentators have been only too eager to abide by his refusal without recognizing it as the price of his visual extroversion. An artist who goes as far as this one in his pictures had to be silent

whenever he was asked to speak. Only in this way could his art be subjected to the existential generalization which was necessary to install it in modern culture, and all the more obstinately since its crass realism gives the lie to its formalist appreciations by his critics. The less one wishes to know about an artist's life, the more noncommittally can it be stylized into a paradigm for all and no one in particular. Perhaps earlier attacks on Bacon's supposedly nihilistic, animallike image of humanity were in reality directed against his homosexual themes, and the persistent acclamations of his pictures as expressions of a general existential crisis of the time were to some extent defenses against those attacks. Even at that time both positions sounded discrepant to the balanced, relaxed, and astute humanism transpiring from all public utterances by the artist himself, which betray no consciousness of any crisis. Now, at the time of homosexual emancipation, they altogether lose their relevancy.

The great retrospective exhibition had the chance of laying open what this emancipation meant for a historical and hence human understanding of Bacon's life's work. The artist, at age seventy-six, was already looking back on sexuality as a memory of the past. In 1979, at the time of his last interview with David Sylvester, when he was seventy, he had stated that after the death of his best friends he felt alone, "exorcized" from the physical intensity of sexual love. Since then he has no longer painted any bloody configurations of love and struggle. The last triptych by the seventy-four-year-old painter on view in the Stuttgart retrospective shows, in the middle panel, a nude man dragging his own shadow up from the ground and embracing it as if it were a body. The face of the man is disappearing in a black window, only one ear, the mouth, and the chin are still visible. In the lateral wings of the triptych, two men,

their faces likewise broken off, are sitting quietly on chairs. One of them has slipped a hand into his tight white underpants as if to masturbate.

Pornography, Mythology, and Pure Form

Bacon had authorized the catalog of the Stuttgart retrospective, which was written by British art critics personally known to him. These critics advanced the standard interpretation of his work, aesthetically detached from its manifest themes. According to them, Bacon does not paint "illustration"; he "willfully disrupts relationships between figures or between the figure and its setting"; he creates form compositions without significant contents. If they ever call a dangerous motif by its name, then it is severed from the action which might have made it understandable. Their art-historical disquisitions about pictorial sources and painting techniques, about representation of space and application of pigment, about relationships to modern painting or photography, pass over in silence what Bacon, in his conversations with Sylvester, had called his "subject."

The authorized catalog begins with the sentence:

> Too much has been made of the "horror" in Bacon's
> paintings, both by critics and by the public.

No doubt the author meant the overvaluation of contents at the expense of form. However, the sentence can also be understood in another way. In present-day visual culture, Bacon's art comes across as much less of a provocation than it previously did. It can become straightforwardly accessible if the bloody agony is perceived to be that of the sexual encounter depicted, not demonized into the cruelty of the world in general. To conceal this art behind formal or existential generalizations is at odds with the visual mass culture which has meanwhile gained ascendancy.

Bacon's filming cameramen, telephoning reporters, and peeping spectators in their stalls, who from the side wings of his triptychs observe and document the horror scenes displayed in glass boxes, may embody the artist's self-critical reflection upon his own exhibitionism, but they also anticipate a public sphere where his sexual themes can be perceived and understood. These themes are, after all, being offered without limits, printed and filmed in full color, by today's mass production of pornographic images. The crasser sadism of contemporary pornography not only tends to blunt the sensitivity of seeing, as do the documentary photographs of massacres and mutilations published in the daily press, it also satisfies a longing for the contemplation of cruelty. In so far as the artistic culture of recent years has begun to address the resulting changes in the habits of seeing, it makes it possible to face naked reality with fewer inhibitions than before. Now unprejudiced distinctions, apt to initiate an emancipated sexual culture, can finally be made.

But if viewers are made to forget the live narrative, to ignore the scenes of embrace, observation, and isolation, all that remains are the sexual groupings which Bacon's commentators just barely bring themselves to acknowledge. Thus, existential questions of sexuality, whose incessant pondering is a constant routine of heterosexual culture, are passed over in silence. Homosexuality is here still limited to its physical appearance. It is this voyeurism from a distance which Bacon has anticipated in the spectators and photographers on the side wings of his triptychs. Their formalist effacement at the hands of his commentators matches the indifference of the peep shows where anyone can view the physiological actions of nude bodies, without wishing to know what those human beings behind the glass windows of the booths or on the screens of the video monitors might feel.

> Prometheus is the epitome of the tragic hero, both winner and loser in a hopeless battle against fate and the gods,

says the authorized catalog, although Bacon in his conversations with Sylvester had expressly stated:

> if one could find a valid myth today . . . , it would be tremendously helpful. But when you're outside a tradition, as every artist is today, one can only want to record one's own feelings about certain situations as closely to one's own nervous system as one possibly can.

True to the historic contradiction between obsolete mythology and modern sentiment he has pinpointed here, the artist has never made an image of Prometheus. Yet presumably the art critic of 1985 could not do without the divine figure of indecisive torment. In an aesthetic culture of crass displays, pornography and mythology are equivalent modes of detachment.

Revision

The museum directors of Stuttgart and Berlin offered the authorized catalog from England in a German translation to their public, but they also commissioned another book by a West German author, Wieland Schmied, which amounts to a revision of the first. As the postscript says:

> They wanted this book as an accompaniment to the largest German Bacon exhibition thus far, which they had long prepared for, and have favorably followed its writing.

Like the British art critics, Schmied had been able to draw on conversations with the artist, and had also obtained the artist's "agreement to writing this book." However, he no longer observed the aesthetic formalization of the homo-

sexual theme but addressed it openly. Still, his concern was not homosexuality itself, but the experiential context of violence and suffering in which Bacon's work presents it:

> Bacon is incapable of imagining the community of two human beings in any other way than as an act of violence. His representations of the sexual act in particular prove Francis Bacon to be one of the most violence-obsessed painters in the history of art since Caravaggio.

In this art-historical perspective, the contemporary artist is linked across the centuries with a famous predecessor whose homosexuality remains unmentioned. A contemporary reference might have been the imagery of interconnected brutality and tenderness that can be found in artistic self-representations of homosexuals today, unconcealed by existential generalities. In an art-critical publication aimed at the sexually undifferentiated general public, it was evidently still impossible to write about such imagery with the same openness as that advancing in contemporary art itself. I myself am in no position to do so. But it is this openness for which Bacon proves to be the trailblazer in retrospect. In any event, the advances of homosexual self-definition in artistic culture suggest interconnections of love and pain which cannot be categorized by sexless existential stereotypes of violence and suffering.

Schmied had to face this question when he chose to focus his interpretation on the sequence of three triptychs which Bacon painted in May and June, 1973, in memory of his friend George Dyer's death. In this exceptional case, the painter has identified the biographical circumstance:

> It is the report of the suicide of my friend, who was found dead on the toilet although he had thrown up before, full of alcohol and pills.

Instead of confronting the unequivocal testimony of the individual, the author chose death over sexuality so as to maintain the existential generalization of Bacon's art.

> Francis Bacon has intensified the sentiment of death, the
> death of his friend, which could also be the death of any
> anonymous contemporary, into the all but insupportable.
> He has *intensified* it by mercilessly describing the event
> of dying as the inescapable fact of our existence, which
> *degrades* us all and makes us all *equal.*

Why should the commemorative image about the death of a human being known by name be valid for all? After all, dying is as manifold as life, and by no means degrading for everyone. An appropriately specific generalization of what one can see in Bacon's triptychs about George Dyer would have related it to the press reports and photographs of overdose deaths of drug addicts in sleazy hotel rooms or in the toilets of railway stations. However, the art historian prefers to think of late medieval images of *Memento Mori* and the Man of Sorrows rather than the misery of life on the margins of society. "Ecce homo," he writes, calling Bacon's pictures

> Metaphors which tell us something we have perhaps
> known about for a long time, but rather wanted to con-
> ceal or suppress from ourselves . . . Thus Bacon's
> wrestlers no longer seek the victory that would have to
> separate them, but they seek the lust of an endless copu-
> lation in order thereby to perish.

But the metaphors are not in the artist's pictures, they are the author's printed words. After coming close to calling homosexual love a paradigm of human existence, he falls back upon the generality of myth:

> Precisely *this* [process of] dying which Bacon shows us,
> joins the history of other great treatments of human deg-

radation, Greek tragedy, Japanese Noh plays, the
mystery theater of the Baroque, [and] the testimonies of
the cult of the dead of so many religions.

To such speculations the author raises his own objections:

> Perhaps it is wrong here to call on Greek tragedy and
> Christian mystery plays. Perhaps any reference to intel-
> lectual history we make in order to clarify the rank and
> importance of a work such as Bacon's triptych of May/
> June 1973, can only lead astray . . . We should be on
> our guard against calling by names of mythical or literary
> heroes what Bacon has left nameless . . .

Never mind that in the triptych Bacon had commemorated
his dead friend by name, the author prefers to vacillate ac-
cording to the conventions of citadel culture. Had he rec-
ognized homosexuality as a realm of culture being newly
defined today, his considerations would not have ended
inconclusively.

Deadly Sexuality

In the Bacon retrospective, the convention requiring art to
have a general relevancy in order to find its place in culture
was put to a hard test. What could be the general relevancy
of an art that links homosexuality with bloody injury and
death? This question became inescapable in the face of a
historical experience which just at this time began to be
urgently discussed in the public sphere. It is the experience
that the social emancipation of homosexuality coincides in
time with the epidemic menace of the Acquired Immune-
Deficiency Syndrome, as if death were following on the
heels of liberation. This experience carries over into the
awareness and fear that in today's sexually emancipated
mass society, the mortal danger of infection transcends ho-

mosexuality and threatens sexuality of any kind. And the rejection or suppression of this awareness backlashes against the emancipation of homosexuality. In view of this perspective, the assertion by the state secretary of Baden-Württemberg that Bacon's art "most profoundly corresponds to the anxieties and menaces of the present time" acquired a topicality just as uncanny as the West German art writer's suggestion that the bodies of nude men in Bacon's pictures "are inseparably intertwined in a deadly embrace." The unintentional urgency of both these phrases, which were hardly written as concealed insinuations, is typical of the self-protective segmentation of citadel culture.

At the end of 1985, when I saw the Bacon retrospective at Stuttgart, doubts were just beginning to be raised as to whether AIDS was confined to homosexual marginal groups and bloody sexual practices. Had the exhibition openly dealt with homosexual love, the consciousness of the disease would have penetrated aesthetic mass culture. Instead, a modern artist was once again assigned his place as a silent envoy from the social outsiders to the culture for all. The widely spaced sequence of his paintings, with their over life-size standard formats, their identical golden frames, and their shatterproof glass coverings, in the brightly lit white halls of Stirling's museum building was staged as a visual spectacle where the figures on stage are no more real than the architectural props. Just as the opened walls and jarringly colored metal railings playfully question the compulsive character of citadel architecture, the sexual menace of Bacon's life's work was being simultaneously obscured and dramatized. What the public may have learned from this festive presentation of testimonies about sexual violence is not known. While the publicity releases of the New State Gallery touted record numbers of visitors praising the architectural aesthetics of the building, no poll nor

press commentary addressed the reaction of the visitors to the sexual aesthetics of the pictures in the exhibition. Had this question been asked at the time when the transfer of AIDS from homosexuality to sexuality at large was becoming a public obsession, the exhibition would have turned into an event of the argumentative culture which citadel culture has replaced.

KRAFTWERK
BOULEZ

Concerts and Records

At last, after five years, a new long-playing record by Kraftwerk, my favorite rock group, came out in the fall of 1986. Its title is *Electric Café*. But the latest work by Pierre Boulez, my favorite composer, *Répons*, of 1981, has not yet become available in any recording. Only a short segment is included on a sampler record issued by the Paris Institut de Recherche et Coordination Acoustique/ Musique (IRCAM), which I can have played to me in one of the listening booths of the music department at Northwestern University, where I teach. In the spring of 1986, Boulez performed the entire work here during the U.S. tour of his Ensemble InterContemporain. The electronic sound equipment, loudspeakers, spotlights, cables, even wooden platforms had been shipped from Paris in order to prepare the university's gym for the performance. The rock group Kraftwerk, on the other hand, no longer appears in concert but today is only present through their recordings. European and American record shops continue to stock all of their work since 1974. The jacket designs of their last two records from 1981 and 1986, *Computer World* and *Electric Café*, depict the four musicians as their own technical reproductions: as nearly identical mannequins, black passport photo negatives lined up on a green computer screen, computer-aided construction drawings of their

heads, stereometrical projections faceted into shiny white metal surfaces.

Such alternatives of live performance and technical reproduction of a kind of music, where traditional instruments and electronic machines are used side by side and integrated with one another, present themselves differently in the realms of high culture and mass culture. Boulez and Kraftwerk both triumphantly display the technical production of their music. But only the rock group expresses concurrent misgivings about the adaptation of musical expression to electronic technology. The modern composer of serious music, by contrast, optimistically demonstrates the same technology as a medium for the free deployment of the modern artistic imagination. The contrast between the crystalline, frozen computer portraits of the four Kraftwerk musicians in blue, white, and red on the black square jacket of their last long-playing record and the colorful, mobile panorama of orchestra and technicians, composer, and public in the gym of my university visualizes those contradictory assessments of the new technology.

From *Computer World* to *Electric Café*

Kraftwerk's song *Computer World*, of 1981, suggests a worldwide sound space where singers recite, in the form of a monotonous litany, the names and acronyms of electronically interconnected international networks of finance and surveillance:

> Interpol and Deutsche Bank
> FBI and Scotland Yard . . .

In another piece, *Numbers*, distorted voices from near and far count, in German, English, Italian, Spanish, and Japanese, number sequences from one to eight. Toward the end, the numbers suddenly multiply and the rhythms get

shorter until the voices fade away, entangled in geometrical progressions of millions and billions. These may be the brokers at the stock exchanges of Frankfurt, New York, and Tokyo, whose simultaneous bids resound through the intercontinental telephone networks. They vainly try to synchronize their overbidding with the beat. The small numbers can still be fit into the 4/4 rhythm, but the longer, composite numbers jar against it, no matter how compressed their accelerated pronunciation. The programmed, hectic pace of the human voices appears to follow the dynamics of the electronic rhythm devices, but their melancholic maladjustment detaches them from the schematism of the machines.

In *Electric Café* of 1986, multilingual voices merely announce the expressionless equality of a worldwide music with no correspondence to historical time:

> Music non stop.
> Techno-Pop.
> Music will go on forever,
> A carrier of ideas . . .

Music's future is assured, but which ideas it will express remains unsaid. The incessantly repeated assurance proclaims its opposite. The apt artistic expression of music is that of its own electronic perpetuation. In the next song of the record, a man is attempting to call a woman on the telephone all over the world, but all he hears is a sound collage of international answering tapes, announcing in many languages that no connection can be made. The woman may wait for the call, but the telephone system doesn't work.

Between 1981 and 1986, the expressive sense of Kraftwerk's music has changed. While *Computer World* still describes the electronic currents of informations, decisions, and transactions that regulate the life of citadel

society, *Electric Café* merely voices the stereotyped, introverted isolation of failed attempts at electronic communication, and the electronic music incorporates this expression into its repetitious self-assertion, devoid of any contents. These are musical reflections of citadel culture.

Répons

Boulez's *Répons*, by contrast, comes across as an auditory panorama of differentiated sound sequences, timbres, tempos, and rhythms, where everything changes and nothing repeats itself. Although the title ("responsory") usually denotes purely vocal music, the piece contains no word of chant or speech which would allow one to pinpoint its musical expression verbally. In exchange for the lack of words, this music presents itself most expressively, as a communication of performing soloists, chamber musicians, sound engineers, and computer technicians with the conducting composer and with one another. The electronic pitch modulations and computerized sound distortions resounding from the battery of amplifiers interface with the pitches and sound levels of the solo instruments. The machines answer the instruments by instantly restructuring their music and playing it back as their own accompaniment. Thus, the title *Répons* transposes the idea of alternating chants onto the technological self-augmentation of instrumental performance, whose choreography displays the work, in spite of its comprehensive technical planning, as a one-time cooperation between artistic, technical, and scientific experts. Within the free space granted to them by the flexible score, all of them share in the making of the work with their musical decisions. This ensemble play of man and machines, planned and spontaneous at once, is its own content and needs no words for its expression.

The collective self-confidence of the artist and his col-

laborators in the unlimited expansion and intensification of musical creativity through the use of electronic machines is the exact opposite of the stereotyped frustrations expressed by the electronic rock band in its latest recording. There may be several reasons why no complete recording of *Répons*, which was first performed in 1981, is available as yet. Perhaps a complete recording of Boulez's entire output in progress, for which he signed a contract in 1969 with the CBS Music Corporation, would not be profitable. Moreover, *Répons* still exists only in a preliminary version. Above all, due to the work's particular combination of organization and spontaneity, each performance is uniqe. Each one is presented as a demonstration of adventurous, creative, technical music-making, with the composer himself acting as teacher and protagonist. To date, this is the only way one can hear *Répons*.

Electronic Music Spaces

Each rock-and-roll group must distinguish itself from innumerable competitors by an unmistakable peculiarity, an unforgettable sound. Kraftwerk's peculiarity consists in a reflective expression no less consistent than that of Boulez of what electronic production does to musical performance. They draw lyrical conclusions from the rapid development of synthesizers, into which the popular sounds of rock-and-roll are preprogrammed as readily available materials of semiautomatic music production. Until a few years ago, this kind of machinery made most musicians dependent on the studios of the big record companies which produce their music. The companies must recoup not just the investments in the sound production and recording equipment but also the much larger investments in the production and distribution of singles, long-playing records, cassette tapes, and compact discs. In the marketing of

rock, live performances and record sales are financially coordinated. The tours where a rock group such as Kraftwerk plays live before the public are subsidized as publicity campaigns for new recordings, whose sales offset their deficits.

The almost identical life-size mannequins which the four Kraftwerk musicians had made and photographed to portray themselves on the back of the dust jacket and the sleeve of *Computer World* make them look as if they functioned electronically, like the robots replacing workers in today's factories. The title of their long-playing record of 1978, *Man Machine*, had announced this already. In the simultaneous public launching of *Computer World* in Paris and New York, two sets of those four mannequins moved about on stage. Ralf Hütter, a member of the group, has drawn from those appearances a hypothetical conclusion:

> With the man machines we can give concerts at various places at the same time.

This assurance mocks its own contradictoriness. Such concerts could only consist of performances where recordings, played back through amplifiers, would accompany the preprogrammed stage motions of the robot mannequins. Without irony, the assertion rings true, however, since the live musicians are in fact increasingly making a kind of music only meant to be heard through reproduction. They could never duplicate their creative work at the machines in the studio in any live public appearance, since it consists in the protracted elaborations of sound components, of tracks played in random sequences and mixed on the master board into the final simultaneous sound. Therefore the musicians' masquerade as computer-guided robots does not profess their naive impersonation of total electronic music production but, on the contrary, caricatures the detachment of musical expression from concert play.

The performance of Boulez's *Répons* is just that kind of impersonation. As the rock musicians vanish behind the fictional images and postures of worldwide marketing, the musicians and technicians of Boulez's Ensemble Inter-Contemporain are on the road with their equipment in order to present their collaboration on stage, including the composer. Since his earliest works, Boulez had constantly designed new, varying choreographies of musicians grouped according to the structural requirements of each individual work. He arranged unconventional combinations of multiple instruments with different sound dynamics visibly onstage, detaching them from one another as they interact. Now, in *Répons*, he deploys the structural engineering of a creative performance which needs not only to be guided by the conductor but also to be steered by a team of technicians. Such a performance predetermines the listeners' experience in time and space more comprehensively than ever before. On the rectangular basketball court stands the square podium for a chamber orchestra composed of twenty-four persons, elevated just a foot or two above the audience which surrounds it in variable blocks of seats. Just below the ceiling, in the four corners and on two opposite axial points of the hall, platforms are installed for six large solo instruments: a piano coupled with an electronic organ, a set of cymbals, another piano, a xylophone with a carillon, a harp, and a vibraphone. Finally, on one of the long sides of the court, the control station of the main computer 4X is located, complete with mixing consoles, keyboards, and monitors. Here the engineers regulate the electronic multiplication and restructuring and the delays and accelerations of the six soloists' play, and they modulate the dynamic variations of sound distribution among the batteries of amplifiers suspended from the ceiling at the periphery of the hall. This electronic sound space literally envelopes the audience.

Back in Paris, in IRCAM's subterranean music studios, a work such as *Répons* is developed in the course of an investigative process which is aimed, beyond musical structure, at a listening experience completely predetermined through an interaction of the evolving score and the networking plan of the electronic machines. It is tested in a rectangular studio, called the "Espace de Projection." The walls of this room consist of steel grills with small square subdivisions, each one framing a window cross in whose quadrants four parallel groups of three prisms each can be turned, two groups in a horizontal and two in a vertical direction. The three surfaces of each prism are coated with different materials, so that the first reflects, the second diffuses, and the third absorbs the sound. The computer-directed, infinitely variable rotations and inclinations of these prisms measure, regulate, and vary the resonance of the combinations of instruments and amplifiers, which are continually tested by the composers as they compose. Thus, in the "Espace de Projection," the results of a network of electronic functions, guided by mainframe computers which reportedly even connect artistic creation with the Institute's scientific and administrative procedures, transpose the calculated composition into the experiential form for listening. If this studio could hold more than just the handful of expert listeners for which it was designed, it would provide the ideal space for the perfect performance of *Répons*. The basketball stadium where I heard the piece is the acoustic compromise to which the concert form of its circulation subjects this music.

Machines and Voices

In one of their interviews, Kraftwerk has stated:

> We draw from our native language, German, and avail ourselves of the machines produced by German industry.

However, the language does not fit the machines as unproblematically as their common German identity suggests. In the course of Kraftwerk's artistic development, their texts have moved away from the initial, quasi-advertising consonance with their technical subject matter, first to a cool, equanimous distance, and then to a restrained emotional recoil. At the same time, the texts became shorter and their presentation more fragmented. On the long-playing record *Radio-Activity* from the end of 1975, the group still seemed to echo affirmative slogans about the production of nuclear energy, so that the left-leaning West German rock press subjected them to political remonstrations. Even then, however, their unemotional delivery was just as far removed from unequivocal assent as from the unequivocal rejection the critics found lacking. In subsequent years Kraftwerk have often stylized their texts as apparent quotations, avoiding any parti pris to be pinpointed, be it assent or refusal.

This neutrality of sentiment is the deliberate, reflected expression of an electronically automated music which subjects voices to the same technical processing as the sounds of instruments or their synthetic imitations. Along with these, voices are taped materials for the musicians to distort and dissolve, modulate and mix, excluding any lyrical emotion of chant. The only limit to the technical modulation of chant is set by the 4/4 beat, which for electronic rock was long sacrosanct. In 1977 Kraftwerk reached this limit when it ended their long-playing record *Trans Europe Express* with a piece just one beat long:

> End-less.
> end-less.

With the lyrical indifference of their songs addressing the living conditions of industrial society, the group dis-

tanced itself from the cultural-critical or even political rhetoric current in West German rock during the first half of the seventies. Since 1975 rock trade journals have begun to question this rhetoric, because it did not play with the increasingly nonpolitical West German rock public. It also stood in the way of international distribution, which was steadily increasing in importance for the record industry's profitability in a shrinking market. With the self-mocking brevity of their lyrics, the Kraftwerk musicians countered the charge of German profundity. By the beginning of the eighties, trade critics were applauding the simplification of the texts to the spareness of comic strip speech bubbles. Once this manner of chanting short quotations had been established, the emotional intensity could be restored without being mistaken for straightforward lyrical expression. Moreover, the simplified texts could be translated into English almost word for word without changing the number of syllables and the rhythm of syntax. On the multitrack master tapes, the voice tracks could be neatly exchanged. The one or two-syllable words of the English versions fit even better into the 4/4 beat than did the German originals and may even have been first devised. In any event, the simultaneous production in German and English has fostered Kraftwerk's international success. In *Computer World* and *Electric Café*, both the shortening and the internationalization of the text are maximized. The English recitals with a German accent suggest an alienation of understanding, in the literal sense of the word, which is carried over into the rhythmical interferences of the beat with the international speech fragments recorded from the radio and telephone networks. Only now does the world-wide extension of the sound space for the syncopated music generated by the synthesizers attain an expressive resonance independent of the fragmented voices.

Synthetic and electric sound
Industrial rhythms all around
.
La música ideas portará
Y siempre continuará . . .

These neatly counted, sequential lines of speech are no more than contrapuntal commentaries to the synthesized rhythms of the music that automatically continues on its course. They are repeating their assurances like rondos or litanies, celebrating the self-sacrifice of the chant to the machinery. It is these interferences which make for the expressive sound.

The ideal of an unending expansion, complexity, and differentiation of musical expression which Boulez wished to attain with his *Répons* does not include the human voice. The title's reference to the medieval responsory, that is, to purely vocal music, is metaphorical, since the work is purely instrumental. And yet, since his *Marteau sans Maître* of 1955 Boulez had worked toward integrations of language and music, or even toward transformations of language into music. He was no longer concerned with verbally articulating any expressive contents of the interplay, as Schoenberg had done in *Pierrot Lunaire*. In his variable repeated musical setting of three poems by René Char, the "fatality" of the serial composition strictly follows the course of its autonomous deployment. It creates the sound space for an imagination where the enigmatic associations of surrealist verbal thinking unfold and turn back upon themselves in the reflexive repetitions of the "commentaries." In reciting the hermetic verse the voice merges with the serial sound sequences, only detaching itself from the instruments by means of a reciprocal interplay within the serial structure. Here the texts are "central and absent" at once, according to Boulez's dialectical for-

mula. Such a composition does away with any directly communicative language function, if that can still be presupposed in the poems themselves. In Boulez's adaptation of five poems by Mallarmé, *Pli selon Pli* of 1962, language is dissolved in instrumental music "layer by layer," in accord with its self-reflexive dissolution as communicative speech in early modern poetry itself. Already in Mallarmé's verses, words are not communications but materials for auditory and associative compositions. When, in 1970, Boulez set to music a single line from a poem by E. E. Cummings, he went so far as to dissect the individual words into their letters and syllabic sounds, which he reassembled in a new order for the composition.

It is for instruments that Boulez has created this kind of hermetic musical poetry. In electronic music, the ideal of fragmenting and manipulating the human voice can quickly acquire a repressive air. In Karlheinz Stockhausen's *Chants of the Youths* of 1955–56, children's voices emerge from, and become submerged in, the electronic sound continuum, representing the resistance of Old Testament confessors in the fiery furnace. But against IRCAM's computers, the human voice no longer puts up any resistance. On the contrary, its acoustic characteristics make it better suited for unlimited electronic analysis, modulation, and simulation than other types of sound. On the mainframe computer VAX 780, a program called CHANT was devised which can numerically calculate the acoustic coordination of voices and instruments during composition. Since 1984, the new microprocessor FPS 100 performs such calculations twenty times faster than before. These electronic processes turn the relationship between chant and composition upside down. The voices on the tape have already sung while the composer is still at work.

Boulez has electronically realized the age-old fantasy of an assimilation of all speech and song to the mathematical

structure of music. The voices' inclusion in the synthesis of instruments and computers eliminates the distance between human expression and instrumental sound, which Boulez, in his pre-electronic pieces from Char to Cummings, had attempted to bridge. Now it is the display of a coordination between solo instruments and chamber orchestra by means of computers which can be circumscribed with a metaphor of unaccompanied chant. In medieval church music, responsories were musical spectacles of the community's harmonious submission to the doctrines proclaimed by the liturgy. In between their choirs and soloists, the clergy staged a codified antiphonal dialogue in Latin chant where they spoke on both their own behalf and that of the community, which acted as a silent audience. This kind of fictional communal music accommodated no subjective expression. It is an appropriate model for the predetermined listening in the rectangular sound space of *Répons*.

Tempi

Technological research at Boulez's institute has shortened the time measurements of musical interaction down to the point where thesis and antithesis collapse in electronic simultaneity. They are no longer being conceived as alternations of question and answer, assertion and resistance, hearing and thought. The digital acceleration of electronic sound processing up to so-called real time instantly expands the sound to incorporate the musical consequences drawn from it by the computer program. Thus, in *Répons*, infinite differentiations of process and infinite contractions of simultaneity converge. Computer-directed sound transformation is far ahead of any interplay between the instruments. The soloists may suspend this transformation by softer play, since only at a certain loudness level will the

sound of their instruments activate the computer. They have to fall behind "real time" in order to assert their independence. This ambivalent dynamics of active decelerations and passive accelerations reenacts the medieval posture of the responsory, as if the electronic impulses were voices. The breakneck collapse of sequence and simultaneity generates the tone of citadel culture which becomes audible in *Répons*.

Meanwhile the composer is perpetually bent on extending the work, which is performed as a preliminary version still under development. In 1981 it lasted nineteen minutes, in 1982 thirty-four minutes, in 1984 forty-five minutes. With rapt attention, the international music public perceives the large spaces of expression, the long dynamic crescendoes which Boulez conquers at the pinnacle of his career. Meanwhile, the technological developments on which the artist relies are advancing no less continually. IRCAM's computers and sound machines are becoming obsolete and are being replaced, and for the new hardware new programs are being written. In the preface of his institute's official brochure, Boulez writes:

> One can conceive . . . of a still closer connection between musical language itself and the tools which help in defining and manipulating it. There are many realms where imagination can still take off freely . . . But if there is one thing I don't doubt, it is that the field of the future is immense, and that more things are still there to discover than our philosophy can dream about.

In 1974, Boulez had dedicated his exotic instrumental piece *Rituel* to the deceased composer Bruno Maderna with the following inscription:

> The alternation perpetuates itself:
> A kind of versicle and responsory for an imaginary ceremony.

A ceremony of remembrance—hence those numerous
returns to the same formulas, changing profiles and per-
spectives all the while.

Ceremony of extinction, ritual of disappearance and of
survival: thus the images imprint themselves on the mu-
sical memory—present/absent, [suspended] in doubt.

Set off against the endless future of the electronic sound
machines, any ensemble of people playing their instru-
ments in real time—which denotes the opposite of simul-
taneity according to the pre-electronic meaning of those
two words—recalls death. In the Office of the Dead of me-
dieval liturgies, the musical performance of the responsory
evokes the limited time of life during which dying and re-
membrance are counteracting one another. Boulez's *Ré-
pons*, its contemporary instrumental equivalent, anticipates
a boundless, converging growth of investment, planning,
and composition.

In Kraftwerk's electronic pieces, the extreme simpli-
fication of the texts makes the alternations between con-
formity and discrepancy with the beat readable without
ambivalence. It is against the 4/4 beat that the synthesiz-
ers' continuous shifts of volume and timbre are implicitly
being measured. In concert rock the 4/4 time is set up as
an acoustic grid against which the players knock and shake
with variable violence. Kraftwerk has shed such gestures
of cultural-revolutionary clamor. In an interview, Ralf
Hütter once said contemptuously:

> Someone does a solo on the drums. A sweating bundle
> sitting there. That's a joke! A form of physical condition-
> ing. I've seen through this edifice. One must think in
> other dimensions.

Kraftwerk's electronic playing technique confirms rather
than opposes the constraints of time measurement, ei-

ther by comical conformity or by the semblance of help-less maladjustment. In electronic synchronization, the beat merges with the computer's steady digital pulse. This is how a piece from *Computer World* describes it:

> I'm the operator
> With my pocket calculator
> I am adding
> And subtracting
> And composing
> By pressing down a special key
> It plays a little melody.

After each repetition of the verse, the beat of the synthe-sizers blends into the infinite four-tone variations of beeps familiar from electronic gadgets. Here is a caricature of the ideal which Boulez promotes with confidence.

Still, in *Electric Café*, caricature becomes depressing. The introductory piece consists of three spoken words:

> Music non-stop
> Techno-pop

It ends in a sound collage where these words are syntheti-cally distorted to sound like the alternating voices of a man, a woman, small children, and a toothless grandfather. The kaleidoscopic repetition of generations within the grid of the ceaseless beat garbles their natural sequence. The natural lifespans of each age are schematized into the uni-form digital time. Here they can be endlessly continued or resumed at will.

Investments

Profits of rock music from worldwide record sales are re-invested into the rapidly advancing technology of synthe-sizers, rhythm machines, measuring and mixing devices.

Normally the studios of the record companies make this equipment available to the rock groups only for the production and reproduction of their finished pieces. For their own, laborious experiments and rehearsals, the groups have to purchase their own equipment. It is only since 1976 that this technology has steadily cheapened and hence spread through most of the West German rock-and-roll scene.

However, the technical expansion of the electronic sound industry has not engendered a market expansion of popular music itself. For along with the production equipment for artists, the equipment for private reproduction by the listeners has cheapened and spread as well. In 1983 the digital compact disk, a sound carrier of perfect acoustic quality which cannot be reproduced, reached the market, but after just five years the digital tape recorder, which permits reproduction, has caught up with it. For the miniaturized Walkman which music fans carry wherever they go, the proliferation of tape copies is indispensable. They expand the consumption of popular music beyond leisure time into the traffic time of pedestrians, bicycles, automobiles, and railways, even into the working time of factories and offices. However, the expansion of listening increases the sales of the equipment rather than the music. Thus, since the beginning of the eighties, the mainstream recording industry has stagnated to the point where only leading groups such as Kraftwerk are able to maintain themselves.

Kraftwerk's early successes provided them with the funds for acquiring electronic equipment at a time when it was still too expensive for other groups. They have capitalized on their investment advantage by identifying not just with the sound but also with the critique of their gear. Thus the obligatory self-reflection of contemporary art has come to pop music. In *Man Machine* of 1978, the Kraftwerk musicians still sang of the star artist who loses his

identity by watching his face in the mirror, and professed the mock-confidence of robots vocalizing in aggressive monotone. In *Computer World* and *Electric Café*, they tune into their equipment with a melancholy detachment which reveals neither doubt nor assent. When *Computer World* was launched, the musicians said in an interview:

> We see ourselves as musical workers. This is why we have this studio, the Kling-Klang Studio, where we have been working for ten years every day. In this work, thoughts and ideas play a certain role, but we don't just compose and play, we also make our own equipment with the help of engineers. We see ourselves as a productive team making not just music, but technology, video films, and other things. That's what we call total music. It's not just sounds, it manifests itself in an electronic lifestyle. We deal with it in all realms of life.

However, in this self-owned electronic enterprise, the artists do not express their control of the technology, but their insertion into the functional correlation of technological advances, investments, and market success. Their stereotyped short texts sound mechanized and emotional, conformist and critical at once. The processing of their own voices by means of electronic machines both celebrates and bemoans their accomplishment. This self-reflection of adaptation, illusionless and decisionless in equal measure, generates the sound of citadel culture.

In *Répons*, conversely, modern music triumphs as a state institution. Boulez, one of modern music's most intransigent representatives, has risen to be France's leading composer. The entire state budget for modern music is at his institute's disposal. Now modern music is no longer affected by the continuing scarcity of a supportive concert public. Its state-supported production is conceived as the initial investment in a gradual transition to self-financing

which does not, however, lead back to the free market for culture. The returns are not expected to come from the proceeds of performances and recordings paid for by the music public, but from variable combinations of state budgets, foundation grants, and sponsorships from industry. A tireless concert schedule is designed as a public relations program by which to animate this process. The world tours featuring the composer with his masterpiece, almost always a thunderous success, are usually underwritten by ministries, cultural organizations, or universities of France and the host countries. On those occasions Boulez himself will lecture, in public speeches or closed seminars, on how the innovative ideals of modern music can be pursued with today's technology and prevail without compromise in today's public sphere.

In Paris itself, IRCAM conducts a widespread popularization program complete with films, television shows, and video cassettes. These show no performances, but rather the technical teamwork of composition. But the most decisive initiative assuring the independence of modern music is, according to the official brochure

> the opening to industry, which has today become indispensable in order to avoid the obsolescence of the Institute's technical resources and to open possibilities of self-financing for it.

Only if the institute succeeds in "optimizing investment decisions" can modern music's ideal of progress be sustained. For, with its transfer to electronic technology, modern music has become subject to the dynamics of investment and depreciation. In order to utilize the computers and sound machines optimally, the institute stays open seven days a week, twenty-four hours a day. In this overheated technical routine, the ideal of an artistic avant-garde in untiring progress contradicts the social ideal of shortened working-

time ascribed to electronic technology in the benevolent utopias of the communication society. Instead, it corresponds to the productive ideal of accelerated work in order to preserve the profit rate.

Accordingly, it is industry which most directly benefits from IRCAM's schedule. Only the industrial use of technologies designed and developed for the production of music can ensure the financial viability of the music center. In cooperation with the Centre National d'Etudes et de Télécommunications, the CHANT programs for electronic voice synthesization are being further developed for purposes of synthetically generating speech. Thus, the acoustic verbalization of the computerized interaction between electronic machines and their users at the workplace and in the public realm is ultimately derived from the hermetic dissolution of lyrics into music which Boulez rehearsed on the poems of Mallarmé. But the institute's most important contracts of technical cooperation and licensed production were concluded with the private companies Yamaha and Sogitec. Here the industrial exploitation of modern music is neatly distributed between mass culture and arms production.

The cooperation with Yamaha aims for a miniaturization and cost reduction of computerized music technology. If, as the institute asserts, modern music can no longer be made without such a technology, the current high cost of the large equipment would restrict it to radio studios and music institutes and thus make artists dependent on those agencies. Boulez is planning a personal computer for electronic composition which every individual composer can own. Yamaha will exploit his concept through mass-produced versions made available to rock musicians. When the miniaturized equipment passes into the hands of individual artists, Boulez envisions them networking with each other, as well as with musical institutions, facilitat-

ing global communication. Even today, his subterranean institute, centrally located but shielded from traffic noise, is electronically opened to the world. The official brochure says:

> An internal network allows access to [the computer system] from every workplace for purposes of research, of musical production or even for administrative tasks. It is linked to the outside by telephone lines and by the tele-information network Transpac. In this way, exchanges of messages, sound files, and program systems with French and foreign centers are facilitated. The management of this equipment park, compelled by market tendencies to be very dynamic, is made more complex by the even faster, sometimes anarchic development of exploitation and application programs.

Thus, unlike the cultural seclusion of past academies and conservatories, Boulez's musical citadel instantly interfaces music production with an expansive process of technological development and financial planning.

About the cooperation with Sogitec the official brochure says:

> Following the putting in place of the prototype [of the sound computer 4X] in 1981, a contract for industrial production and sale has been concluded with the Sogitec corporation. The computer has been produced in a limited series and has found its application in the industrial and military realms: simulation of sound environments for the training of pilots (of aircraft and submarines), analysis of industrial noises, processing of submarine sonar signals.

Thus IRCAM's self-financing feeds its products back into the cycle of the state economy to which it owes its installation, ending in arms production, for which the state spends

infinitely more money than for art. In citadel culture, the leading composer of his time signs a contract with an electronic subcontractor of the submarine shipyards. The infinitesimal analyses of Schoenberg's "sea of never-heard sounds," electronically intensified beyond auditory perception, can serve for the mutual positioning of the nuclear missile launchers patrolling the waters around the citadel compound of the industrial states. Here modern music has reached the peak of its significance for society at large. Just as in the European aircraft, space, and arms industry, in music, too, the costs for research and production of modern arms can no longer be sustained by the free market, but only by the state. And just as the state-directed high technology of capitalist industry maintains the semblance of following market laws, Boulez, in his *Répons*, has staged state-supported art as the free play of artistic initiative. In this equation, it is irrelevant whether it will ever be made into the long-playing record I want to buy.

High Music and Pop Music

The correspondences between electronic high music and electronic pop music, which can be observed in *Répons*, *Computer World*, and *Electric Café*, have not accomplished the approximation between elite art and popular art so often asserted in citadel culture. Boulez and Kraftwerk are operating in strictly separate realms of public culture. Although their ostentatious display of electronic production technology is similar, its expression differs according to economic circumstances. Where the rock group, working for a free market with its risks, presents itself as critical, the officially appointed avant-garde composer professes confidence. Without referring to one another, both pursue their work in a culture of suspended contradictions.

During the seventies, the situation was different. Then,

the academically trained musicians and intellectuals of West German rock culture were studying with Stockhausen, Ligeti, and Berio. They aspired to a popular music carrying serious messages of social critique. In the eighties, those aspirations were withdrawn. Now the critical reflections of pop music shrank to the inconclusive cynicisms of comic strips, where social conflicts are merely caricatured. While *Computer World* and *Electric Café* give resonance to the agonies of electronic communication society, *Répons* suggests no doubts about technical progress. In 1987, the titles of works presented by IRCAM's young star composers soared to the traditional heights of modern mythological fantasy: *Aloni, Jupiter, Antara, Kristallwelt III, Etude pour Pulsazioni, Io.* In the institute's program leaflet, the composer of *Jupiter* relates how he developed for his work

> a program environment, INTERPOL, which presents itself
> as an ensemble of programs destined to structure the
> sounds or the phrases collected by the control processes
> of [the computer] MAX.

He proudly goes on to describe his composition as a self-display of its electronic elaboration. Was he conscious of the irony inherent in the association between Jupiter and Interpol? Did he wish to conjure up the god of the Greek Olympus who surveys everything and can interfere everywhere, as a mythological personification of omnipresent police control?

Six years earlier, in *Computer World*, the Kraftwerk musicians had associated Interpol not with Mount Olympus, but with the Deutsche Bank, thereby reducing to the simplest formulas the question of a contemporary historic meaning of technicized music, the question Boulez leaves open. Kraftwerk chimes in with the choir of citadel culture which loudly bewails the conditions of its creativity. The concluding piece of *Electric Café* circumscribes them:

Musique technique
Son électrique
Culture physique
A l'âge atomique
La música electrónica
Figura técnica
Arte política
En la era atómica
.
Musique rhythmique
A l'âge atomique.

The immutable rhythm, which the text verbalizes and follows, distinguishes this "political" from Boulez's unpolitical art, which has overcome the constraints of time measurements and secured its distance from politics through its proximity to power.

HABERMAS

Discourse Library

I am attempting to write this without quoting from the literature of cultural critique and cultural theory, to not engage myself with its prominent authors and preformulated concepts. In this literature, the process of the so-called discourses is carried on where competing authorities become the subjects of multiplying commentaries whose submissiveness is concealed by their critical form. A limited pluralism of original perspectives is thus congealed into a canon for reference, with an ensuing semblance of universal critical deviations which mask their fundamental conformity. To its collaged copyright concepts, the names of the authors who coined them are often attached in brackets. In the discourse library of citadel culture, any bibliographically consistent use of the literature on cultural theory is neither technically feasible nor theoretically desirable. Its pluralism will not expose itself to any refutations. Innumerable authors are arbitrarily selecting authorities, conventicles, allies, or adversaries for discussion. The expansion of printing techniques and publishing houses, and the growth of the reading public by young people drawn from the labor market to the expanding institutions of higher learning, have opened the market of discourse to a mass audience. And yet the proliferation of paperback series, collected works, dossiers, congress reports, and journals in book-

stores and libraries overwhelms any sense of the intellectual orientation it purports to offer. Instead, the self-inflating popular library of discourse neutralizes itself into a boundless, kaleidoscopic collage of colorful dust jackets, flashy titles, and recognized names.

A few days before Christmas, 1985, passing through the main railway station of Frankfurt, I spotted from afar behind the glass door of the station bookstore the portrait photograph of the West German philosopher Jürgen Habermas. It had been blown up, graphically processed, and printed on the poster for his paperback book *The New Obscurity*, which had just come out. "I have one purpose of thought: the reconciliation of a modernity at odds with itself," read the large letters below the portrait. Did the new paperback offer instant "reconciliation" along with the diagnosis of "obscurity"? Was an individual thinker at work to solve a crisis of the times? The poster proclaimed the familiar two-pronged thought of critical theory, which purports to analyze social reality according to the principles of its potential improvement. The designer of the poster had short-circuited this claim according to the pattern of an instant alternation between crises and remedies, current in citadel culture.

Theory of Communicative Action

The title of the paperback advertised on the poster read like a contradiction to that of Habermas's philosophical masterpiece, *Theory of Communicative Action*, which appeared in 1981. While the earlier title projects a constructive enactment of rational ideals, the later one denotes a current condition out of reach for those ideals or resistant to them. In the *Theory of Communicative Action*, a two-volume work almost twelve hundred pages long, the author had accomplished the task of working through and critically assessing the mass of pertinent literature with biblio-

graphical responsibility. The conclusiveness of his new theory of society was to prove itself by coming to terms with a philosophical tradition extending from Marx to Horkheimer and Adorno and by making it compatible with a sociological tradition with Weber, Mead, Durkheim, and Parsons as its classical authorities. In the great work's design, four sections where this literature is discussed alternate with four "intermediate observations" where Habermas advances his own thinking. Thus the bibliographical process through which the *Theory of Communicative Action* was elaborated is apparent as a demonstration of the debating rather than explicatory mode of thinking it promotes.

The book deals with a process of social emancipation in which the unfolding clarification of theoretical thought and the communicative regulation of social practice interact. This process is to carry theoretical thought beyond the reflection of subjective consciousness in objective reality, within which the philosophical tradition derived from Kant and Hegel has remained mired and which has only produced unsolvable, either hopeless or defiant, contradictions between subject and object to date. At the same time the process is to untangle social practice from the compulsive cycles of conflicts between conformity and protest, between repression and rebellion, and redirect it toward constructive implementations in social reality on the basis of a collective mutual understanding. However, Habermas had to start with the observation that today's industrial mass society, at the peak of its technological rationalization, does not promote but inhibits communicative thought and action, since it substitutes for their verbal forms of understanding the alienated circulation forms of money and power. Thus he reconstructed from basic research in anthropology and linguistics an unalienated concept of vital communication, which he then retraced in the behavior forms of particular groups in modern society. The resulting

opposition of rationalization and communication, of "system" and "lifeworld," makes for a counterpointed argumentation that mirrors the dynamics by which the innate human rationality of the "lifeworld" seeks to assert itself against the technical rationality of the "system." The theory of this projected process is simultaneously intended as a contribution to its enactment.

According to Habermas, the actual process of total social rationalization has already advanced too far, and has expanded too globally, for the contradiction between "system" and "lifeworlds" to be rescinded by pursuing political utopias in thought or revolutionary force in practice. Rather, the modernization processes already inherent in the "system" and embracing all its "lifeworlds" are to offer the conditions for the "system's" self-correction. Neither rebellion nor refusal are a match for it, only a collective, rational altercation on the level of its own intellectual and institutional complexity. Such an altercation must be institutionalized in political democracy and in an administration of justice with democratic legitimacy. It is in these democratic institutions that Habermas's projected rational communication society finds the political morality of its self-determination.

> We are presupposing the autonomy of actors, the independence of culture, and the transparency of communication.

These are, according to Habermas, the "three fictions," but also the unredeemed demands, suggested to the people by the social process itself. "Modernization processes have been followed, as if by a shadow, by what might be called an instinct formed by reason," which insists on unalienated communication. As long as communication has not been enacted on these terms, the "lifeworlds," in their unresolved altercations with the "system," lead a shadowy existence, as in Hegel's dialectics of master and serf. The

"system" threatens them with a total technical manipulation against which they have to defend themselves if they wish to continue to exist under their own conditions of communication. Habermas uses the metaphor "provincial" in order to circumscribe the political and social marginality of the alternative groups and minorities whom he calls as witnesses for the *Theory of Communicative Action.*

The imbalance between "system" and "lifeworld" in terms of political power prevents Habermas from defining their altercation as a conflict, since any such conflict would be prejudged in favor of the "system." The philosopher, rather than designing the dynamics of actual change, can do no more than define the initial positions from which change might take off. As long as he conceives of his work as a critical analysis, he is just being realistic. However, if the change demanded by critique is to be, at the same time, a principle of the social process itself, his argument is obliged to advance from theory to contemporary history and to prove itself in practice. As long as theory does not become historical toward the past and political toward the future, the "contemporary-historical motif" which the author professes in the introduction to his book remains concealed behind the "differentiation" of his academic discipline, behind the limits of his specialty within the division of labor. The existing democratic institutions of law and politics would have to offer the preconditions for an enactment of the confrontation between "system" and "lifeworlds" in reality. If not, the self-assertion of the "lifeworlds" that agree to conduct themselves according to the rules of communicative action can be ignored at any time as one-sided, unencumbered but ineffectual demonstrations of their subjective protests. This situation perpetuates the asymmetrical confrontation between overwhelming society and powerless subjects, which Habermas encountered as a fixed notion in the philosophical tradition of

critical theory from Hegel to Horkheimer and which he
wanted to overcome in his own theory of communicative
action.

The Fixed Period of Communication Society

The "communications-theory turn," which Habermas has
claimed to bring about in the face of critical theory and its
Marxist tradition, replaces the notion of work with that of
communication as the fundamental category of social prac-
tice. At the time when he conceived the theory, there arose
in the capitalist industrial states, faced as they were with
an irreversible, structural depletion of employment, the
new political ideology of a technologically rationalized
communications society. The underlying economy's in-
creased productivity through automation has tended to dis-
place the livelihood of its members from production to
communication processes and services. Habermas's an-
thropological paradigms and linguistic analyses make the
reader forget that he is dealing with an economic process
limited to the capitalist industrial states, and involving the
transfer of work to ancillary Third World countries. To the
underpaid working women in the computer factories of
South Korea or in the garment sweatshops of Mexico, com-
munication theory does not open any prospects for emanci-
pation. The nonviolent forms of mediation and compromise
guided by communicative reason are designed for citadel
society, whose productivity is dependent on colonialized
work. In the regions of the world where that work is being
done, communicative reason does not contribute to social
progress. There, the "lifeworlds" still confront the "sys-
tem" by way of political conflicts or armed struggles. From
this perspective, the social process of capitalism cannot
appear as a homogeneous functional system to whose im-
manent logic one must adapt in order to counter it effi-

ciently. On the contrary, the continuing conflicts at the periphery of capitalism are projections of the contradictions within it between growth of production, autonomous arms industry, and social appeasement policies.

Historically, the *Theory of Communicative Action* is a summary of argumentative culture as it had been developed during the seventies in the Federal Republic of Germany under relatively favorable economic conditions. When the book appeared in 1981, however, the new economic crisis had reached its peak. One year later the term "turn" (*Wende*), which Habermas had proudly claimed for his theory, acquired an unexpected political ambivalence when it was used to characterize the profound changes being brought about by the new conservative government in the Federal Republic. While Habermas's book rose to prominence on the academic scene, the ideal of a dynamic mediation between technological progress and social emancipation which it defined had already become retrospective. Thus the book no longer stood for a political agenda, but came to express the illusions of citadel society about its self-critical transparency.

Habermas's theory of communication has transferred the argumentative culture of the seventies, by way of its philosophical codification, into the citadel culture of the eighties. Here, its revisionary projections are congealed into conceptual axioms which cannot be refuted by the experience that reality does not allow itself to be changed according to them. Their anchoring in a long tradition of fundamental philosophy and social theory, pursued by academic scholarship, institutionalizes these projections within the "system" for whose dissolution they were conceived. A secondary literature, multiplying over the years, keeps the theory occupied with itself as a topic of exegetical or critical discussions. Thus argumentative culture is installed in citadel culture as a realistic, nonviolent al-

ternative to the utopia of revolution, declaring the status quo to be a setting of change. When Habermas defines the "communications-theory turn" as a reorientation "from goal-directed to communicative action," he assigns to social theory the function of a formalized critique which identifies neither goals nor adversaries.

Historical Antecedents

In its philosophical singlemindedness, the great work of 1981 is the manifesto of a concept about the politics of scholarship dating back to 1957. At that time, Habermas had supported the mass protests and strikes against the nuclear armament of the Bundeswehr, the West German army under NATO command. His idea of a public sphere, which is defined as both politically responsible and politically efficient, as a counterforce to the parliamentary institutions of democracy helped to legitimate those mass movements. And it is from their failure that, in his book *Structural Transformation of the Public Sphere* of 1962, he had drawn the conclusions. The extension of democracy over and beyond its political institutions argued for in this book amounted to an unstated political critique of institutional democracy.

When in 1968 the protest movement against the war in Vietnam and the student revolts erupted, Habermas once again sided with the extraparliamentary opposition to the democratically legitimated state. In his contribution to the book *Bedingungen und Organisation des Widerstands* (Conditions and Organization of Resistance) he advanced the belief

> that the self-reflection of scholarship, which is the
> medium of scholarly progress, is connected to the nation-
> wide discussion of practical questions and political deci-

sions through the form of critique which both have
in common.

Habermas thereby attempted to redefine the limits of legal-
ity for provocative demonstrations. By forcing a debate in
the public sphere, demonstrations would use it to influ-
ence the parliamentary institutions. In his books, articles,
and interviews of subsequent years, Habermas derived
from this self-critical extension of democracy beyond its
constitutional institutions into the public sphere a political
perspective for a social theory which is being pursued at
universities and other institutions of higher learning as an
academic discipline with political claims but without po-
litical mandates.

In such a concept of a politically activated rationality of
the social sciences, the question of political efficacy, that
is, of the political success or failure of the critical theory of
society, cannot be obviated. The forces in West German
society who conducted themselves according to this con-
cept were unable to prevent the nuclear armament of the
Bundeswehr in 1957 and in subsequent years were unable
to oppose the methodical West German rearmament pur-
sued by the governments of every party, and constitutionally
legitimized by their respective majorities in parliament.
Only in the realm of educational policy did Social Demo-
cratic governments in office between 1969 and 1982 launch
certain democratization processes in which Habermas
might have found his ideals confirmed. It is accordingly in
those years that he enlarged, deepened, and synthesized
them into the comprehensive theory of a critical public
sphere as the corrective to parliamentary democracy. How-
ever, when the *Theory of Communicative Action* was finally
complete in the book of 1981, its confirmation in the
economic and social policy of the Federal Republic had
become even more doubtful than before. True, a philo-

sophical work does not have to deal with arms production, with economic cycles, or with the social order. But can it then still address itself to the totality of the social process? Only in passing does Habermas touch upon the material living conditions of the unified, nondescript society whose theory he projects, pondering them as possible motivations for the internal logic of the "system" whose self-propelled functioning they don't affect.

In personally acting out the ideal of a communicative reason open for debate, Habermas leaves nothing to be desired. With tireless commitment, he takes positions in the public sphere on important political issues of the day. The paperback series of his "smaller political writings" is growing longer. And yet, do the social and political institutions allow these steady interventions to take effect in the social process itself, as the *Theory of Communicative Action* postulates? After all, the theory had not just been designed as a debating strategy for political culture, but as the substantial analysis of mass society's universal consensus philosophy, where rational arguments can produce social change. In one of the book's decisive passages, Habermas has cast the "ambivalent potential" of the "public spheres of the media" into a positive mode:

> But tapping this authoritarian potential is always precarious because there is a counterweight of emancipatory potential built into communication structures themselves.

If this ambivalence is turned into the negative, as its conceptualization would suggest, it exactly denotes the discursive mechanism, reversible at will, of citadel culture.

The New Obscurity

In 1971, Habermas presented the first draft of his *Theory of Communicative Action* in a series of guest lectures at

Princeton University. From 1977 to 1981 he wrote the book. Between 1979 and 1982, conservative governments acceded to power in England, in the United States, and in the Federal Republic. In 1985, Habermas's historical perspective had darkened:

> The future is negatively pre-empted; at the threshold to the 21st century outlines of a horror panorama begin to appear that shows general life interests to be endangered worldwide: the spiral of the arms race, the uncontrolled proliferation of nuclear weapons, the structural impoverishment of the developing countries, unemployment and growing social imbalances in the developed countries, problems of environmental impact, large-scale technologies operating at the risk of catastrophe—all of these provide the cues that have penetrated the public consciousness via the mass media. The intellectuals' answers reflect their helplessness no less than the politicians'.

After such a verdict, how could Habermas hold on to the confident theory of his book of 1981 by which he had wished to overcome the historical pessimism of Horkheimer's and Adorno's *Dialectic of Enlightenment?* In the intervening years, the theory had been put to the political test for a third time after 1957 and 1968. In the summer of 1983, an all-embracing coalition of alternative protest movements, which Habermas had invoked in 1981 as examples of the oppositional latitude open to the "lifeworlds," experienced once again its powerlessness, as it embarked on its most important political initiative: the demonstrations against the installation of American medium-range missiles in the Federal Republic. The failure was all the more poignant since the peace movement's civic-minded, rational restraint from any violent action lived up to Habermas's ideal

of political dispute and agreement. It was bound to recall to him the failure of the protest movement against the nuclear armament of the Bundeswehr, a quarter century earlier, for which he had first formulated his theory of a critical public sphere. When, after the second political test case, the student revolt of 1968, the Christian Democratic Union holding office in 1957 was replaced by the Social Democratic Party, Habermas may have perceived his theory as relevant for political progress. But in 1983, once again a Christian Democratic government held office, and once again its nuclear arms policy seemed to provoke a threat of war. Worse still, this arms policy had been initiated by the preceding Social Democratic government itself. Had nothing changed? Was the critical dynamics of society, which Habermas had projected in his principal work, being refuted by a cyclical relapse?

Now the philosopher saw himself pushed into a defensive posture in the perpetuated, inconclusive conflict between "lifeworlds" and "system." The democratic institutions he had expected to provide the preconditions for realizing the critical potential of communicative action, were now, on the contrary, fulfilling a conservative function, decidedly and successfully resisting any opposition coming from the public sphere. Now Habermas no longer merely justified extraparliamentary opposition as a form of argumentative pressure upon institutions; he radicalized it into a reflective civil disobedience which is on principle entitled to question rather than respect legislatures and jurisdictions. In this utopia of a flexible democratic state of law, no institution can reclaim its constitutional legality as established once and for all, but must legitimize itself time and again in perpetual altercations with the public sphere.

> With this idea of a mistrust against itself, which cannot be institutionalized, the state of law stands out above the

ensemble of its regulations as they are positively stated
at any given time.

Such a state of law, which not only permits "symbolic" dis-
obedience but allows itself to be affected by public mis-
trust as a political corrective, would float on a perpetual,
total social debate about the legal system, making the
awareness of its insufficiency into the principle of its func-
tion. In the *Theory of Communicative Action*, Habermas,
following Max Weber, had still rated the "modern" sphere
of law as so fundamental that he even exempted it from
ideology critique. Four years later, in the face of the mili-
tantly legalistic defense of the nuclear missile installation
in the Federal Republic, he made the sphere of law into an
arena for the *salto mortale* of orderly subversion. The term
"political culture," to which Habermas now wished to see
the institutions subject, amounted to a formalized, and dra-
matized, legality where only the argumentative procedures
are secure but the basic social values are up for renego-
tiation. The West German courts prosecuting acts of sym-
bolic protest at American missile bases never honored this
political citadel culture of flexible legitimacy. What Haber-
mas justified as an enactment of communicative reason,
they branded with the legal terms coercion and violence.
Even in the communication society, the philosopher's
abstractions and the judges' metaphors were incompatible.

Now Habermas at last addressed the political subsis-
tence issues of mass unemployment and declining quality
of life, which in 1981 he had still neglected in his attempt
to replace work by communication as the fundamental
principle of formalized social theory. Those issues would
have exacted a more radical reform dynamics from his
theoretical model:

How can society in its foundations be remodeled in such
a way that its priorities are placed in a new balance, not

only from the perspective of the economy as a whole,
but also from the point of view of the individual living
conditions?

The philosopher who asks how a society can "in its founda-
tions be remodeled" so "that its priorities are placed in a
new balance" circumvents with architectural metaphors
any discussion of the alternative between revolution and
reform, which he had prejudged in favor of the latter for
many years. No matter how categorical the question may
sound, it is posed from the narrow perspective of Western
European industrial societies. Its generalized, historically
indeterminate form internalizes it as a fundamental prob-
lem of citadel society, which habitually takes itself to rep-
resent the status of the world at large. Only in this society
everybody communicates with everybody else, but not in a
decision-making process of necessary changes, but in a
cycle of inconclusive debates. Communication theory's
educational privilege remains off limits to the masses of
manual auxiliary workers of Western Europe's potential
leisure society who are toiling in the Third World. For
them, work remains the fundamental category of social ac-
tion, and communication remains the technique whereby
citadel society appropriates their work.

Does Habermas perceive the "new obscurity" as a stand-
still of the social dynamics which he had projected in his
communication theory? No doubt he recognizes the aim-
less ambivalence of the current state of affairs with suffi-
cient clarity.

> After all, the ambivalence has never assumed a more
> tangible existence than in those arms which are being
> perfected in order never to be put into action.

His philosophical question about remodelling society
makes sense only when philosophy can articulate an exist-

ing tendency toward change in society itself. This assumption had informed the deliberateness of the *Theory of Communicative Action*. In the face of a state of absolute ambivalence, the question becomes hypothetical. The ambivalence is perpetuated in the notion of remodelling, which by definition takes the whole for granted and hence avoids the alternative of demolition and rebuilding.

Critical Theory in Retrospect

Habermas has not been amiss in an historical assessment of critical theory's successes and failures, all the more so since critical theory has long become the subject of historical research. Reviewing the period between the two world wars, he observed that, in the thirties, the work of the Frankfurt Institute for Social Research, under the pressure of world-historical events, lost first its revolutionary and then even its reformist objectives. The defeat of the socialist workers' movement in all industrial societies outside the Soviet Union, the triumphs of Fascism and Stalinism, and the restoration of the capitalist economic and social order in the course of the Second World War threw critical theory back upon exasperated denunciations of world history or upon utopian postulates. It was neither developed into a comprehensive theory of society, nor did it redeem its original claims of contributing to social change. This was consistent with the premises of the Frankfurt Institute's originally Marxist program, which required social theory and social critique to motivate and reinforce one another.

In his great work of 1981, Habermas explicitly claims to resume and implement the double project of the early critical theory. However, in his critical assessment of the revisions necessary for this task he does not dwell on the historic reasons for its failure.

Against this, I want to maintain that the program of early critical theory foundered not on this or that contingent circumstance, but from the exhaustion of the paradigm of the philosophy of consciousness.

As long as the philosopher rates the dramatic history of the pursuit of theory in the thirties as no more than "contingent circumstance," he can ignore the historical circumstances of his own work, past or present. Hence his critical survey of the tradition on which to found the *Theory of Communicative Action* is limited to an immanent "paradigm change" from the philosophy of consciousness to the theory of communication. After more than thirty years of continual, peaceful history of the Federal Republic, the democratic state of law where Habermas lives and works, he could no longer empathize with the times of historic upheavals and catastrophes which had so directly affected Horkheimer's, Adorno's, and Marcuse's work. Moreover, twelve years of Social Democratic governments may have strengthened his confidence in the reform potential offered by the political order of the Federal Republic. The plebiscitarian claims intruding upon this state of affairs during the two crises of foreign and defense policy in 1957–58 and 1968 had prompted his fundamentalist critique of constitutional democracy but had not, in the final analysis, been able to discourage his steady harmonization of philosophy, the social order, the constitutional state, and the public sphere. Thus Habermas never joined in the axiomatic, apodictic critiques of "bourgeois" democracy advanced in the texts of earlier critical theory, from the *Dialectic of Enlightenment* to *One-Dimensional Man*.

It is not the consistent, critical examination of philosophical tradition but the anchoring of theory in the constitutional state which enabled Habermas to conceive of the

"change of paradigms" required to arrive at that comprehensive social theory which had eluded Horkheimer and Adorno all their lives. His *Theory of Communicative Action* seemed to fulfill all the conditions of a systematic interconnection of philosophy, social science, and politics. It had been cleared through a detailed discussion of the theories of great predecessors and had been developed to supersede them by its greater adequacy, not only to the present social reality but to the entire social process since its origins. Bibliographically, it was supported by empirical research as well as critical literature. It even advanced a conclusive critique of society's current status in the name of that society's constituent principles, a critique which pinpointed the chances of, or could even serve as a political strategy for, its implementation. It accommodated both Hegel's dialectical interaction of analysis and postulate and modern social science's requirement of empirical verification. More could hardly be asked of a work of academic literature. And the author's untiring interventions in the public sphere transcended the academic confinement of theory, made good on its claims of critical topicality. And yet never did Habermas ask himself the question whether this theory might not project an ideology, the ideology of the democratic constitutional state, whose fundamental values it transposed, beyond its institutions, into the public sphere, and further, into the anthropological foundations of civilization itself.

Aesthetics of Modernity

Can such an achievement be cast in doubt by the gloomy assessment of contemporary history which Habermas himself felt compelled to make in *The New Obscurity* of 1985? As he now attempted to theoretically legitimize civil disobedience against state institutions as an impact of the pub-

lic sphere on the social process, his theory became less suitable as an ideology of the constitutional state, and at the same time less credible as having been derived from the reality of social institutions. The conservative government in office since 1982, whose goals and policies Habermas came to attack with increasing exacerbation, had ascended through the democratic process and could deploy its operations within the legality of the democratic constitutional state. Now Habermas veered toward those abstract contradictions which he had wished to overcome with his critique of the Hegelian tradition of the philosophy of consciousness. Both in *The New Obscurity* and in his book *The Philosophical Discourse of Modernity*, which also appeared in 1985, he postulated the same ideal of a radical resistance inherent in modern art into which his predecessors in critical theory, Adorno and Marcuse, had withdrawn the notion of social opposition. Already in *Theory of Communicative Action*, Habermas had projected "an analysis of cultural modernity, which replaces the now superseded theory of class consciousness" (in the published English translation, the word "class" has been omitted). Now he followed his predecessors on their retreat from political economy into politicized aesthetics, a retreat which in critical theory has been beaten time and again whenever its negations became so absolute as to require hypothetical counterpositions.

With his revalidation of modern art, Habermas professed to be countering what he believed to be a new, restorative tendency in artistic culture corresponding to the conservative turn in contemporary politics since 1980. But modern art needs no such defense. It had triumphed in democratic industrial society at the very latest when the term "classical modernism," which Habermas uses, was coined. This term harmonizes an originally irreconcilable contradiction. In the kind of art which since the beginning

of the twentieth century had been promoted under the designation "modern," any "classical" canonization was rejected as a cultural constraint. Between 1929 and 1939, during the time of the Great Depression, modern art had adapted itself to some extent to a public that was turning politically conservative by retreats to the classical tradition. The term "classical modernism," which may have been first advanced in the seventies, denotes on the contrary the installation of modern art, without aesthetic compromise, in dominant culture. Today it is being used as a trademark in the titles of auction catalogs and on the department labels of museums to justify the multimillion dollar amounts being paid for modern art from the time before 1945.

The notion of "classical modernism" is just as retrospective as the notion of "postmodernism," to which it is the complement rather than the contradiction. The postmodern critique of modern art does not question the latter's nonconformity in the name of conservative values, but only rejects its dogmatically exclusive claims to an epochal validity. Conversely, the canonization of modern art as "classical" does not entail any demands for its imitation or continuation, as the concept of classicism implies. As long as the protests and provocations of "modernism" can be relativized in pluralistic coexistence, nothing stands in the way of their aesthetic transfiguration. In the first twenty years after the Second World War, any social or political radicalism implicit or explicit in early modern art had been concealed behind formalist or existentialist absolutes. Today, on the contrary, that radicalism is highlighted in sumptuous exhibitions and thorough documentations. In view of the negative political balance sheet of artistic opposition in the times of the two world wars and the world-historical dictatorships, it no longer constitutes a threatening precedent for a destabilizing impact of art upon society. Accord-

ingly, citadel culture also promotes contemporary art the more assiduously the more oppositional its posture.

The term "obstinacy," which Habermas adapted from Max Weber for his repeated characterizations of modern art, perpetuates Adorno's idiosyncratic denial of communication and Marcuse's extroverted grand refusal as formulas for a hypothetical resistance of art against society. However, in the theory of communication, artistic nonconformity cannot as easily be rated oppositional as in the traditional philosophy of conscience with its perpetual contradictions between subject and object. Habermas takes into account that the self-realizations of artistic imagination and creativity can only function within the autonomous "lifeworld" of an artistic culture that is socially secured. Indeed, in contrast to the past, today art is no longer compelled to oppose social conditions in order to protect its interest and its autonomy. In Habermas's terminology, its "lifeworld" has "differentiated" itself to become the art world of citadel culture, and is thus dispensed from any obligation to justify its presentations argumentatively vis-à-vis the public sphere. It merely acts in the public sphere through proclamations to which no contradictions of substance can be raised. When Habermas, early on in *Theory of Communicative Action*, defines aesthetic criticism, he realizes that in communication society the criteria according to which works of art count for "authentic" are founded on the presentation of just those works by way of circular reasoning. He explains "why we regard aesthetic arguments as less conclusive than the arguments we employ in practical or, even more so, in theoretical discourse." Thus, the theory of communication defines aesthetic culture by its difference from argumentative culture. Indeed, the internal debates staged in today's art world in order to secure for its objects, gestures, and actions a place in the

self-constructed history of contemporary art do not have to face counterarguments, as cognitive and normative reason do. They are ratified in grand exhibitions and well-endowed state museums by plenipotentiaries of cultural politics who lack democratic mandates and who don't feel accountable to the public at large, only to the art public. Invoking precedents of official or public hostility to modern art from the distant past, they act as sovereign cultural elites. Their presentations are so smoothly adapted to the art market, so calculatedly attuned to goals of social policy, that contemporary art can function without friction in the network of communication society.

Disaster World and Library

In between the extremes of smallest "lifeworlds" and global "systems," the *Theory of Communicative Action* unfolds analytical, anthropological, and alternative patterns of a "rational internal structure." The patterns remain isolated as abstract paradigms and do not connect to form historical continuities that would explain how their opposition to the "system" might work in reality. Conversely, the interest-conditioned, subjective "decentering" of communicative "lifeworlds" creates no political consciousness about the global functional contexts constantly affecting them. Every hostage-taking or bomb explosion, every crash of oil prices or dollar notations interrupts the rational internal structures of citadel societies or turns their self-contained functioning into a fiction. Despite all the reservations which Habermas has raised against his own model's utopian incongruity to real history, he reenacts that "neglect of economics, warfare, and the struggle for political power . . . in favor of the logic of societal development" for which he reproaches Mead, the ethnologist. It is this neglect which enables him to found his "eurocen-

trically limited view" of things, to which he once confessed in an interview, nonetheless on anthropological, ethnographic, and linguistic research.

"I have to have paper before me, empty paper, paper written on, books all around me," Habermas said in the same interview. He has utilized the scholarly working procedures of philosophy, where discussions of the literature are habitually carried over into the formation of theories, for the purpose of reconstructing the process of society. Yet even the conscientious study of the classics from the history of theory cannot overcome the bibliographical quandary today facing every effort at a synthesis with claims to the objectivity of traditional scholarship, the quandary of a steadily growing, unsurveyable mass of scientifically processed experience, which has become on principle incongruous to subjective thinking. The thematic totality and the methodical systematics of Habermas's enterprise continue the claims which, long ago, Hegel raised for his philosophy of the subject, even though his bibliographical conscience and his ostentatious openness to corrections have replaced the untenable posture of single-minded subjective explication by the "fallibility" of the communication model. The author's subjectivity merely multiplies itself in the philosophical culture of experts which he has himself described.

In the library, surrounded by books and papers, a scholar's philosophical lifework unfolds over the decades, the continuous creation of great and lucid books. Concurrently, in the public sphere the principled activism of a political intellectual unfolds, a thinker who more than his predecessors has committed himself to the confirmation or refutation of his theory through communicative practice. Now it is becoming apparent that the progressive correction and development of the theory, the autobiographical forward-working of consistent thinking, has been subject

all along to a history which neither develops forward nor corrects itself but seems to stand still or oscillate in new obscurities. Current ideologies of ahistoricism founded on Nietzsche and Heidegger, furnished by newly prominent philosophers to the conservative social order of the eighties, are easy targets for refutation at the hands of this superior thinker. Yet Hegel's demand for an illusionless convergence of thought and history has still not been achieved. One begins to suspect that with Habermas the comprehensive reflection of philosophy in terms of social theory has once again only been undertaken for the sake of its defense. The revolutionary drive of Marx's theory toward its self-effacement by social practice was abandoned in light of historical experience. Marx's demand for liberation from the constraints of institutions was withdrawn into a confidence in the inherently rational self-corrective makeup of those institutions. After such retrenchments, philosophy could once again be reasserted in its equivocal double role as a theoretical equivalent and as a political corrective of the social process.

In the most recent test case of communicative action, history has bypassed theory. In 1983, American Pershing II and cruise missiles were stationed in the Federal Republic in defiance of the West German peace movement; starting in 1988, they were being dismantled again in the course of a process of global politics beyond the reach of the "lifeworlds" gathered in the peace movement. According to citadel society's typical circular reasoning, the dismantling of the missiles was accomplished thanks to their installation. The peace movement's political goals were not at issue in the underlying decisions. Communicative action had neither lost nor won. Indeed, if the modernization processes of the "system" produce "the glittering brightness of a completely transparent crystal palace," as Habermas, adapting a metaphor of Max Weber's, suggests, then critical

thinking, which "follows" those processes "like a shadow" on the terms of their own rationality, remains a schematic reflex, emerging and disappearing like the headlines of the public sphere. In the crystal palace of citadel society, critical culture flashes like a built-in cabinet of distorting mirrors which seems to change the proportions of conformity in passing. Theory conceptualizes such illusions of change.

LUCAS
MORRIS

At the Peace Congress

In April 1986, when the political debates about the Strategic Defense Initiative of the United States government were at their height, I flew from Chicago to Tübingen, Federal Republic, in order to deliver a lecture at a peace congress of West German humanities scholars. My topic was "American Prewar Art Today." I had derived the concept of prewar art from my studies on German art during the two world wars. In the years 1911–14, and even more so in the years 1936–39, modern artists had devised images of conflicts and catastrophes because an imminent war was being urgently debated in the public sphere. Could one also speak of a prewar art in 1986, when war was a dominating subject of political discussions, and when all media of art were dealing with war more urgently than ever? After all, the notion of prewar art was conceived in retrospect from the experience of world wars which had actually taken place. To use the term today would imply its anticipated confirmation by a third world war in the near future, that is, convey resignation before the inevitable. As a theme for mere historical contemplation it might work to paralyze the resistance against current war policies. Would such a lecture be in keeping with the purpose of the peace congress?

I tried to come to terms with this question by predicating my lecture on a fundamental difference between

retrospective and contemporary historical analysis. If we
were now able, by means of art-historical scholarship, to
identify prewar art in the years preceding the First and
Second World Wars, we might alert ourselves to tracing
such an art today without having to wait for its confirmation
by subsequent history. Becoming aware of our own histori-
cal situation as it is addressed by today's prewar art, we
might contribute to the strengthening of political resis-
tance against war as a clear and present danger. The his-
torical experience of art might advance from retrospective
contemplation to preemptive political action. As part of a
movement to prevent war, the lecture would have refuted
its own thesis, and this would have constituted its eventual
success.

Such unresolvable speculations made my lecture into a
typical example of the hypothetical reasoning of citadel
culture. Still, it fit into an event where the contributions
of cultural historians were based on the principle "Never
again War!"—the plain and simple principle of European
antiwar movements in the twentieth century with their
confidence in historical remembrance as a moral force. Dis-
comfort with self-sufficient culture was noticeable through-
out the congress, but it remained an open question how the
assembled scholars of cultural studies would become po-
litically active on this occasion.

Prewar Consciousness

In citadel society, militarily secured as it is, war conscious-
ness is all-pervasive. Military information of all kinds and
the widest scope deluge the daily media experience of
populations living in deep peace and great comfort. But
unlike the openly militaristic culture of earlier prewar
times, war no longer represents an ideological value. The
global armament is ostensibly designed for an emergency

which must be avoided under any circumstances, to the point of raising doubts about the technical feasibility of war. Citadel culture displays this unresolvable contradiction by means of pictorial fantasies which at one and the same time aesthetically transfigure and morally deplore the extreme case of war. Still, the interdependence of arms production and capitalist economy has not changed from earlier times. Thus the testing and application of arms, whose production is indispensable for the economic functioning of industrial societies, is being transposed to wars in faraway countries which are only visible by means of media images, suggestive, to be sure, but at a distance.

The pervasive war consciousness of the public sphere continually turns in on itself so as not to have to follow its internal logic to the point of unbearable fears. Armament and disarmament as professed simultaneous political goals of all governments concerned prompt a kind of suspended political thinking which defers the dissolution of its contradictoriness into a permanently postponed task. It has enabled the democratically elected, conservative governments of the United States and the Federal Republic to invoke mandates of popular majorities for their expansive armaments policies, with all the more self-assurance since they had openly announced those policies in their election platforms of 1980 and 1982, respectively. Yet those mandates were not based on informed deliberations by the voters about the military objectives and consequences of those programs, but expressions of their confidence in the success of a politically consolidated, simultaneous peace and war economy. For arms production was successfully presented in the public sphere as a necessary expansion of investment and technology policies benefitting the peace economy as well. In view of the high unemployment rates persistent throughout the eighties, this argument was par-

ticularly effective for the propaganda of conservative employment policy since it compensated to some extent for the employment cutbacks achieved through rationalization. In the capitalist economy, the production of arms already makes sense before their defensive function is at issue. The defensive function itself is ideologically defused by representing it as political rather than military, on the assumption that the arms continuously being made and replaced will never be put to use. Thus, war and peace thinking interpenetrate in the suspended mental balance of citadel culture. The foreseeable futility of the ongoing discussions about armament and disarmament during the eighties generated a permanent vacillation between expectancy and resignation, which was accompanied and fed by an abundance of extreme projections of the actual event of war in all pictorial media of citadel culture.

Those projections almost always cross the threshold from conventional to nuclear war, which is so categorically stated in the publicly proclaimed strategy of deterrence, although it is unlikely that such a threshold has been unequivocally defined or can ever be maintained. Rather, the projected strategies of the Third World War, for all that can be inferred about them, seem to be predicated on a continuum of arms technology where conventional blends into nuclear warfare and is tactically connected with it from the very beginning. Only the transitions from one to the other are said to be subject to political decisions entrusted to the judgment of elected politicians. Nuclear weapons are not just confined to bombs or missiles, but distributed by the thousands in small doses and with short ranges across the potential battlefield which coincides with the supposedly protected territory. Nevertheless, citadel culture dwells on the abstract notion of a qualitative difference between conventional and nuclear war, an absolute opposi-

tion, an unimaginable emergency, transfigured, for a long time already, into the negative myth of the "atom bomb."

Star Wars

For a long time the title of the film trilogy *Star Wars* (1977–83) has been maintained as a popular nickname for the Strategic Defense Initiative. At first the U.S. government resisted having the program called by that name, while the films' producer, George Lucas, sued against the application in a court of law on grounds of copyright infringement. For the government's public relations effort, it would have been detrimental to associate a movie spectacle of whole spaceship fleets battling one another and entire planets exploding in fireballs with a technological strategy supposedly capable of preventing wars in outer space once and for all. The film producer, on the other hand, wished to keep his distance from the government's policy, although the mass success of his *Star Wars* series coincided in time with that government's first election victories. Despite the resistance on both sides, it is probably the first time in the history of culture that a work of the visual arts has yielded not only the catchword but the terms of popular visual imagination for the economic and political goals of a world power.

The film trilogy makes interplanetary warfare of the highest technical complexity comprehensible by means of the simplest patterns of action. It depicts the rebellion of a federation of planets where life is based on freedom against an overwhelming "evil empire" of the galaxies. A handful of youthful heroes and judicious sages prove their ethics and are eventually aided by the friendly creatures of nature in vanquishing the superior technology of dictatorship. The story extends through three instalments from a

seemingly hopeless oppression to a feast of self-liberation. Its underlying schemes are commonplace in comics and science fiction, but the extraordinary success and the massive political impact of the *Star Wars* film trilogy have reached far beyond the public of that literature.

The fundamental fiction of the three films consists in depicting conventional warfare in outer space on the basis of an arms technology which is in fact being produced and perfected for nuclear warfare. The immense increase of military striking power shown here derives from fantastic exaggerations of a technology familiar from the daily life experience of the general public. Jet aircraft from the illustrated popular handbooks and journals of the arms industry are stylized into the shapes of the T and X fighters flying at light instead of merely supersonic speed despite their aerodynamically absurd but visually expressive form. Their dogfights in outer space do not differ in principle from those of the propeller-driven, canvas-covered airplanes over the trenches of France in the First World War. The laser beams they fire upon one another instead of machine-gun bursts are familiar from everyday electronic equipment. They constitute the universal ordnance of the *Star War* films, suitable for pistols in man-to-man combat just as well as for giant cannon in attacks of one planet against another. Only nuclear arms are nowhere to be found. The two "death stars," to be sure, blow up in nuclear explosions, but these are caused by direct laser hits into their nuclear power centers. The public is thus led to associate the strategy of battles in outer space with the publicity for electronic hardware of boundless efficiency, just as the Strategic Defense Initiative is supposedly based on laser beams hitting intercontinental nuclear missiles with computerized precision.

The two successive "death stars" of the evil empire are

giant metal spheres, the ultimate products of a comprehensive fortification and armament. When the first one comes hovering through the night of outer space, innumerable points of light, glimmering on its curved surface, recall the metropolitan areas emerging below a plane at night landings in Los Angeles or New York, suggesting a globe-shaped city. In the light of day, however, it appears that the surface of the globe is built over with throughways, bunkers, and bastions. This citadel, bristling with weapons, holds the star system in check. After it has been destroyed, the empire builds a replacement, but at the moment of the decisive showdown with the rebel forces, the "new death star" appears not yet ready for action. Seen from afar, the contours of the sphere are still jagged, not yet rounded off, and on closer view the surface is torn by building excavations and hollow scaffolding. But nobody is working here. Indeed, the *Star Wars* films show a comprehensive environment of military technology as a given, leaving viewers wondering about how all of it was produced. We see its utilization and destruction, we see technicians, soldiers, pilots, generals, battle stations, and command centers, but no workers, no production machines, no factories.

The publicity and commentary literature of the *Star Wars* films has documented how this semblance of space-dominating technology was actually produced. It shows the small-scale models of airplanes and spaceships, made from plastic and cardboard, which were filmed at close range, and explains the computerized image-processing by which the footage was then treated. The film team worked with the illusions of the model construction industry, which has enabled the public to make its own miniature versions of the latest war production, from intercontinental missiles to submarines, gluing together thousands of minute, pre-pressed, numbered pieces of plastic during long hours of

precision handiwork. Here the divided and automated labor at the assembly lines and in the montage halls of the arms industry is reunited in the two hands of the individual worker at home, and transfigured into an artistic leisure activity. That the model industry should offer models of weapons more than of anything else shows how much in the eyes of the public war production conditions the aesthetic attraction of advanced technology. The artistic homework for which this industry provides the handbooks and blueprints reproduces jet fighters and space stations as showpieces of miniature sculpture in full color, and it is these which go into action in the *Star Wars* films. The action on the screen is in turn reproduced in the colorful glowing, noisy video boxes of the electronic game parlors where the public rehearses electronic war games. Here anybody can start airplanes and rockets on their whizzing flights, move through the split-second switches of battlegrounds, release the blinding, thunderous explosions of missile fire, and attempt to guide the automatic course of war by means of alert psychophysical responses. Sooner or later everybody fails these contests with the machine, but is free to insert more coins and start anew. This electronic war aesthetics of observation and reaction is equally far removed from work and struggle. Mimicking the riskless simulated combat training of actual fighter pilots, it furnishes to the public the illusion of control over warfare from a distance, transmitted and secured by means of images.

Natural Force and Rebellion

The evil "empire" of the *Star Wars* films may be technically overwhelming, but its officers and technicians are only capable of carrying out orders and serving the war machines. As a result, they are consistently depicted as the losers. The rebels, on the other hand, are imbued with

an elementary, positive sense of life, called "the force," which animates their exertions over and beyond any technical limits. Their mythical grounding in nature is the cause of both their freedom and their superiority. This is what the fairy-tale simplification of the action according to the old schemes of Arthurian sagas and tales of the Wild West conveys. The effect of the films rests on such short-circuits between archaic and utopian notions.

The political theme of these films is a revolt of democracy against dictatorship. The "empire" has suppressed the last constitutional representation of the star system, the "senate." Now it rules by the sheer force of the "death star," which threatens insubordinate planets with annihilation. The rebels have set up a base on a moon which circles such a planet. The "death star" is flying toward this planet in order to enter the orbit of the moon, to overtake and destroy it. However, at the time of its construction, its energy and guidance center had been left vulnerable. A single pilot in a small fighter aircraft will be able to dodge its electronic defenses, penetrate to the center, and fire a missile through a six-foot-wide safety valve right into the nuclear reactor. The ensuing chain reaction will make the entire "death star" explode. No computer-guided targeting equipment has enough precision for such a direct hit, only the human ingenuity of the pilot with the confidence in the "force" within himself will pull it off.

Such a struggle in the universe is the opposite of the U.S. space strategy projected for reality. This strategy is to provide an all-but-automatic, technical defense against missile attacks which can be calculated to a fault, excluding both human ingenuity and human failure. The satellites and space stations that are to orbit the earth in outer space are supposedly designed to aim their laser beams at entire swarms of incoming missiles with mathematical targeting precision. In the *Star Wars* trilogy, by contrast, the

struggles in outer space appear both aggressive and fallible. The "death star" uses laser beams to cause a planetary explosion that dwarfs any imaginable nuclear explosion. No wonder the U.S. government wished to keep the public image of its strategy distinct from that perspective.

It has remained unclear what political goals the government pursued with its strategic planning at the time when it launched and promoted the Strategic Defense Initiative. During the years 1983 to 1985, at any rate, some of its officials were openly pondering the possibility that a Third World War might be offensively conducted, survived, and won with nuclear strikes. The perfect technology of the "death stars" in the *Star Wars* films would match such a strategy, if it really existed, better than the daring of those mythical heroes of freedom and defenders of democracy who wage old-fashioned aerial duels in their futuristic jets. The uncertainty of such associations derives from the ambivalence of the ideology of attack and defense advanced and debated in citadel culture. The mass public can appreciate the moral reprehensibility and eventual technical inferiority of a seemingly perfect battle star in outer space without being deflected from its aesthetic appreciation of a projected war in the universe. The fiction of a "force" of nature, which makes the unrelenting, irresistible freedom struggle of the individual so successful, provides the necessary adjustments. The image of the ideal and the image of the enemy blend into one another. And the changing mixture of breakneck war technology and timeless mythical clichés allows for no time to separate aesthetic enthusiasm from political judgment.

Robert Morris

During the years 1968–80, Robert Morris had been a leading participant in the self-reflection staged and played

out in the contemporary art scene. In his work he had abandoned traditional media and turned to minimal and concept art. In 1981, however, he returned to the traditional format of painted and framed pictures on the wall. Since then he has used this format to pursue total wars of annihilation as his main subject. However, even in his seeming restoration of panel painting, Morris has upheld the radical reflection on artistic practice attained in his previous work, representing it in the pictures themselves. This striking fusion of traditionalism and conceptualization has prompted a discussion in which the prewar consciousness of the early eighties coincided with the reflective deliberations of the contemporary art scene.

The "radical epistemological break," as one of Morris's critics has called it, consists in laying open the conditions and trajectory of both the artist's creativity and his interaction with the public in a continuous process which equates art with its exhibition and which finally takes its place. In the sequence of his installations and performances since the late sixties, Morris has presented such public self-reflections in the grand style. For the exhibition "Art and Technology" at Los Angeles in 1969, where artists collaborated with large corporations on specific projects, he designed a landscape of uninhabited wilderness with giant cooling and heating installations buried below the ground in order to instantaneously change the weather. The installations were the same as those used for the climatic stabilization of subterranean intercontinental missile sites. In the artificial landscape, a cold wind would blow out of motionless trees, stones on the cool ground would radiate heat all of a sudden, and a helicopter would circle above in order to film the weather changes in infrared and color. For the Observatory Project of the international sculpture exhibition Sonsbeek 70 in the Netherlands, Morris used bulldozers and cranes to shape a plain field into a circular

platform for the observation of the sunrises at the four turning points of the earth orbit, by analogy to the Stone Age monument of Stonehenge. For his *Cenotaph* series of 1979 and 1980, he contrived elaborate archaeological and topographical descriptions of tombs where victims of hurricanes, mine disasters, drownings, and air crashes would be buried. He transferred these texts by serigraphy onto eight onyx slabs which were exhibited at the Sonnabend Gallery in New York City, suspended from four huge black crosses, each one surmounted by the plastic cast of a human skull. In the *Jornada del Muerto* series of 1981, finally, Morris constructed a horror chamber of nuclear war. Large picture panels with documentary photographs, fitted into patterns of North American Indian decorative art, hung on the walls. Four human skeletons painted black, straddling huge mockup missiles, evoked the four apocalyptic horsemen. The next step led back to painting.

The restoration of panel painting followed from reflections on the relationship of art and war. By means of art-historical and literary quotations, Morris established a historical continuum where the struggles and catastrophes of earlier times point to the war planning and war threats of today. The back sides of the *Jornada del Muerto* panels had shown enlarged reproductions of Leonardo da Vinci's drawings of the Flood, which the public could view through mirrors on the walls simultaneously with the contemporary imagery on the front. In the *Psychomachia* panels, blurred silhouettes of fighting men can be discerned in the clouds of fire and smoke, recalling the epic poem of the early Christian writer Prudentius, where the individual's moral conflicts are allegorized as life-and-death struggles between virtues and vices. Such learned, retrospective quotations relate the world war theme to past artistic documents of religious and ethical ideas, but their confrontation with the present threat makes them appear incongruous. As a

backdrop for the absolute myth of nuclear explosions and world conflagrations, the history of culture appears antiquated. Morris identifies his own pictures as the last testimonies, for the time being, of a millenarian history of human ingenuity bent on devising destructive processes of cosmic dimensions for both terror and admiration. Contemporary critics of Morris's art usually extol this kind of historical repetition at the expense of the political urgency of his theme. Are his images of catastrophes just variants of a codified apocalyptic imagination whose incessant predictions or warnings of an imminent end of the world have been familiar for over two thousand years? It seems that in his most recent works, Morris has put this question to himself.

Firestorm

The *Firestorm* series of paintings, made in 1983–84, consists of pastel-and-watercolor panels in blazing colors depicting the bright glow of explosions and conflagrations, framed by charcoal-colored reliefs with the casts of human body parts and shattered objects. Here Morris has refrained from evoking any memories of the apocalyptic tradition. One of the panels is positioned on a kind of scaffold, detached from the wall, and on its reverse a small child's drawing can be seen, showing the same landscape which the large picture on the front side shows being consumed by flames. Is this a work of Morris's own childhood, an autobiographical rather than a cultural reference? True, even the artistic credibility of children's drawings depends on a convention of modern art, but the personalization still authenticates the artist's statement.

In several of the *Firestorm* pictures, metal bands with lengthy stamped inscriptions are nailed onto the inner edges of the frames. They can only be deciphered if one

steps so close to the picture that one can no longer see the painted surface. Two of the inscriptions recall the bombings of Dresden and Hiroshima:

> In Dresden, it was said afterwards that temperatures
> in the Altstadt reached 3000 degrees. They spoke of
> 250,000 dead. Wild animals from the destroyed zoo were
> seen walking among those leaving the ruined city.

Thus the half-abstract, half-allegorical fireworks of the colorful panels are identified as tokens of a historical memory which they do not show. In 1937 Picasso declared a version of his half-autobiographical, half-mythological repertory of bullfights and women to be a picture of the bombing of the Basque town Guernica by the German Legion Condor on 26 April 1937, by simply attaching labels with the names "Picasso" and "Guernica" below the mural. Since then, modern artists have attempted to take positions vis-à-vis the catastrophes of contemporary history without compromising the self-referential autonomy of the modern tradition. Morris's stamped inscriptions speak to the contradiction between helpless subjectivity and overpowering reality which those attempts lay bare.

Only with such self-limiting reflections in mind did Morris venture to make a new statement about the theme of the continuous war history which might end in a Third World War. The stamped inscriptions on the frames anticipate the political critique of the aesthetically transfigured shock effects apparent in the painted pictures.

> None will be ready when it touches down. Yet we have
> seen it gathering all these years. You said there was
> nothing that could be done.

The pessimistic link between futile memory and resigned expectation provides the license for the aesthetic experience. By including himself in his diagnosis of helpless

contemporary-historical perception, the artist turns the extroverted self-reference of contemporary art into a political confession.

In the framing reliefs of the *Firestorm* series, Morris has formed sculpture from the negative of reality. He has shaped a plaster surface into a foundry mould with continuous imprints of skulls and faces, dolls and their severed limbs, phallus and vagina replicas from the sex shop, cogwheels, and tools. The cast with the synthetic material Hydrocal recovers the positive relief of all these objects. It recalls the hyper-realist Baroque *Memento Mori* iconography of tombs and reliquaries. Here, the practices of American Pop Art and object montage, which have abandoned the concept of sculpture as the work of human hands, are recovered in a traditional format. Making the relief suggest the process of modeling the viscous plaster mass, Morris has arranged sequential rows or chaotic piles of objects as if arrested in motion, congealed, petrified. These dynamic patterns continue the colorful flames and explosions of the pictures contained within the frames. Their charcoal grey suggests carbonization from the heat.

Everywhere in these reliefs, imprints of the artist's hands appear intermixed with the arranged objects, testimonies of the working process as well as expressive gestures. Clenched into fists, these hands appear to stem the viscous flow of the plaster mould; with bent fingers, they drag streaks of liquid plaster away; clutching ax-shaped trowels, they seem to split the setting surface. Many of these fists are raised in gestures of apparent rebellion, all the while manipulating dumps of discarded, damaged, or broken objects and mass graves of skulls and body parts into structured arrangements. Performance art becomes art production or vice versa. One of the stamped inscriptions reads:

Concussion waves (which leave no marks on the body), incineration, flying glass, and melting roofs that created a rain of molten lead and copper on those below.

The composition of masses of debris in precipitation patterns of destruction and dismemberment, of burnout and nuclear disintegration, comes across as a gesture of powerlessness, a forensic securing of evidence after a blast, a wallowing in rubble. The artist's work of form creation is simultaneously presented as subject to the shock waves of destruction. Rows of hands appear to keep the viscous surface flowing, others, tied with ropes, are gripping it as if to hold it in place for setting, in inconclusive alternation.

Nearly all the frames show rows of hands masturbating in lockstep, or perhaps close sequences of renewed attempts at masturbation without success. Twenty years ago, they would have been viewed as provocatively obscene. The sexual freedom of imagery attained today makes them appear all the more commonplace the more obtrusive their repetition. With this motif, Morris exposes the sexual exhibitionism of contemporary art as acceptable behavior in a culture of meaningless extremes. In 1974, he had himself photographed, for an exhibition poster, in the nude, wearing dark sunglasses under a black, polished steel helmet of the German Wehrmacht and displaying in his muscular arms the sparkling heavy silver chains with which his neck and wrists were shackled. The masturbating hands on the frame reliefs of the *Firestorm* series link the self-critique of such earlier confessional displays of sexuality to the politically hopeless visual evocation of the all-destructive war.

When Morris at the beginning of the eighties moved from the art of performance and installation to that of panel painting, he did not abandon the total reflection of contemporary art upon the terms of its production and display, but con-

tinued it within the traditional medium he had recovered for himself. Here it is objectified in deceivingly conventional forms. Art critics who have written about the *Firestorm* series in exhibition catalogs and art journals have not taken his cue. Their allegorical or moral explications of his subject matter are straightforward, as if the artist had found his way back to making unequivocally readable pictures. These critics were just as oblivious to the history of art during the last twenty years as they were to the most recent history of war which Morris wished to visualize in his cycle. As they aestheticized his images of nuclear explosions into lethal light visions, they promoted a sentiment of tragic exaltation. They banished the public consciousness of imminent catastrophes, which is as vague as it is universal, into an unhistorical perspective on a future beyond politics, just as their speculations about physical or cosmological absolutes are written with disregard to the historical past. Thus, contemporary art criticism invests the notion of the visionary artist genius of the avant-garde with the traditional function of apocalyptic rhetoric, that of representing the historic future as both predetermined and incalculable. To think that way in reality would mean foregoing one's own survival, engaging in aesthetic meditations of one's imminent death. In his *Firestorm* series Morris has presented just this alternative, but alternatives are not decided in citadel culture.

Mass Art and Elite Art

It is not the war theme as such, but the war theme as an opportunity for the advancement of artistic technique, which makes the works of Lucas and Morris into prewar art. Both artists have linked their pursuit of technical and aesthetic revision and innovation in the media of film and

painting to reflections upon the absolute incidence of war. Postmodern critics habitually compare the modern avant-garde's fixation on progress to the morally indifferent, potentially threatening automatism of progress in capitalist technology. Indeed, the intransigence of modern art, which in earlier times tended toward radical rebellion or utopian designs, today approaches the absolute destructiveness which capitalist technology has reached. In this respect *Star Wars* and *Firestorm* are similar. In the public's perception, aesthetic fascination with aircraft zooming through outer space and blazing nuclear explosions alternates with shocked revulsion at the terror-stricken faces of the pilots at the moment of their crash and the carbonized imprints of skulls and bones.

Only a public culture that reduces politics to aesthetic associations can allow the victorious optimism of the film trilogy and the gloomy pessimism of the picture series to escalate into such contrary extremes without expressing political conflicts in society. The implied confidence in the superiority of a war technology in outer space, which is misrepresented as nonnuclear, remains just as illusory as the apocalyptic fear of atom bombs as an absolute extreme of nuclear warfare for which no strategy can be imagined. In citadel culture, aesthetically oversensitized and politically numbed as it is, Lucas and Morris play complementary roles. In the American public, a social group of academics and intellectuals, who are politically informed, who on the whole reject government policy in their cultural work, but who are unable to mount any politically effective opposition, face a majority whose political education is kept to a minimum, but whose decisive assent to a policy of peace-securing war production is confirmed by election results and opinion polls. The masses in the movie theaters who enjoy the triumphs of spacecraft and laser tech-

nology over any enemy through images superseding any previous film experience in intensity and speed, are being attuned to the military triumphs of American technology and productivity. Meanwhile, the public of the art galleries stare at the world-historical speculations on destruction where one of the most consistent thinkers among contemporary artists shows the escapades of modernism to be without political issue. His confessional art of self-neutralization addresses those educated elites who remain locked into the short, abrupt emotional cycles of hope and disappointment, utopia and nihilism, which animate the modern tradition. The popularization of that art by means of exhibitions, books, and academic teaching compensates for the confinement of its methodical high-priced marketing and steadily expands the cultural reservation where these elites can both enjoy and bewail the privilege of their enlightened powerlessness.

It is well known that American defense industry corporations, in their negotiations with the Department of Defense, routinely upgrade their cost calculations and thus generally achieve higher trade margins and profit rates than the American consumer industry, which produces for the free market and increasingly succumbs to Asian and Western European competition. No wonder, then, that the masses, whose employment is to a large extent dependent on this war economy, have come to regard it as particularly productive and promising. The technological vision of the future projected in the *Star Wars* films provides them with the ideology of their job security. On the other side, the apocalyptically preformulated doomsday consciousness of the cultural elites expresses misgivings about their integration into the academic and cultural institutions supported by the war economy. And no altercation between the two segments of society is taking place.

Final Resolution

These were the considerations about American prewar art of the present time which I delivered to the peace congress at Tübingen, although without the conclusions about the suspended balance of contradictory extremes which I am now attempting to circumscribe with the metaphor of citadel culture. I summed them up in the style of the critical theory of the seventies:

> We are dealing here with a twofold division of political consciousness: (1) between the certainty of an integrated economy and technology where war and peace production are connected and the dangerous military and political consequences of the strategy underlying that economy; and (2) between an assumed political and military separation of conventional and nuclear warfare and the actual total nuclear definition of the planned conflict from the very beginning and for its entire geographical range. Political divisions of consciousness are sustained by ideology, and ideology is the message of a socially accepted culture, including art.

And I concluded:

> Such a demonstration contains in and of itself no politically progressive elements of any kind. On the contrary, it may be an enterprise of resignation to expose a unified late capitalist culture comprising both popular art and high art in spite of their mutual contradictions, a culture where the critical impulses of modern art, to the extent they still exist, are being neutralized in the process of their public acceptance. In speaking about this unified culture, no matter how critically, I am becoming one of its collaborators or promoters. What is there to do? At

this moment, it cannot be the task of an individual to draw conclusions from the traditional position of enlightenment which I am claiming to represent along with many others, past and present. The past failures of that position, however, must themselves become the subject of analysis. Then perhaps another repetition can be avoided. Today, a prewar art may be upon us for the third time in this century, but its simultaneous identification, its critical analysis as part of historical actuality, was lacking in the two earlier world wars. Conceivably our time of total scientification also facilitates an instant, potentially simultaneous history. Contemporary art would then no longer be merely the subject of art criticism, as it has been before, but of an instant, radical art history, radical in both the historical and the political understanding of the term. And art history, according to the scholarly standards it has presently reached, is not an autonomous discipline anymore, but blends with political history. A political activation of this concept of scholarship imposes itself, but it cannot be projected by a single individual, it can only be worked out by means of a collective process, and for this we have gathered here.

In April 1986, such a collective process could only be a demonstration. Three years after the failure of the mass movement against the installation of American medium-range missiles in the Federal Republic, the attempt was made to proceed from a documentation and discussion of twentieth-century war culture toward an expression of political will in the present. In the long hours of the night before the conclusion of the congress, a committee deliberated about the final resolution. The West German congress participants, most of them state employees, were imbued with such a strongly constitutional sense of democracy that a petition to the federal government suggested it-

self as the form the resolution should take. The government was urged to desist from its rearmament policy in general and from its unconditional support of the American Strategic Defense Initiative in particular. It was thus asked to recant a policy with majority support in parliament, even though three years earlier it had repudiated demonstrations by hundreds of thousands and declarations by millions, invoking the legitimacy of the constitutional state.

One of the successive draft versions of the final resolution included an appeal to those "with political and military responsibility," as if the constitution of the Federal Republic allowed for a responsibility of the military to the citizens equal to that of elected politicians. When I suggested the deletion of the two words "and military," the error of constitutional law was quickly corrected, but the conviction lingered on that the military organizations of the capitalist industrial states, despite their subordination to political institutions, make decisions exempt from political responsibility. When the plenum met on the last day of the congress, I found myself voting with a substantial minority against the legitimist petition. On the next morning, by which time most participants had left, the steering committee received from a citizens' monitoring post outside the U.S. missile base at Mutlangen the news that the Pershing IIs had been made operational during the day of the American bombing of Libya. The intercontinental military machine, functioning with lightning speed, had overtaken the political initiatives of both the West German parliament and the peace congress which had just closed. I took my return flight to Chicago.

CONCLUSION

At the Documenta 8

Just before I left Berlin in September 1987, I traveled to the art exhibition Documenta 8 at Kassel in order to view Robert Morris's most recent picture cycle. Every four years the city of Kassel mounts this international show of contemporary art, which constitutes the most important event in its program of cultural tourism. This year, the publicity campaign announced a kind of contemporary art

> which interferes in the critical discourse of our time, and designs metaphors for social systems and models for social action. Which comments, appeals, and intervenes by means of pictorial arguments. Which moves on from pure perception or self-experience to memory and responsibility. Which is a subjective concave mirror of history and society.

This seeming proclamation of an argumentative art with an engagement in contemporary history distinguished the Documenta of 1987 from its two predecessors of 1979 and 1983, which had dwelt on the aesthetic self-sufficiency of the art world. In view of the menacing historical situation, the "emergency case," as one of the catalog writers put it, the claims for social relevance habitually raised in contemporary art could no longer be taken for granted. With their reassertion of engagement, the organizers of the ex-

hibition expressly contradicted Hegel, who, as the catalog asserted, "wanted to release art from social significance."

Interfere, appeal, intervene: these words recalled left-wing traditions of modern art during the years 1916 to 1936, the times from the Dada movement to the Popular Front, an art of aggression against the social order and of opposition to governments in power. If in 1987 an official exhibition were to raise comparable claims for contemporary art, that art would have faced up to political discussion just as it had done then. It would have overcome the aesthetically isolated, inconclusive consciousness of conflict pervading citadel culture. In such a case, however, it would have been necessary to be able to discern political positions of artists or artists' groups. However, the abstract, emotional social critique that could indeed be observed in some—by no means in most—of the works on view, could not be pinpointed politically. Predictably, none of these works was ever drawn into political debates in the public sphere beyond the art scene.

It has been said often enough that political pronouncements of an art that operates in the institutions of capitalist culture will have no political impact no matter how strident they may be. The Documenta's critics were quick to point out that here, too, artistic opposition did not turn on the commercialized functional mechanisms of the international art scene, and thus tacitly remained beholden to the underlying social order. Hence it is not the show's political inefficacy which is remarkable, but the new, exaggerated claims to politics so emphatically raised in its publicity, despite all experiences to the contrary from the history of modern art. The show itself offered the accustomed spectacle of citadel culture's social critique, which neither touches upon its own working conditions nor takes political stands. Accordingly, even the occasional straightforward pronouncement was being insulated from the public

sphere of politics. This could be verified in the case of Robert Morris's works on exhibit, which I had come to view.

Robert Morris's Most Recent Paintings

At the Documenta, the invited artists were allowed to exhibit works of their own choice. Thus, Robert Morris made the historic theme of the painting he had pursued since 1980 fit the occasion. As late as May 1987, he had planned to show two pictures from his *Firestorm* series, but at the last moment he changed the subject. He sent a cycle of three huge panel paintings he must have deemed especially appropriate for a West German art exhibition of that year. All of them were based on one and the same famous photograph of piles of naked corpses from a German extermination camp and framed by half-detached relief slabs in Hydrocal. With this picture cycle, the American artist provided the show with a work of art "which interfered in the critical discourse of our time" and "commented with pictorial arguments," as had been announced in the Documenta program. One year earlier Jürgen Habermas had provoked in the Federal Republic the so-called Historians' Struggle, which was still being carried on by a number of university professors and writers in the daily press and had found a strong public resonance. This debate turned on the question of whether the mass extermination of Jews and other minorities under the National Socialist government of Germany could be compared to other officially planned and organized mass-murders and genocides in the twentieth century, in particular those in the Soviet Union under Stalin in the decade between 1929 and 1939. If those crimes were not unique, it was argued, one would not have to search for their ultimate reasons in German history alone. During the years 1986 and 1987 this was not just an academic but a political issue in the quest for a

historical tradition for the Federal Republic, which the Christian Democratic government, through their building projects of a national war memorial at Bonn and a museum for German history at Berlin, was planning to monumentalize. Since Morris had been able to read at length in the American press about the Historians' Struggle, he must have been aware how politically timely his contribution to the Documenta was. As he followed up on his earlier pictures of firestorms and bombings with the cycle about the extermination camps, likening the latter to the former through their color schemes and relief frames, he posed just the question of comparison at issue in the West German public debate.

Morris had copied the extermination camp photograph in three different enlargements and collages onto aluminum plates and painted them over with encaustic pigments, each one in a different color key. This treatment made the photographs appear somewhat blurred over wide areas, and offset some of the individual bodies and faces all the more clearly. The artist had thereby not merely aesthetically softened the raw impact of the photograph, but also transformed the random piles of corpses into meaningfully accentuated configurations. The three pictures were displayed in a special room, the two smaller ones flanking the third and largest in a triptych-like arrangement. In each of the panels, one color was dominant—green to the left, red to the right, yellow in the center—and in each one, the recurrent photograph was placed in a distinct context of pictorial associations.

In the left-hand panel, the much-enlarged, seemingly undamaged nude body of a young woman was highlighted among the corpses, almost as if she were still alive. Covered by a transparent layer of green pigment, the body appeared as if floating under water. Its coincidental similarity to Edvard Munch's painting *Madonna* even suggested uncanny

associations of erotic attraction, in gruesome contrast to the technically expedited murder of the woman actually documented in the photograph. One could think of a desperate, anonymous love across time and death as the ultimate remembrance of this unknown woman's lost life. At the same time, however, one was also compelled to think of the ambivalent blend of sexuality and murder which has become conventional in the tradition of modern art, and whose uninhibited aggressiveness is being popularized in the contemporary deluge of pornographic imagery with a sadistic bend. The masturbating hands imprinted on the framing relief panels appeared to confirm such futile or reckless associations. On the right-hand panel, red flames appeared to be flickering over the piles of corpses in the photograph, which were reduced in size and therefore enlarged in scope, recalling the fire sacrifice pleasing to God suggested by the word "holocaust." But since the burning piles of corpses also recalled baroque pictures of the damned crashing into hell, they suggested the converse conclusion of an absolute doom which cannot be retrospectively redeemed by means of that biblical word. Thus both panels induced ambivalent reflections of a transfigured memory still incapable of coming to terms with the raw pictorial document.

The largest picture, in the center of the triptych-like arrangement, was not framed with relief panels, but fitted into the fiberglass cast of a giant boulder which, sawed through in the middle, appeared to slide apart into two halves to uncover in the depth of the earth a prehistoric tomb, filled with skulls and bones. Morris had created this sculpture in 1985 to visualize a cosmological theory of the physicist John Archibald Wheeler, which proposed that the beginning and the end of the universe can only be conceived of as events with a human witness present. An open eye in profile incised on the split boulder suggested the

witness, by contrast to the live human faces with their eyes closed in the tomb, lying there as if fossilized next to the skulls of the dead, surrounded by human body parts and broken tools. This juxtaposition drew on speculations about death and sleep, sacrifice and mourning, blindness and exposure. In the new picture cycle of 1987 the same relief encased the aluminum panel with the photograph of the German mass grave. A yellow beam of light seemed to fall upon the dead, as if to reveal, from an anticipated archaeological dig of the future, the historic moment of their death as a precedent of Wheeler's cosmic catastrophe. The precedent was historically unmistakable. It was the work of the American army photographers who in 1945 had compiled the visual record of the liberated concentration camps. The American artist of 1987 was transposing himself back into the split mentality with which those photographers must have worked, their technically detached survey of a horror unbearable to witness. To dig up one of their photographs from the archives and present it, transposed into huge pictures, in a West German art exhibition, amounted to an artistic reenactment of the reeducation campaign whereby, after the end of the Second World War, American military authorities had compelled the German population to view those photographs. The total reflection of concept art and performance in which Morris had trained for twenty years now enabled him to stage his submission to the show as a meaningful act of historic topicality.

The apparent message of the three pictures was as clear as it was problematical. In the age of planned nuclear mass destruction, the memory of the mass murders in the German extermination camps remains entangled in ambivalent ideological clichés. These clichés prevent politically unequivocal conclusions, particularly as long as the memory, in changing contexts of contemporary history, is partly enforced, partly suppressed again and again.

Nothing would have been more obvious than to relate the pictures to the contemporary debate in the public sphere which attempted to come to terms with those mass murders, historically as well as morally. Some of the Documenta's visitors may have made the connection for themselves, yet in the exhibition reviews in the West German press, of which I have examined the complete collection, any such reference was lacking. Art critics confined themselves to their standard verdicts, mixing aesthetic with moral evaluations, but missing out on historical reflections.

> In the case of Morris art, whose substance and morality consists not the least in its form, falls victim to a sentimental kitsch aesthetics,

wrote the leading West German news weekly, *Der Spiegel*. With his stated values of substance, morality, and form, the anonymous critic postulated aesthetic criteria to which contemporary art is otherwise rarely held. In the entire West German press, Morris's new pictures were neither described in any detail nor assessed in terms of contemporary history, although their theme had just been extensively discussed in the West German public sphere on the occasion of the Historians' Struggle. At about the time the Documenta opened, a paperback reprint of nearly all the contributions to the Historians' Struggle appeared in West German bookstores. Yet no one writing about Morris made any reference to it.

Such a disjointed public effect of contemporary art and contemporary-historical literature, which precludes any responsible political discussions about art, characterizes the segmentation of citadel culture and facilitates the pluralism of its exaggerated viewpoints. Images of historical catastrophes are severed from the context of their political understanding and aestheticized into presentations of suffering and lament in general. Robert Morris had vainly at-

tempted to break through this convention by confronting the West German public with its ugliest historical trauma. Moreover, by fusing photography and painting, he had forced the decisive question whether or not the extreme historic horror, of which visual documents exist, lends itself to be represented, let alone aesthetically transformed. However, the West German public denied the artist any precise perception or any consistent consideration of his work. Thus Morris failed in his attempt to find the way from the theatrical self-staging of today's art back to an argumentative culture.

The incongruities of citadel culture emerging here made its dramatic balancing acts appear all the more precarious. The critical reflection on a specific moment of contemporary history, which Morris erroneously took for granted in his most recent pictures, would have differed from the apocalyptic resignation and aesthetic fascination, the politically indeterminate sentiment about nuclear catastrophes he had evoked in his pictures of 1983 and 1984. As soon as he attempted to lay down the political context of the argument, he overtaxed the assimilative capacity of citadel culture, which normally shies away from no extreme in the breaking of conventions and in the brutality of images.

Looking Back on Contemporary History

As I completed the German text of this book, in the summer of 1988, an historical review on citadel culture was beginning to suggest itself. The upsurge of the economic cycle which the democratic industrial states had undergone between 1980 and 1986 seemed to have passed its peak, and the universal self-observation and self-documentation accompanying the corresponding social process in the public sphere called instant attention to this shift. In the United

States, the second postwar recession of 1980–82 had been overcome by an initially imperceptible combination of government indebtedness, accelerated short-term investment, rearmament, and curtailed social spending. This policy had led to the quick but short-term recovery of 1983–85, whose duration came into question once again in 1986 and 1987 because of slower growth rates and the abruptly rising budget and trade deficits. Militarily, the period began with the two-pronged NATO policy of negotiating in the pursuit of nuclear rearmament and the Soviet invasion of Afghanistan, the two justifying arguments for the intensified arms production of the recovery phase. The high point was reached in 1985, the last year the U.S. defense budget grew in absolute figures. In that year, shares of the American defense and space industry had risen in value by as much as 80 percent compared with those of other industries. The governments of the United States and of the Federal Republic were attempting to promote the Strategic Defense Initiative as the top project of capitalist technology, a project to insure absolute military security and expansive industrial productivity at one and the same time. The growth rates of the gross national product in the capitalist industrial states rose to their highest margins. Since 1986, the American defense budget has again been decreasing in real terms, and along with it the shares of the pertinent industries have dropped. Now the political threat of the Strategic Defense Initiative was being discussed with less and less urgency, although its development program continued at a slower pace and on a shrinking scale. After the Challenger space shuttle and the most important space rockets blew up one after the other in 1986, American space industry underwent a crisis which made it appear doubtful whether the defense system in outer space could ever be built, regardless of whether its military mission made sense. Now the cutbacks in the U.S. federal

budget prompted private corporations charged with the development of the Strategic Defense Initiative to reduce their investments. Since then the timetable for the deployment of the electronic citadel can no longer be maintained, no matter what the political circumstances. These dates suggest how quickly the historical situation has changed between 1980 and 1986 and between 1986 and now.

The steadiness of economic resurgence, or even of continual economic growth, of the capitalist industrial societies has become uncertain once again. Its cost, however, has become all too certain. In the United States, real wages and social services for the work force were scaled down, whereas in the European industrial states with their more developed social policies, permanent unemployment tended to stabilize. The economic emergency of the subordinate developing countries in Africa and Latin America deteriorated further. A growing mass production of drugs, compensating in part for the economic disparity between both spheres, could not be checked because the compensation helps maintain the political stability which sustains the economic disparity. The destruction of the environment continued. The overindebtedness of most government budgets increased. The overproduction of food in the industrial countries continued to be subsidized without being assigned to alleviate the hunger crises in other parts of the world. The relative limitations of rearmament were not prompted by a change in policy, but by difficulties in financing. Disarmament initiatives followed from the prohibitively rising cost of advancing arms technology.

Under these circumstances, during the years 1980–87, the consciousness has hardened that growth as a principle of success in a capitalist economy carries with it worldwide political crises without prospects of significant change. Accordingly, inconclusive representations of crisis situations have become the principal theme of citadel culture.

In so far as this culture is dependent on the short-term success of the capitalist economy, and at the same time emphatically presents itself as the culture of the democratic public, its critique would have to be linked to a political critique of democracy as it is currently institutionalized. "Whoever does not wish to speak of capitalism, should also be silent about fascism," Max Horkheimer wrote in 1939. Today, whoever speaks of capitalism should not be silent about democracy. I am under no illusions about the political dubiousness of such a conclusion from cultural critique.

Whereas in the two leading socialist states, in China and the Soviet Union, fundamental changes of economic and social policy were under way in 1988, in the capitalist industrial states, free market economy and political democracy were not being regarded as in need of any revisions. On the contrary, changes of state socialism in the East were being hailed as rapprochements to capitalism's own fundamental values and used as arguments to confirm them. No matter how one judges the contrast between political reform in one and political stagnation in the other of the two geopolitical camps, the public is led to perceive the fundamentally conservative politics of the capitalist industrial states as all the more immobile the more expediently these politics manage short-term adjustments to the crises caused by the economic system they sustain. Because the interdependence of capitalism and democracy precludes any fundamental change, the democratically legitimized governments remain indecisive in the face of these crises. Economic growth is the only goal they pursue with uncompromising determination. The abrupt vacillations between forced self-assurance and unacknowledged helplessness on the part of both governments and opposition parties have brought about a suspended problem

consciousness in the public sphere, where unredeemed promises and predictions alternate with unredeemable critiques and programs of reform.

Gloomy Achievements

Citadel culture was, and is, the culture of this consciousness. It illuminates the contradiction between our vital confidence in the economic and political system to which we owe our own affluence and freedom, and our diffuse but unavoidable knowledge of that system's unalterable crisis effects. Hence in the works of citadel culture which I have discussed in the individual sections of this book, artistic or intellectual perfection appear as the form of crisis sentiment which agencies of cultural policy use as a means of aesthetic crisis management. The prominent artists or intellectuals who offer their maximum achievements within this culture are no newcomers. Many of them can look back on long careers. Over the decades of postwar history, they have maintained their work with more or less autobiographical consistency. The eighties were the times of their grand success. But the more tenacious the working effort, the more complex the synthesis, the more grandiose the presentation, the more erratically their messages vacillate between utopian solutions and nihilistic dissolutions, between boldness and gloom. Stirling's New State Gallery at Stuttgart, where modern and historic architecture, functional urbanism and aesthetic monumentality have been made compatible through collage, opens to a mass public for a festive transfiguration of Bacon's bloody agonies of homosexuality. Boulez's *Répons*, the masterpiece of state-produced modern music with the machines of the computer industry, celebrates musical communication as an electronic liturgy, while in Kraftwerk's records the com-

puterized mix of voices and synthesizers intones monoto-
nous litanies about the power of international networks of
banks and police organizations, about the futility of indi-
vidual music-making and mutual understanding. Lucas
has carried the technology of animation to the highest stan-
dards of computerized image-production in order to stage
the perfection of destructive firepower in outer space as a
human test of courage and subject to a mythic force of na-
ture, while Morris has renewed the art of panel painting
through the self-reflections of concept art in order to install
on the walls of galleries and museums his series of blazing
projections of terminal wars. Bilal has drawn his colorful
comic strips about the mythical deliverance from dictator-
ship and misery under the auspices of gods from outer
space and has later replaced the fantasy of liberty with a
mythic escape from the horror of embattled metropolises
toward the sunny South. Eco's fictitious cultural history
from the late Middle Ages positions the power-obsessed
corruption of culture and the powerless curiosity of critical
reason into a mutual refutation. Habermas's scholarly anal-
ysis of thoroughly organized modern society with the help
of the classics of sociology, anthropology, and linguistics
deduces from that society itself a hypothetical counterforce.
In all these top achievements, the anticipated futility of the
challenge to the status quo emboldens its expression.

Sexual Sufferings

Robert Morris's gruesome retransformation of the nude
woman in the pile of corpses from the German extermina-
tion camp into an erotic figure is the critical extreme of a
particular sexuality which in citadel culture accompanies
the aesthetic transfiguration of futility, a sexuality both un-
leashed and painfully broken. It recalls Bilal's Jill Bioskop,

the nude victim of her brutalized environment, panic-stricken by her sexual and historical afflictions, splattered with the blood of her attackers, drug-dazed, incapable of continuing her survey of contemporary-historical events. It recalls Eco's nameless girl, the beautiful Brazilian actress in the film, nude in rags, sexually submissive to all, pushed and dragged in chains, unable to articulate a word of explanation, in the book a victim of torture and the burning stake, in the film barely escaping to go on living in dirt and wilderness. It recalls Bacon's retrospective mirroring of violent homosexuality, the malformations of his nude bodies without heads, shrunk into compounds of sexual organs and gestures, displayed to the public on pedestals, the embrace of one's own shadow on stage, the contemplation of memory as the masturbation of the voyeur. It confirms Morris's own gestures of artistic self-gratification, the masturbating fists next to the modelling hands in the frames of his fiery panoramas of doom, compromising the gestures of subversion and protest.

All these provocative sexual exhibitions of citadel culture are not just attainments of the sexual permissiveness granted by democracy, but also preconditions of success with a public that perceives both gratification and horror compulsively in sexual forms. The steady increase of that permissiveness in films and comic strips pertains to the marketing of mass art by producers and publishers, to the reflexive mutual outdoing of artistic avant-gardes in theaters and art shows. However, just as steady growth as the primary condition of success in late capitalist economic cycles does not lead to the welfare of society as a whole, but to recurrent crises of overproduction, the continually increasing sexual freedom of imagery in citadel culture does not open perspectives on the social emancipation of sexuality, but merely imbues social critique with

deceptive immediacy. It offers aesthetically intensified after-images of the ideal projections from the cultural revolution of the seventies, as Stefan Aust has recorded them from conversations of the Red Army Faction, the West German terrorist group:

> Anti-imperialist struggle and sexual liberation go
> together.
> Fucking and shooting is one thing.

Since it has become apparent that such equations could not be solved, citadel culture intensifies the sexual question, but no longer offers any prospects of a political response. Its fascinating configurations of sexual frustration and depravation elevate the permanent social maladjustment of sexuality into spectacles of aesthetic enjoyment. The sexual form in which contemporary history is being presented, which is as urgent as it is shortsighted, backlashes on sexuality itself. It addresses a form of experience which more strongly than any other presses for reality and yet remains more strongly than any other confined to subjectivity. The lack of an answer to the political question of emancipation has a particularly painful effect on this experience. Habermas's silence about sexuality, on the one hand, is the price for his attempt to overcome the philosophy of the subject by the theory of communication, the negative of his utopian abstractions. Morris and Bilal, Eco and Bacon, on the other hand, represent the suffering about contemporary history as sexual pain. About that pain, Michel Foucault has written a voluminous work which keeps the discourses of citadel culture spellbound. The increasingly menacing sadism of contemporary pornography, finally, soothes history's sexual frustrations with the magnified close-up views of functioning sexual organs. The mass successes of its absolute image-making freedom,

which in the video-equipped masturbation halls of West German big cities provides services of public order, make pornography the cathartic popular art of citadel culture.

The Culture of Cultural Critique

The closed panoramas of a universal critique without targeted protests or demands, which the top achievements of citadel culture offer, mirror the omnipresent but aimless problem consciousness in the democratic public sphere, where the freedom of universal critique without regard for practicality likewise counts for a value as such. In the Federal Republic of Germany, the creeping experience of the political futility of critical culture led, in 1978, to the Stammheim trials of the Baader-Meinhof group and then, in the prison cells of the maximum security courthouse there, to the provoked suicides of intellectuals who felt terrorism was the only way for them to engage in practice. Since the beginning of the eighties it has spawned a culture of aesthetic self-gratification unconcerned with politics which takes the political inconsequentiality of critical culture realistically into account. This new aesthetic subjectivity does not feel accountable to the revolutionary or utopian social claims which the left-wing cultural critique of the seventies has proved unable to redeem.

In so far as culture continues to address contemporary history, it incorporates the self-avowal of its political inefficacy into its presentation as a simultaneous cultural critique. The hypothetical self-effacement of culture has become the commonplace of its tradition. Habermas has considered the possible futility of philosophy just as clearly as the Kraftwerk musicians voice the end of any musical communication, and just as the shackled, masturbating fists in Morris's Hydrocal frames profess the argumentative

impotence of extreme images. None of this impairs the precision of the treatises in paperback, the resonance of the compact discs, or the luminosity of the pastel paintings. On the contrary, by linking extreme objections against the status quo to anticipated confessions of powerlessness, citadel culture can claim the authenticity of disillusioned verdicts without the obligation to pass judgment. This is a culture of cultural critique, whose self-reflective feedback prevents it from extending its universal problem consciousness to its own production and consumption in citadel society. Its built-in self-critique provides the blind spot for the contradictions of its success.

The fundamental notion of the culture of cultural critique is encapsulated in the catchword "modernism" in the United States, which translates as "die Moderne" in the Federal Republic. The underlying term "modern" ambivalently denotes both the social rationality of capitalist democracy and the intransigence of avant-garde art which was originally advanced as a challenge to social rationality. The ambivalence stems from the appropriation of the avant-garde as the representative culture of democracy after the Second World War, charged to fulfill the ideals of technical progress, individual self-realization, and loyal opposition all at once. In the seventies, when the disappointments of such expectations became rampant, social critique began to turn on modern art, first from the left, and eventually in general. In the terms "postmodernism" and "classical modernism," citadel culture has created for itself a seemingly disjointed, but actually complementary pair of concepts which allows modern art to be judged negatively and positively at one and the same time. The ideal of modernity is forever being criticized but never abandoned in the process. An alternative to it is just as inconceivable as is its implementation. The underlying in-

decision about whether culture confirms or opposes society turns into political circular reasoning, which feeds the "discourse" of deconstructive thinking.

The Metaphor of the Citadel

Under the social conditions of a perpetual cultural critique, all critical contradictions can be stepped up to noncommittal extremes or short-circuited to unsolvable alternatives. The balance of nuclear arsenals, which the public simultaneously experiences as a universal protection and a universal threat, provides the military grounding for this way of thinking. The technology of nuclear war is pictured in countless documentary films and color photographs, charts and diagrams, all ultimately released from the archives of defense ministries and arms production companies, since the most vividly descriptive images pose the smallest risk for the secrecy of arms technology and policy. These documents are turned into the authentic sources of a fantastic visual culture which substitutes familiar mythological or apocalyptic notions for the incomprehensible calculations of arms research and strategy. In Lucas's *Star Wars* films, compact cities fly through outer space, and Bilal's bundled rockets look like tipped-over multitowered castles. Such equations between wall and projectile, between defense and attack, visualize the double military function inherent in the idea of the citadel all along. They illustrate the ambivalence of the word "security," that key word of citadel society, used to justify aggressive and repressive force for maintaining a nonviolent, liberal social order. Just as West German NATO strategy papers call attacks "forward defense," so as not to conceive of defense as self-destruction, the operational guidelines of West German riot police use the term "passive

armament" for a legal description of motorcycle helmets worn by demonstrators for protection against their batons. Citadel mentality does not feel the paradox of such collaged contradictions. In February 1987, on a grey, rainy late afternoon, I stood at a traffic intersection of the Kurfürstendamm in Berlin, looking to my right at a huge welded sculpture made out of enlarged police barriers seemingly piled up at random, a newly erected official monument of the student movement of 1968, and to my left at a small demonstration, lost, dogged, surrounded, isolated and intimidated by an outsized caravan of green-and-white police vans, blue lights flashing, and massive squads of armed riot police in their visor helmets and green battle dress. No claims to playful irony can mask such cynicisms in the official art of liberal democracy.

Citadel culture shows centers of power whose functional compactness presents itself as externally menacing and internally repressive, but susceptible to dissolution at any time. The dictatorship of the fortified Cité of Paris in Bilal's *The Immortals' Business* is toppled by the mythical rebel pair of the astronaut and the Horus falcon. In the labyrinthine library of Eco's *Name of the Rose*, the seeker of truth, by dropping his oil lamp, accidentally destroys the authoritative books of tradition in a conflagration that turns the hierarchical community itself into ashes and rubble. The solid stone rotunda in the midst of Stirling's New State Gallery at Stuttgart is breached by pathways leading to the street. Max Weber's "transparent crystal palace" of a totally organized rational society where individual "life-worlds" get caught in the administration of bureaucracies, yields the secret of its humane remodelling to Habermas's analysis of communicative reason. And in the *Star Wars* films, the evil empire's "death stars" with all their weaponry explode under the fire of a single rebel inspired by the "force" of nature.

In such fantasies, the notions of historic change take mythical, apocalyptic, or theoretical forms. When Bilal conjures up Egyptian gods to return in 2023 from outer space in order to change the course of history in Paris, when Eco deploys the catastrophe of his fourteenth-century abbey according to the timetable of the seven apocalyptic trumpets, when Habermas theoretically penetrates the "system" to wrench from it a "power-free discourse," they are imagining processes of historical change which cannot be conceived historically. The reformist or revolutionary perspectives on the future drawn up during the seventies in left-wing cultural theory, which were still historically argued, have lost their credibility. In the eighties, they are being replaced by hypothetical critiques, fantasies, or postulates which can be projected without consequence in the free space of culture. The easier myth, apocalypse, and theory come to citadel culture's protagonists, the harder it has become to cope with the rising tide of empirical data from contemporary history. Their metaphorical "projects" of imaginary historical processes can do without dates. Eternal return, anticipated doom, or dialectical speculation are attempts to overtake the course of economic planning or technological development which can be electronically gathered and statistically calculated. It is these calculations that determine ever more oppressively the reality of peoples' lives, while the direction they are taking is becoming uncanny and obscure. Statistical projections of population figures and energy supplies, of social security funds and weapons systems far into the twenty-first century have become commonplace, but short-term economic forecasts and programs of social development rarely exceed a year or two and even then most often do not come to pass. In view of such discrepancies between the statistics of present and future, culture cannot be expected to maintain any measurable chronology.

Still, the time fantasies of citadel culture are discrepant to the progressively objective grasp on history facilitated by citadel society's institutions of learning, whose financial and technical expansion has broadened and accelerated the documentation of the past to the point where it begins to resemble the instant facticity of contemporary information. This process has not, however, resulted in a historically sobered self-assessment of public culture, all the less so since the deconstructive thinking which has simultaneously spread in academic institutions undermines the validity of the results no sooner than they have been reached. Thus the built-in self-doubt of citadel culture is being extended to its consciousness of history. Historians exploiting archives work side by side with literary theorists and philosophers capable of converting any document into ambivalent discourse. And the segmented academic institutions are shielding both groups of scholars from any decisive altercation.

For me, the progressive documentary assessment of past culture unintentionally but unavoidably moves it farther and farther away into the historical distance, making it increasingly incongruous to contemporary ideological projections. Nothing prevents us from likewise historicizing present culture. In the instant historical distance where it belongs, this culture can no longer block our disillusioned historical experience, no longer make our politics fall short of its goals. Since citadel culture is designed to aestheticize and dramatize historical conditions abstractly, its historical understanding would be its appropriate critique. I know I am not providing such a critique in my own short, aphoristic text. My propositions, short-circuited as they are with the metaphor of the citadel, are surrogates for a history of the present whose painstaking scholarly elabora-

tion would take the very time in which history unfolds and changes. Since contemporary culture would be past at the moment of its adequate historical analysis, the critique that follows from the analysis would come too late. The quandary has no conceptual solution. For the same reason it would be pointless to reason out the relationship between history and actuality on the basis of the overabundant literature which has long been and is still being written about it. Thus present culture defies the historical mentality, but it can no longer overcome its cool detachment. In the breakneck technical expansion of all experience, no matter how fragmented and unclear, past and present are catching up with one another to the point of diminishing conceptual distinctions. Since the present is documented more than ever, and since accounts of the past are being overturned by more documentation, historical experience seems no longer a mode of understanding reserved for the past.

A radically historical designation of cultural critique can do without theorized political alternatives. The self-imposed obligation of left-wing intellectuals like myself to stay constructive, to back up critique with counsel and action, has in the course of the past twenty years been disappointed a thousand times. Our conscious or unconscious supposition that cultural critique has to answer Lenin's question what is to be done, and can still remain confined to theory, was a haughty self-delusion which has made our analyses subject to the wrong refutations. Our instinctive political interpretation of all culture during the seventies has blurred the differences between a politically functional or politically relevant culture and a culture which neither fulfills nor claims political functions or relevancy. For the ideological discrediting of the claims to a purely spiritual, triumphantly subjective culture that were current until 1968, such political interpretations have served

their purpose. Today, cultural critique is being carried on in a self-contained microcosm of abstract political discourse disconnected from the institutional and administrative operations of actual politics. That the unswervingly oppositional self-representation of culture has come to be unconditionally sponsored by conservative interests in the name of opinion pluralism has not enlightened it about its political inconsequentiality.

Perhaps the detached historical observation of a unified pluralist culture which idles opposition by grandiosely staging it might appear as yet another start of Hegel's owl of Minerva for its flight in the dusk or of Walter Benjamin's Angel of History for his flight against the storm of unfolding catastrophes. Still, neither in Hegel's time has Western European culture entered its final phase, nor has, in Benjamin's, the alternative between apocalyptic world destruction and messianic redemption been decided either way. In view of citadel culture's splendid performances and secure lifestyles, dusk and storm are themselves but metaphors for a bird's eye perspective on the citadel whose outside view remains unsurveyable for its inhabitants. Yet even today we can seek out and stand for an argumentative, partisan culture, and can assess and assert its credibility. Such a culture will raise no longer unredeemable claims to universality, but will assert its subjectivity, leaving no doubts about whom it represents and to whom it is addressed.

EPILOG

"And we've now moved what amounts to a medium-size American city completely capable of defending itself all the way over to the Middle East."

President George Bush
Statement to the press about the
U.S. military deployment in Saudi Arabia
Kennebunkport, Maine, 22 August 1990

Update

Obsolescence

This book, with Enki Bilal's picture of the impenetrable Berlin Wall on the cover, appeared in its original German version in October 1989, less than four weeks before the Berlin Wall was opened, and two months before it began to be dismantled. Between December 1986 and September 1987, I wrote a brief first version in eight instalments for immediate publication in a West German national weekly. Between January and August 1988, I expanded this text into the German book, which, because of publishing delays, appeared as late as it did. From January through July, 1990, I worked on the present, literal English version, which is scheduled to appear in February 1991. One might say that by that time, according to its own premise of

writing instant cultural history, the book will either have lost its purpose or must be presented as a testimony from the past.

I found it necessary to write the present epilog taking note of my distance in time from the main body of the text, but not to change the picture on the cover. The image of the Berlin Wall now serves to sharpen the retrospective view on the period of the eighties and its distinctive culture, which I tried to circumscribe with the metaphor of the citadel. It turns out that the abrupt historic changes now in progress in Eastern Europe have been in the offing without being planned or at least anticipated by citadel society. Hence the peculiarly abstract, unfocussed exaggerations, the suspended political resolve, the jarring vacillations, that can be observed in the belligerent or despondent postures of much of the politics, and hence the culture, of those times. Was citadel culture then the culture of a blind end to the Cold War, a final rebound already lacking in political self-confidence? Will the agitated immobility it represented now be replaced by a culture that is focussed on purposeful change?

Historic Change

What has changed and what has remained the same are at present a matter of constant reassessments and debates, particularly among intellectuals on the left. The acute military confrontation between the capitalist and socialist camps has subsided, to be sure. We are told that this amounts to a victory of the former over the latter, and to the former's political and moral vindication. Such ideological reassurances cannot obscure the persistent historical dynamics of capitalism, which taken by itself, has not become any more reassuring all of a sudden.

It now appears that throughout the eighties in the capitalist industrial states real wages have stagnated compared to the growth rate of gross national products, since their nominal gains were steadily offset by inflation and unemployment. And since capital investment is by definition aimed at reducing labor costs, even if new jobs were generated by expansion, productivity in the OECD countries has grown in excess of employment. In the United States, unemployment was reduced by keeping overall wages and social benefits down, but in Western Europe it has by and large stayed the same. In both parts of the world, labor has steadily been transferred to low-wage, "developing" countries, and substantial minorities remain excluded from the benefits of sustained affluence. Drugs and crime have dramatized these disparities of opportunity.

The second feature of capitalist industrial society which is not about to change is its debt growth. The year 1985 was when the United States turned from the largest international creditor into the largest international debtor country. In the Federal Republic, attempts at deficit reduction undertaken between 1982 and 1987 have remained unsuccessful in the long term. The public debt has been on the increase once again, and it is now taking a quantum leap for the purposes of financing the unification of the country. Thus, taken together with the growing, unshakable debt burden of the Third World, interest payments to capital have everywhere been rising steadily, not through a rise in the profit rate, but through the growth of the principal. The governments accumulating the debt stand ready, both in the United States and in Germany, to cover their mounting deficits by tax increases, assertions to the contrary notwithstanding. And when taxes rise, the growth in earnings of the working population will be further minimized in favor of interest service on capital.

One of the premises of this book has been the tandem policies of the United States and the Federal Republic throughout the eighties, which culminated in the secret agreement of March 1986 about German-American technology transfers for the Strategic Defense Initiative, the military project of the decade. Today, the two countries have rearranged their relationship on the new premise of the subsiding confrontation with the Soviet Union. This realignment follows from the divergence in economic growth between the United States and the Federal Republic during the last three years. Whereas the former is attempting to live down its policy of a simultaneous belligerent arms buildup and economic recovery by dealing with its inordinate indebtedness, the latter is poised to finance the capitalist retooling of East Germany, and the market expansion into Eastern Europe and the Soviet Union, by way of the capital market. The new all-German government is thus about to embark on the course of deficit spending and public debt taken by the U.S. government in the previous decade. The political premise of this long-term economic projection is the end of the military threat and the conversion of Eastern Europe to capitalism and democracy.

The Third World, however, stands as the loser of the decade. The gross national products and per capita incomes of most of these countries have stagnated or shrunk. The economic disparity between the Third World and the capitalist industrial countries has been exacerbated. In South America, where constitutional democracies have replaced the military dictatorships of the seventies, the equation between democracy and capitalism, whose double triumph is expected as the outcome of the Cold War in Europe, has not worked. These countries are tied to the industrial democracies by a debt grown so much out of proportion to their productivity that they are relapsing into economic

and social crises time and again. Since their inevitable default has been acknowledged, the write-offs now in progress by the banks in the developed countries transfer the debt to the domestic capital markets.

In this situation, the sentence "Whoever speaks of capitalism must not be silent about democracy," which I adapted in the conclusion of this book from Max Horkheimer's dictum of 1939 about the connection between capitalism and fascism, assumes a new ambivalence, since that same equation now resounds everywhere as a self-congratulatory conclusion from the collapse of Communist party rule in Eastern Europe. It is being confidently restated although the government of the People's Republic of China in the summer of 1989 forcibly suppressed democracy while continuing economic liberalization. The equation implies what has not yet been experienced: that political democracy validates the capitalist market economy and that political freedom will entail economic affluence.

New Strategy

Have these historic developments removed the omnipresent threat of war, the apocalyptic suspense before the nuclear holocaust, which pervaded the eighties so intolerably that their culture was bent on tragic or utopian escapades? The political change began to be manifest in the fall of 1987, when the agreement between the United States and the Soviet Union on intermediate nuclear force reduction was signed, and was all but concluded in the spring and early summer of 1990, when the Warsaw Pact became inoperative and, as a result, NATO formally redefined its political strategy. Since then the question of what will become of arms production as a substantial or

even integral part of the capitalist economy has assumed a new political urgency.

The Strategic Defense Initiative is being continued with ever more tentative arguments so as to justify its projected fourfold budget increase. However, since strategic weapons account for only about 15 to 20 percent of the defense budget, the receding threat of a nuclear confrontation with the Soviet Union need not be critical for the political economy of U.S. arms production. The emergence of the Third World as a region of intensified economic and political crisis serves as an alternative focus for maintaining its current levels, and it is there that since early 1990 the thrust of U.S. global strategy has been redirected. Now military readiness is no longer to ensure security from attack, but to counter threats to the global capitalist economy posed by the crisis of the Third World, the outcome of the eighties.

The increased resolve to wage war anywhere on the globe is predicated on the gradual American retreat from worldwide military bases which have become untenable under nationalist pressure. The resulting concentration of military power on the territory of the United States itself requires an air force that can fan out to any location to fight two moderate-sized wars at once, and an army redefined as a fast-reaction force capable of moving in by air. On the strategic maps, the imaginary protective domes, circles and parameters of the citadel have been exchanged for dynamic bundles of arrows projecting aggressive forays from the center into all directions.

Now the American limited military interventions of the eighties are construed as a string of successful precedents for the new global strategy. Grenada in 1983, Libya in 1986, the Persian Gulf in 1988, Panama in 1989 appear as trial runs for the first major show of force unfolding in Saudi Arabia as I am writing these words. In each one of

those precedents, a deliberate overcommitment of military power and technology was timed to coincide with a quick upsurge of domestic political support. However, when the retired commander of the U.S. expeditionary corps in Vietnam wished to include the war in Vietnam as a successful precedent, he drew the wrong analogy, since that war was lost because it was no longer backed at home. Today, technical investment in long-range, high-velocity weaponry and telecommunications must offset the short-winded political support for foreign wars among the population. In the words of the Air Force Secretary:

> Sharp, short-duration operations where we punch hard
> and terminate quickly will characterize our use of power.
> The American people are rightly intolerant of conflicts
> that last longer than warranted and cause unnecessary
> suffering and loss.

During the eighties, the protests or fears, the resignation or self-deception of the public in the face of nuclear war was a reaction to a strategy pursued by their elected governments with no possibility of repeal on the part of their constituents. This military disenfranchisement of the mass democracies made for the apocalyptic or escapist moods of citadel culture. The newly projected substitution of arms technology for political support acknowledges the drain on democracy as the ostensible empowerment of the people when it comes to war.

Bilal's Projection

Enki Bilal's view of the historic change in Eastern Europe is on record in the comic-strip album *Breakthrough*, which appeared in the spring of 1990, an international collection of works by leading comic-strip artists devoted to the col-

lapse of communism and focussed on the image of the Berlin Wall. It was edited by Bilal's text author Pierre Christin, who concluded his programmatic introduction with lines that read like a manifesto:

Images have been toppled,
new ones are being born.
All visual artists must cooperate
at the pressing renewal
of our stock of images.

Bilal contributed no comic strip to the album, only two full-page pictures, one for the cover and one for the conclusion of the book. The picture on the cover shows a young family crammed in a room of a shabby apartment: a Soviet soldier, his right arm wrapped in a bloodied bandage, sits next to his two children, his blonde wife embracing them from behind. They have gathered for the sitting at a table covered with paraphernalia symbolic of Soviet demise: a cracked red five-pointed plaster star, a wooden set of the hammer and sickle painted yellow, four unused bullets, the soldier's steel helmet, a small photograph of him goose-stepping in parade, an empty vodka bottle, his party card. The window opens onto a view of the flags of the Eastern European countries which have shed their communist regimes, flying in the blue sky. The family listens to the news through a portable radio resting on the table.

Christin has had his layout designer cut the run-down Communist symbols from Bilal's cover picture and intersperse them with the columns of his text. Bilal's own concluding plate is less emphatic. It shows the couple from the cover decades later, posing in the same position, their hair greyed, their children gone, distinguished-looking in dapper suits before their earlier portrait which hangs on the wall in the place of the window. The exact duplication

of poses invites a comparison between their situations then and now, but the political conclusion is left in suspense, since one cannot tell whether the aged Soviet soldier and his wife have become wealthy capitalist or privileged Communist citizens. This is hardly the new kind of image Christin had called for in his manifesto. Discrepant with the stereotypes of liberation advanced by most other comic artists in the book, it is yet another noncommittal, ambivalent mirror configuration of citadel culture.

Kraftwerk

Computerized Retrospective

At last, a new album by Kraftwerk will come out in the fall of 1990, after a hiatus of yet another five years following *Electric Café*. This time, however, I'm not just going to the store to see whether it is already out. The Kraftwerk musicians, upon reading the German version of this book, asked me to write the introductory text for a picture book about them. It will come out in time for the appearance of their album, and in time for their world tour, their first in eight years. I am experiencing my own transition from cultural critique to culture.

In June 1990, I flew to Düsseldorf to visit Ralf Hütter and Florian Schneider in their Kling-Klang Studio in a back street near the railway station, eager to hear the new songs and sounds for the recording in the works. However, I witnessed the consummation of a protracted effort by the rock group to computerize their musical repertory accumulated since the beginning of their career. Between 1986 and 1990, the relevant computers, sound machines and software have sufficiently advanced and dropped in price to make such an effort feasible. Now the heterogeneous

analog and digital electronic sounds produced and stored over the years have been seamlessly recast into digital form and made accessible to both mathematical and visual survey and recall, analysis and reproduction. This electronic retrospective on the biographical and historical trajectory of Kraftwerk's music since 1974, which consists of six long-playing records and one maxi-single containing forty-five pieces in all, would be an undertaking like Marcel Proust's *Remembrance of Things Past*, if it could be activated to propel the ongoing work. In their mid-forties, the musicians are storing their past innovative contributions to the cutting edge of the fast-paced rock-and-roll scene in an electronic memory instantly to be drawn upon for a new, synthetic simultaneity of long-term creative achievement. Such a recapturing of past work with advanced electronic equipment is the opposite of Pierre Boulez's expansion of his perpetually unfinished work-in-progress into the "sea of never-heard sounds." Tracks and bars, sequences and voices are cut up into hundreds of minuscule units, inventoried, file-named on document directories and saved on diskettes. No fidgeting with loops, no search on spinning tapes in real time will delay the renewal of the total oeuvre in the state of its electronic atomization. Finally Interpol's and Deutsche Bank's electronic surveys of people and money, evoked in *Computer World* of 1981, have been made into an artistic procedure whereby to construct an autobiographical hall of mirrors, a sound kaleidoscope which reconfigures into simultaneous patterns the bounds and breaks of sixteen working years. This, rather than the progressive elaboration of new songs, has been the group's endeavor during the last five years. I for my part am faced with the challenge of gauging what, if anything, has changed in citadel culture since 1986, when Kraftwerk issued their last album and when I began writing this book.

Electronic Doubles

Meanwhile, in Italy, engineers are at work on a new set of mannequins representing the four Kraftwerk musicians, to be ready in time for the tour this coming fall. Finally, the electronic circuitry has become available to make these dummies move to the computerized tunes. The synchronization is completely calculable because the moving automata and the resounding music can share the same programs. The back cover and dust jacket of the album *Computer World* of 1981 show photographs of the old, immobile mannequins which Kraftwerk carried with them on the world tour of that year. The show played on the bewildering contrast between the live musicians in motion and their congealed doubles. Small computer boards were clipped like badges to the dummies' shirts and ostensibly wired into the hollow interior of their bodies, suggesting that the dummies were programmed to play the computers whose keyboards they faced in a row, the semblance of an endless circular feedback between man and machine. Ten years later, this fantasy is about to be redeemed as a projection. The movements of the new dummies according to the impulses of the music generated by the computers will appear as the opposite, as if the dummies made the computers sound.

Only the heads from the old mannequins will be preserved and transferred to the new one. Although their smoothed-out features are partly stereotyped to look like commercial showroom dummies, they do resemble the four musicians at age thirty-odd, the time when they were made. It has taken electronic technology until now to bring them to life so they can finally act as the doubles they were meant to be. But as Florian Schneider stood next to his double in its opened transport case, heads on level, they no longer looked alike.

Computers on Tour

When Kraftwerk goes on tour this fall, they will carry with them their entire electronic studio and display it on stage as if it were a battery of musical instruments. The performance will consist of calling up and modulating the digitally prerecorded materials. Thus, the ideal of the musical man-machine, which the group had proclaimed in their album of 1978, will come into its own. The performance will both confirm and deny the group's contradictory assertions, which they have maintained over the years with the characteristic ambivalence of citadel culture. On the one hand, they have asserted that the dummies might be sent on tour with the recordings, forming twenty licensed Kraftwerk groups for simultaneous, identical performances in different places. On the other hand, they have maintained that, despite the reproductive technology carried to perfection, each one of their live performances is unique, developed out of their encounter with varying audiences in variable spaces and temperatures, in changing interactions of echoes, body heats, and moods.

It is for just such an infinite variety of musical situations that the computers are now capable of processing the sound materials, since along with the atomized inventory of their repertory, the musicians have acquired and developed a variety of instruments with which to sensitize the processing itself. Rather than alphanumeric keyboards, the synthesizers' sequential rows of black and white piano keys are played to call up and edit the musical computer files, which can also be activated by striking padded drumsticks on a harpsichord, or by just breathing into a trumpet or flute. Thus the computers are spontaneously played as if they were musical instruments, the reverse of mechanical reproduction. Should the fully electronic dummies join the live musicians in the performance, perhaps sharing the

keyboards as they were depicted ten years ago, comput-
erized music will be represented by human movements in
a perfect circle on either end of the operation, with guid-
ance and obedience looking the same.

Choir of Whispers

The musicians, in the midst of intense rehearsals, were not
sure of what would be the theme, the title, the new songs
of the recording in the works. With their newly elabo-
rated technology they would recast and reinterpret some of
their most successful pieces from the past; a new song
would be included, but had not yet been written; the al-
bum's title might be anything, perhaps just the date when
the recording happened to be finished. Were the distinct,
forceful statements of the earlier albums now being fol-
lowed up with a sampler of "Kraftwerk's greatest hits"?
Did the retrospective computerization of the rock group's
music bear out my understanding of the crucial lines from
Electric Café,

> La música ideas portará,
> y siempre continuará . . . ,

to the effect that the idea of this music was the perpetuation
of its own self-sufficiency, although on ever higher stan-
dards of technical accomplishment? However, Kraftwerk's
work in June 1990 was not focussed on any new words. One
new piece they showed me is called *Choir of Whispers* and
consists of a sequential analysis of recorded voice groups
whispering inaudible words, or perhaps merely inarticulate
sounds. The elements of the sample, split up into com-
puter files to be surveyed in luminescent directory col-
umns of names and numbers on the screen, can be varied
and reconfigured in all conceivable acoustical parameters,
up to the pitch of a mass crescendo at full blast. The con-

cealment or disappearance of the human voice can be transformed into maximum sound.

Will the *Choir of Whispers* be included in the new recording? Since I found the two previous albums of 1981 and 1986 so expressive of their respective moments in history, the question of what constitutes Kraftwerk's self-proclaimed *arte política* is posited more urgently at a time when a political assessment of the present can be obviated less easily than in the seemingly immobile times of the eighties. When *Electric Café* was released in the fall of 1986, Ralf Hütter gave an interview in which he voiced his dissidence from the Federal Republic's conservative politics, siding with the anticapitalist and antimilitarist stance of the Green party. Here, in an inadvertent contradiction to Boulez, he declared the application of electronic technology to music to be an implicitly political alternative to its military use. To present expressive equivalents for the experiential forms of advanced industrial society, to the point of deliberately emulating its production techniques, and to counterpoint the emulation by a stressed emotional disengagement, may still have been a way of subversive mimetic representation in which many critics on the left believe. However, at a time when the socialist alternative to capitalism stands historically discredited, the perennial utopian postponement of any redemption for such beliefs has also lost its credibility. Hence I would not blame Kraftwerk for discontinuing their technological elegies in 1990, if that is what they are going to do.

Habermas

Little Red Book

From Kraftwerk's Kling-Klang Studio I went to the municipal art gallery of Düsseldorf, where an historic exhibition

of art from the time of 1968 was on view. With bold pictures of charging riot police, Vietnamese napalm victims, and portraits of Che Guevara and Mao Zhedong still fresh in my mind, I chanced upon a glaring red paperback with the title *The Revolution Catching Up* in the art bookstore next door. It was the seventh volume of Jürgen Habermas's "smaller political writings," which the philosopher had just put out to join the debate raging amongst German intellectuals about the imminent unification of the country. It was the first time in many years that Habermas, who is close to the reform policies advocated by the Social Democratic party and is often referred to by Social Democratic politicians, had directly addressed the subject of revolution. For in West Germany the ouster of the East German Communist regime in the fall of 1989 was hailed as the first successful revolution in German history after the failures of 1848 and 1918. Two essays in Habermas's new book stand out as interrelated, as one provides the premise for the other. The first was written sometime in 1989 and is entitled "The New Intimacy between Culture and Politics." The second was written in March 1990 and is entitled "Again: About the Identity of the Germans."

In "The New Intimacy," Habermas paints a "sobering picture of politics." In the five years since he wrote *The New Obscurity*, institutionalized politics have failed to produce the changes demanded by majority consensus in the public sphere, perpetuating instead the self-contained immobility of the constitutional state. In the face of their democratic legitimacy, Habermas implacably lists the areas where those politics are structurally bound to fall short of their self-announced objectives. To compensate for the lack of change, he notes, politicians increasingly seek out the medium of culture as a realm into which they "shift" their unsolvable problems for the mere semblance of debate and action. I was reminded of my own views about the

political function of citadel culture. Yet Habermas was still not ready to concede the public sphere of literary culture to the deceptive crisis management of the authorities. Rather, he held onto its viability as an arena for himself to press for change. In doing so, he joined a host of German intellectuals, liberal or conservative, in their breathless dash for the opportunity to give advice on the urgent issues of German politics today. Habermas must have perceived the dynamism of the East German "revolution" as an alternative to the immobility of the West German constitutional democracy.

Politics by Intellectuals

On 18 March 1990, the first democratic elections in the German Democratic Republic were won by the Christian Democratic Union on the platform of a speedy accession to the Federal Republic, invoking an article to that effect in the latter's constitution. East German voters thereby opted for the policies proposed by the Christian Democratic government of the Federal Republic itself, whose elected officials had campaigned on East German territory. The outcome of the elections did away with any aspirations to a democratic reform of the existing socialist state, harbored by the political activists who, in October and November 1989, had galvanized the popular mass protests against the Communist regime. Accordingly, the left-wing opposition in the Federal Republic itself was no longer able to envisage German unification as a political accord between two sovereign states on equal terms to form a new political entity where, through a retroactive impact of a democratic socialism, some of the excesses of West German capitalism might be corrected, and some of the social achievements of East German socialism might be retained. The underlying bipolar schemes of a redrawn balance between

left and right had proven unrealistic in the face of the economic asymmetry between West Germany, the leading European industrial country in full prosperity, and East Germany, an economically destitute former Communist territory with 12 percent of West Germany's gross national product and a quarter of its population, whose inhabitants wished to share immediately in West Germany's superior living standards.

Many left-wing and liberal intellectuals in Germany bitterly deplored this democratic triumph of capitalism, playing out to the fullest the habitual sorrowful mood of citadel culture. They questioned the political maturity of the East German electorate, which in their view had succumbed to sheer material interests and to the campaign tactics of the West German parties. This disdain for the actual process of democratic politics contradicted their initial acclaim for the reassertion of democracy against Communist repression. Once again I was reminded of my skeptical adaptation of Horkheimer's dictum about capitalism. However, at a time when political freedom seemed to triumph, West German intellectuals were in no position to proceed from their denunciation of capitalism to a self-critique of democracy. Instead, they deluged the public, first with their own utopian counterschemes to obviate the election results and delay the unification process, and later with proposals about a new national holiday or anthem of a unified country. The discrepancy between their aspirations and those of the East German electorate recalled the song from Bertolt Brecht's *Three-Penny Opera* of 1928:

> Adventurers with their courageous nature,
> Their fervent wish to risk their necks,
> Who are always so free and tell the truth,
> So that the Philistines read something bold . . .

I only ask you now: Is that comfortable?
Just he who lives in wealth lives pleasantly.

Shaping Ideology

The second of the two interrelated essays in Habermas's new book had first been published in the West German national weekly *Die Zeit* on 30 March within two weeks after the East German elections. It had been with a similarly programmatic essay in *Die Zeit* that Habermas, in 1986, had triggered the Historians' Struggle to which I referred in the conclusion of this book. The declared purpose of the new essay was even more ambitious, since it argued not just for a political revision of historical awareness, but for the enactment of a fundamental constitutional process. Originally, the essay bore a different title than when it was reprinted in the book:

> "The Nationalism of the Deutsche Mark: Why it is Correct to Implement German Unity According to Article 146, that is, to Strive for a Plebiscite about a New Constitution."

Habermas was thus calling for nothing less than an alternative to the political course of action just endorsed by a democratic majority in East Germany. As he had done during the past two decades on more than one occasion, the philosopher launched his political theory into the public sphere on a collision course with institutional democracy. Just as he had attempted in those times to vindicate the political legitimacy of protest demonstrations and civil disobedience, he was now invoking a plebiscitarian counterforce to representative democracy of which the West German constitution is particularly weary, and which it only offers as a constitutional venue for the singular event of reunification.

Consistent with his lifelong disregard for the economic
foundations and limitations of democratic politics, Haber-
mas refused to deal with the historical logic of capitalist
expansion, which was propelling the political unification
of Germany with the greatest speed. Rather, he framed the
ongoing process in terms of a nationalist ideology of West
German power, symbolized in the strong West German
currency, to be adopted by East Germany, along with the
capitalist system, even before political unification had
taken place. In Habermas's view, this ideology threatened
to override the political self-awareness of the West German
citizenry formed over the past twenty years or so, based on
sober-minded pride in constitutional regularity and prac-
tical confidence in economic achievement. Now, Haber-
mas feared, German nationalism of old was rebounding in
the "nationalism of the Deutsche Mark," a sequel, in its
quest for dominance, to Bismarck's imperialism, even to
Hitler's belligerent expansionism. With metaphors skewed
by exasperation, he compared West German money to the
dive-bombers of the Second World War.

By dealing with the historical process in ideological
rather than in concrete terms, Habermas was able to ad-
dress the process of capitalism as an issue of conscience
that could be influenced by intellectuals like himself. In
yet another effort at a validation of the public sphere for
national political education, he advanced his construct of
a "constitutional patriotism" as the only permissible na-
tional sentiment for the united German state of the future.
It was for this purpose that a plebiscite about unification
was to be held. Habermas conceded that such a plebiscite
would be a mere formality, unlikely to affect the political
course of events, but he deemed it necessary as an exer-
cise in political consciousness-raising. His transfiguration
of communicative action into a basic civic virtue required
a reasoned political reconsideration of the unified Ger-

many as a new state on the part of its constituents. This would have been a constitutional projection of his own philosophy, in defiance of the East German election the week before, an imaginary democratic scenario devised to substitute for a critique of democracy.

Recoil

When Habermas launched his intransigent counterposture to the economic and political realities of the day in the national press, he was availing himself of the public sphere of culture which, in "The New Intimacy," he had reclaimed from the elected politicians. However, the hypothetical nature of his demands proved, against his own logic, that culture serves as a deceptive displacement for extrainstitutional opposition just the same as it does for the powers that be. Unlike the politicians, though, extrainstitutional opposition on Habermas's civil terms is confined to that sphere. Hence the overdrawn argument run hot on its own frustration, the strident metaphors, the unjust verbal slurs, the loss of the lucid, cogent reasoning which had distinguished his earlier texts. Habermas's hardening recoil onto past schemes in the face of the new situation of 1990 recalls Bilal's inconclusive double family portrait of the Soviet soldier and Kraftwerk's loss for new words. Am I for my part to similarly cling to my concept of citadel culture?

Review

Past and Present

My project of an historical sketch about contemporary culture was to take the word "contemporary" literally and seriously, testing it against the unfolding chronology of historical change as I was writing. It was intended as a

challenge to the term "modernity" or "modernism," current in academic and critical literature, which is usually reasoned out in such a timeless, categorical fashion as to become a contradiction to its topical claims. In 1873 Arthur Rimbaud voiced his often-quoted demand, Il faut être absolument moderne, in despair about the anachronism of all artistic culture, and acted upon it by abandoning culture for good. Today, the chronological vacuity of the term "modern" makes up for culture's historical abstraction. By contrast, any instant historicization of contemporary culture such as the one I am attempting here remains subject almost as instantly to retrospective revisions. Hence the publishing history of this book may have made it the first victim of its premise. To print in 1991 a literal English version of a text from the years 1986–88 without alterations—and that is what this book is—may be tantamount to documenting in a literary freeze-frame how the present appeared to a contemporary in the past, but not how it would look today.

The historic events of the fall of 1989 have suddenly ended the Cold War politics whose last phase citadel culture illuminated, and have thus removed the subject matter of this book into the distance even more abruptly than a less dramatic change of times might have. Was the conservative reviewer of the German version right when he wrote, in December 1989, that "the book had the bad fortune to fall on the market just at the moment of its refutation?" He would have been had I attached any claims of permanence to my historical analysis of culture or made any predictions. Thus it is up to the readers to decide whether it is the culture or its analysis which is now out of date, or whether they have grown out of date together. My book cannot escape being read as its own case study for my contention that all thought is conditioned by historical circum-

stance, and hence acutely subject to historical revision and critique.

Radical Thinking

The critical juncture of 1989 makes it necessary to acknowledge more deliberately than in the main text the radical tradition which has informed my thinking. One or two West German reviewers have called me on the Marxist premises of the emphasis on the economic and political dependency of culture, which at present makes for its ideological appropriation by authority and opposition alike. Such diagnoses are now stopped from proceeding toward positive political conclusions according to past Marxist dialectics. The past decade has brought much uncertainty for left-wing intellectuals like myself. It began with a resilience of conservative authority so bold, and with so much democratic backing, that it could afford to accommodate rather than to combat left-wing culture. It ended with the failure of socialism as a form of government in Eastern Europe, depriving Marxists of their last illusions about practicable political alternatives to capitalism. Under these circumstances, left-wing intellectuals have a hard time reconciling a sober-minded perception of historical reality with a credible definition of what they can commit themselves to stand for. A West German critic of this book aptly observed that I

> cannot decide whether [I] wish to declare a partisan critique of capitalism as outdated, to renew it, or to suspend it.

The book will carry this question to its readers. Yes, a partisan critique of capitalism, whose defects are obvious in light of what I have stated in the first section of this epilog, is still in order. And yes, such a critique is being sus-

pended by the cultural environment, no matter how stridently it is being voiced. However, its renewal does not depend on whether or not I for one will be able to make up 209 my mind. It will depend on whether a critique of culture based on historical observation can find an interactive audience which will inform its political purpose. "Partisan" means nothing less.

Distance and Participation

Meanwhile, I will accept the reviewer's characterization of a "suspended" cultural critique. He and others have duly noted the resulting ambivalence. Any nostalgic yearning on my part for the argumentative culture of the seventies, discerned by still other reviewers, is unintentional. Rather, as has also been remarked, the book is just as much a part of citadel culture as it is its critique. After all, I have defined citadel culture as the culture of cultural critique. Such contradictions occur in most critical writing on contemporary culture, mostly unacknowledged since the conceptual cant of poststructuralism or critical theory serves to paper over the disparity between the limits of individual experience and the judgment on the present world. The contradiction between the sweeping judgment inherent in my metaphor and the heterogeneous, arbitrary selection of themes has not escaped some of my critics. One of them has charged me with writing in the mode of Walter Benjamin, whose theoretical premises and metaphysical beliefs were strong enough to inform his so-called micrological analyses of disparate cultural phenomena as suggestive of world-historical processes. In light of Benjamin's posthumous popularity in cultural critique today, I should take the charge for a compliment, but I cannot share in the overblown assurance of judgment and prophecy which many writers on the left have drawn from those texts of over half

a century ago. Just as Benjamin's Angel of History, blown away by the storm of catastrophes, cannot hold onto the perspective of his survey, the Archimedic point of cultural critique which many of those writers claim is either constantly being shifted or projected into the imaginary.

Ruin or Expansion of the Citadel

So why does this book still appear with Bilal's picture of the intact Berlin wall on its cover? The conservative reviewer who saw the German version appear "at the moment of its refutation" because the Cold War was over, went on to dwell on the metaphor all the same, picturing the citadel as a romantic ruin "in the emphatically free landscape" of the future. Meanwhile, the Strategic Defense Initiative, the metaphor's military equivalent in reality, is officially planned to be ready for deployment in 1993 to survey that landscape. Liberal West German critics, more skeptical about the newly imminent age of freedom, have speculated that capitalism's expansion into the East will just integrate new territory into the citadel, reconfiguring *intra muros*, as one reviewer wrote, its external borders toward the Third World and its internal borders toward poverty. If the term citadel culture serves for debates like this, I can let it stand.